CONTEMPORARY PHOTOGRAPHY AND THE GARDEN—DECEITS AND FANTASIES

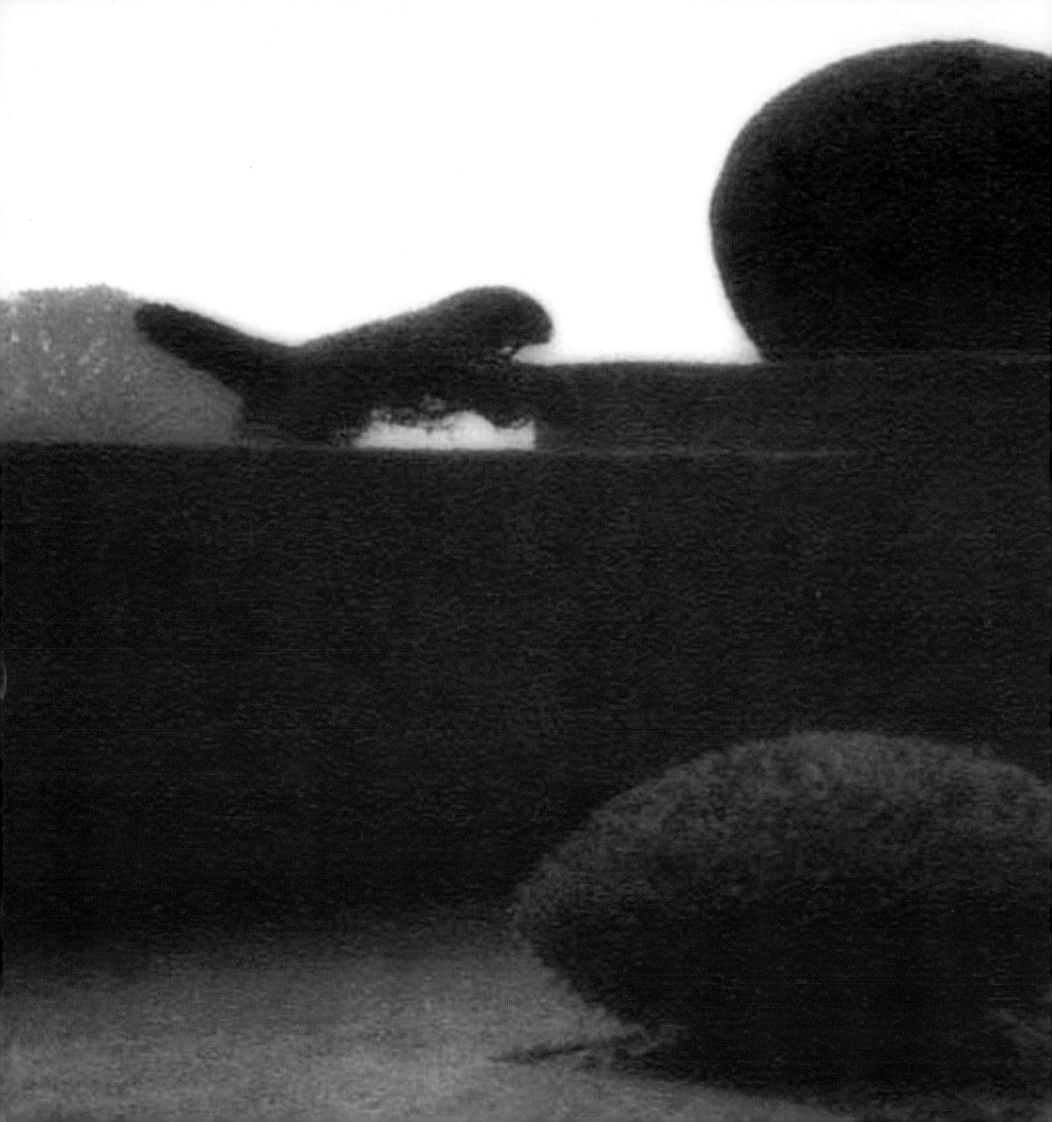

DECEITS & FANTASIES

CONTEMPORARY PHOTOGRAPHY AND THE GARDEN

Thomas Padon

with Robert Harrison, Ronald Jones, and Shirin Neshat

Harry N. Abrams, Inc., Publishers, in association with the American Federation of Arts

This catalogue has been published in conjunction with *Contemporary Photography and the Garden—Deceits and Fantasies*, an exhibition organized by the American Federation of Arts.

For the American Federation of Arts:
Publication Director: Michaelyn Mitchell
Exhibition Curator: Thomas Padon

For Harry N. Abrams:
Publication Director: Margaret Kaplan
Editor: Elaine M. Stainton
Designer: Eileen Boxer

Works by Linda Hackett: Photo © 2001 D. James Dee
Works by Len Jenshel: © Len Jenshel
Works by Marc Quinn: Photo Stephen White
Works by Jean Rault: © Jean Rault, Courtesy Galerie Michèle Chomette, Paris
In the Ronald Jones essay, the poem "City Trees" by Edna St. Vincent Millay is from *Collected Poems*, Harper Collins. Copyright 1921, 1948 by Edna St. Vincent Millay. All rights reserved. Reprinted by permission of Elizabeth Barnett, literary executor.

Published in 2004 by Harry N. Abrams, Incorporated, New York, in association with the American Federation of Arts, New York. All rights reserved. No part of the contents of this book may be reproduced without the written permission of the publisher.

American Federation of Arts
41 East 65th Street
New York, New York 10021
www.afaweb.org

Harry N. Abrams, Inc.
100 Fifth Avenue
New York, N.Y. 10011
www.abramsbooks.com

Library of Congress Cataloging-in-Publication Data

Padon, Thomas.
 Contemporary photography and the garden : deceits and fantasies / Thomas Padon with Robert Harrison, Ronald Jones, and Shirin Neshat.
 p. cm.
Exhibition catalog.
Includes bibliographical references and index.
ISBN 0-8109-4955-5 (hardcover) — ISBN 1-885444-29-X (pbk.)
1. Photography of gardens — Exhibitions. 2. Gardens in art — Exhibitions. I. Title.

TR662.P33 2004
779'.3'074—dc22

2004000876

Front cover: Linda Hackett, *Allium Giganteum* (detail), 1992 (p. 75)
Back cover: Sally Mann, *Untitled*, 2001 (p. 107)
Title page: Lynn Geesaman, *Hedge, Knightshayes Court, Devon, England*, 1991 (p. 63)
Facing contents page: Jack Pierson, *Luxembourg*, 1999 (p. 122)

Exhibition Itinerary to date
The Middlebury College Museum of Art
Middlebury, Vermont
January 20–April 17, 2005

The Parrish Art Museum
Southampton, New York
May 22–July 17, 2005

Columbia Museum of Art
Columbia, South Carolina
October 21, 2005–January 2, 2006

Tacoma Art Museum
Tacoma, Washington
January 14–April 30, 2006

Printed in and bound in China

Dedicated to the memory of James T. S. Wheelock

CONTENTS

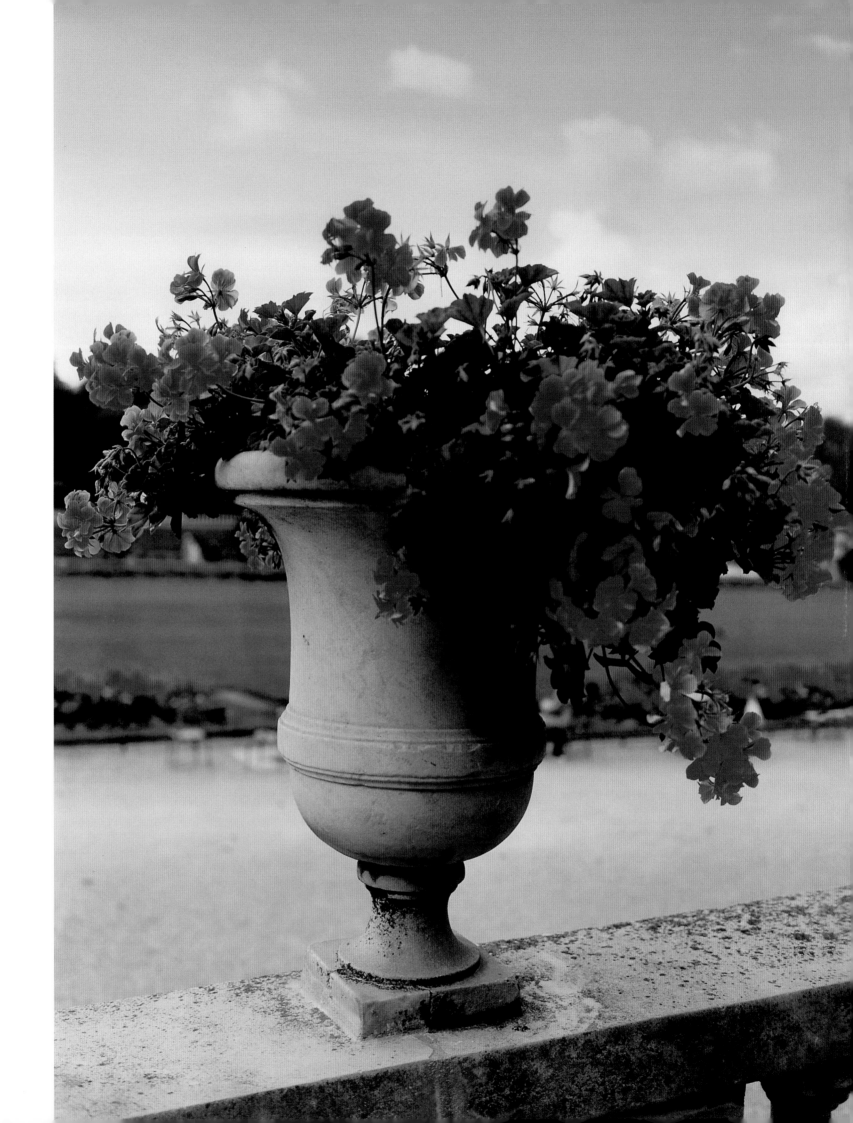

ACKNOWLEDGMENTS

Contemporary Photography and the Garden assembles a group of extraordinary photographs made by artists who have taken the garden as a subject in their work. Looking at these pictures, one is struck by the variety of artistic responses to the forms, atmosphere, and rich symbolism of the garden. We are delighted to present this beautiful and stimulating body of work to a broad national audience.

It is always gratifying to acknowledge the work of the very accomplished curators with whom we work. It is with special pride, however, that I acknowledge the curatorial talents of Thomas Padon, AFA's Deputy Director for Exhibitions and Programs, who served as curator for this wonderful exhibition. Tom's informed and sensitive selection of photographers to include in the exhibition and images he chose for the show has become a captivating exhibition and publication. Tom also wrote the lead essay for the catalogue, which places these photographs into the context of the history of photography, and selected the other contributors to the book: Robert Harrison, Ronald Jones, and Shirin Neshat. We are grateful to them all for the varied ways in which they enrich this catalogue. We also want to especially thank AFA Trustee David Davies for his support of this project.

The entire staff at the AFA has worked hard to bring *Contemporary Photography and the Garden* into being. Tom has been the guiding light throughout the development and realization of the project. He has been ably assisted by Lynn Mador, Assistant to the Deputy Director, who provided invaluable help with research and with the coordination with the artists; and Paige Hamilton, Curatorial Assistant. Michaelyn Mitchell, Director of Publications and Design, coordinated production of this handsome and important catalogue and deserves acknowledgment for the high level of expertise she brought to the project. Assisting Ms. Mitchell was Anne Palermo, Assistant Editor, who deftly took care of so many details related to the production of the catalogue. Kathleen Flynn, Head of Exhibition Administration, oversaw many aspects of the exhibition tour. I also want to thank Megan Fox Kelly, Curator of Exhibitions; Margaret Touborg, Deputy Director for Institutional Advancement; Laura Fino, Grants and Sponsorship Manager; Nelly Silagy Benedek, Director of Education; Suzanne Burke, Assistant Educator; Heidi Riegler, Director of Communications; and Julie Maguire, Registrar.

We would like to acknowledge Eileen Boxer for designing a book that responds so sympathetically to the subject matter. We also very much appreciate the expertise and enthusiastic support of Margaret L. Kaplan and Elaine M. Stainton at Harry N. Abrams Inc., our longtime publishing partner.

Above all, we are tremendously grateful to the sixteen photographers represented here—for their beautiful work and for generously lending it to this exhibition.

Finally, we recognize the museums participating in the tour of this important exhibition. It has been a pleasure to work with them, and we thank them for being such enthusiastic partners.

JULIA BROWN
Director, American Federation of Arts

This project has been many years in the making, and numerous people have been instrumental in making it a reality. I want first to express my profound gratitude to Julia Brown, Director of the AFA, for her ongoing support of and enthusiasm for the exhibition. Michaelyn Mitchell, AFA's Director of Publications and Design, contributed not only her usual expertise in shepherding the catalogue through publication, but gave me much appreciated encouragement and advice throughout my work on the exhibition. Others at the AFA whom I'd like to thank include Lynn Mador and Paige Hamilton, who meticulously managed many aspects of the exhibition and whose research and dedication were invaluable to the development of this project. Anne Palermo deftly handled the assembly, documentation, and rights clearance of the photographs for the publication. I am indebted to Nelly Benedek, Suzanne Elder, Kathleen Flynn, Megan Fox Kelly, and Julie Maguire for their much appreciated assistance. I also want to acknowledge Serena Rattazzi, former AFA Director, for her encouragement in the early stages of the project, as well as Eileen Armstrong, Christina Ferando, Gail Fisher, Jennifer Jankauskas, and Helaine Posner.

My thanks extend to all the artists whose photographs are included in the exhibition. For several years now, I have had the pleasure of collaborating with them and speaking to them about their remarkable photographs. I am indebted to them all for their kind cooperation and for giving of their time so generously. Sally Mann and Catherine Opie deserve special recognition—they responded with enthusiasm and a sense of adventure to my invitation to take part in a commission to do new work specifically for the exhibition. It has been a privilege to be associated with these two artists as the extraordinary work they created took shape. I also want to acknowledge the generous cooperation of the galleries with which we have worked.

This publication has benefited enormously from the prodigious talent represented by the contributing authors: Robert Harrison, Ronald Jones, and Shirin Neshat. Their texts provoked and extended my own thinking about gardens as a subject in contemporary photography, and I am very much indebted to them for agreeing to contribute to this publication.

It has been a privilege for me to collaborate once again with Harry N. Abrams. Thanks are due the entire staff, in particular, Margaret L. Kaplan, who championed the publication and whose expert advice and encouragement are deeply appreciated; Elaine M. Stainton, who skillfully edited the publication and made valuable recommendations for the texts; and Michael J. Walsh, Vice President of Design. Warmest thanks are also due the very talented Richard Phibbs for his generosity. Finally, I am indebted to Eileen Boxer, whose formidable talents resulted in the stunningly beautiful design for the book.

THOMAS PADON

DECEITS AND FANTASIES

THOMAS PADON

Gardens have been a compelling subject since the advent of photography in the mid-nineteenth century. In the mid-1980s, however, an unusually large number of artists began turning to the garden as a subject in photography. In their work, this generation of artists has explored variously the human imprint on the landscape; the garden as an expression of man's attempt to shape nature; the distinction of private versus public spaces; and the degree to which gardens reveal the aspirations of the cultures that created them. Ranging from depictions of gardens as tranquil havens, to places of tension where exquisite beauty seems to coexist uneasily with the inexorable forces of nature, these photographs reveal the artists' exploration of the diverse sculptural forms, atmosphere, and rich symbolism of the garden.

In addition to being a highly popular subject over centuries for artists working in a variety of media, gardens are extraordinary works of art in their own right. Though seemingly "natural," they are created by man like any other work of art; a garden can thus be considered no more natural than a seventeenth-century painting by Claude Lorrain can be considered an actual Arcadian landscape. For centuries, there have been proponents for the acceptance of gardens in the pantheon of fine arts along with disciplines such as painting and sculpture. In his influential book *Italian Gardens*, the noted garden designer, author, and photographer Charles A. Platt wrote: "while the other arts of the Italian Renaissance have been exhaustively treated . . . there is no existing work of any great latitude treating the subject of gardens . . . "[1] These days gardening must no longer sheepishly sit off to the side of its sister arts. The validity of a garden as a work of art can be demonstrated not only by the four artists in this exhibition who have combined the creation of a garden with photography, but by the number of contemporary artists who have created gardens (either alone or in conjunction with other media) and designated them as

such. Like Noguchi, who made one in the mid-1980s outside of his museum in Long Island City, New York, several artists have created gardens in conjunction with museums, most notably Robert Irwin, who designed an elaborate project for the J. Paul Getty Museum in Los Angeles (fig. 3), and Lothar Baumgarten, who created a garden for the Fondation Cartier pour l'Art Contemporain, Paris (1995).[2] Irwin referred to the work as "a sculpture in the form of a garden that aspires to be art" (the salient point being that he considered the garden

FIG. 1

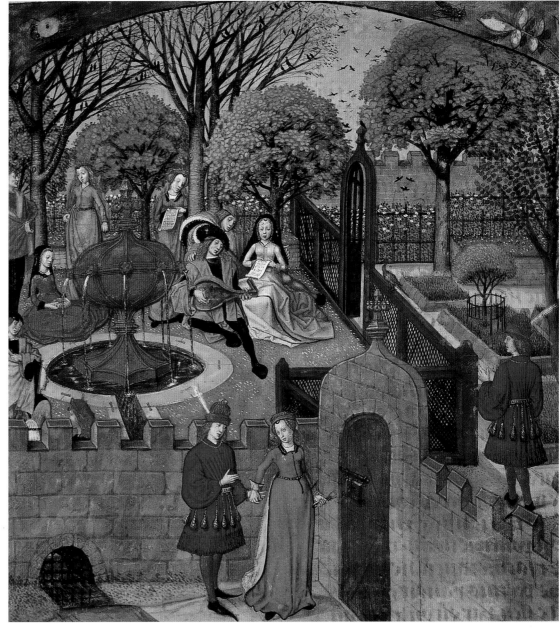

FIG. 2

FIG. 1 Charles Adams Platt, *Boboli Gardens*,
1892 (Italian Gardens Collection). Gum
bichromate print, 19¹³⁄₁₆ × 23¹³⁄₁₆ in. Addison
Gallery of American Art, Phillips Academy,
Andover, Massachusetts; Gift of Penelope Jencks
in memory of Gardner Platt Jencks (1993.59)

FIG. 2 Master of the Prayerbooks, *Roman de la
Rose, Lutenist and Singers in a Garden*,
ca. 1490–1500. Illustrated manuscript (Harley
MS 4425, folio 12 verso), 8½ × 8 in. The British
Library, London

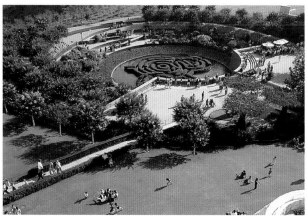

FIG. 3

a sculpture).[3] Ronald Jones and Shirin Neshat have also created gardens: Jones as a commission from the city of Hamburg (fig. 4), Neshat as part of *Tooba,* a film she made in Mexico (p. 136). Later in these pages, Jones muses upon the meaning of gardens in his retelling of the events of an evening at the home of Edna St. Vincent Millay as described in a letter from the poet's husband, Eugen Boissevain, while Neshat speaks about the importance of gardens to Iranian history, religion, and visual and literary culture.

A study of garden typology would reveal as many types of gardens as there are entries for garden history in a library database. The garden is not easily defined. Each individual, each culture, has its own definition of this place that is demarcated not only by a physical boundary but by the imagination. All gardens share, however, a presumption of a heightened experience of nature. It is an irony that such an experience is to be had in a setting of total artifice, no matter how artfully contrived, an irony explored by a number of artists in the exhibition. Gardens also share formal properties—color, shape, texture—and sensitivity to factors such as atmosphere, light,

FIG. 4

and the seasons. The latter, and the cycles of life and death that they represent, separate the garden from other types of art. Even meticulously maintained, gardens change constantly. As Geoffrey James—whose work is included in this exhibition—has noted, "more than any other works of art, gardens are vulnerable to the passage of time, victims not only of the encroachments of nature but of the caprices of fashion and pressure of speculations."[4] Temporal concerns affect not only the physical manifestation of the garden as man attempts to keep up with nature's shaping of it, but our very ability to understand the garden and gain fulfillment within its boundaries.

In his essay in this book Robert Harrison traces the idea of the garden in the Western imagination through millennia as expressed in religion, philosophy, literature, and garden design. He points to the ambiguous place that gardens inhabit in our culture today and suggests that their very concept may be dated. Harrison questions whether we are willing any longer to devote the time necessary to fully appreciate gardens, which require much more than a passive spectator.

Gardens are intricately linked with the history of photography. Eugène Atget is so allied with documentary photography and gardens as a subject that one cannot examine either without a consideration of his work. Obsessively photographing the gardens in and around Paris from about 1890 to just before his death in 1927 (figs. 5 and 6), Atget worked within the mode of objectivity that John Ruskin, among others, prized in the relatively new medium

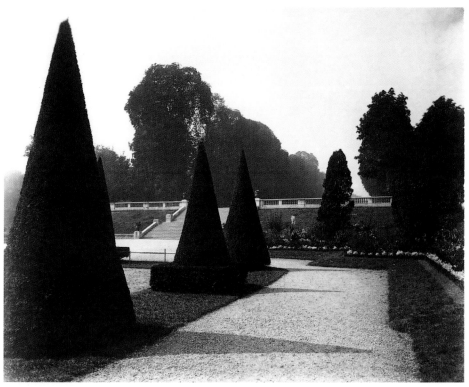

FIG. 5

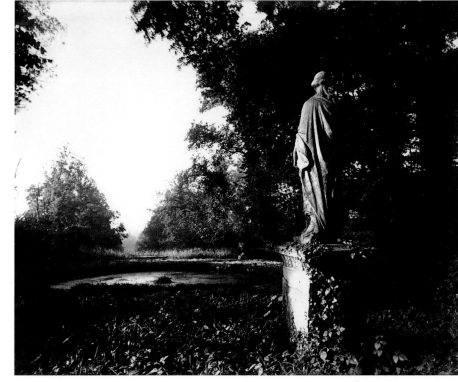

FIG. 6

FIG. 3 The Central Garden, designed by
Robert Irwin. The Getty Center, Los Angeles.
Copyright 2002 J. Paul Getty Trust. Photo
Susan Goldman

FIG. 4 Ronald Jones, *Caesar's Cosmic Garden*,
1995–2002. Julius-Kobler-Weg, Hamburg,
Germany. Courtesy the artist and Metro
Pictures. Photo Felix Borkenau, Hamburg

FIG. 5 Eugène Atget, *Saint-Cloud, Park,*
ca. 1921–22. Albumen silver print, 7¼ × 8½ in.
National Gallery of Canada, Ottawa; Purchased
1980 (P70–126)

FIG. 6 Eugène Atget, *Sceaux,* 1925. Gelatin
silver print, 7 × 8⅞ in. National Gallery of
Canada, Ottawa; Purchase 1974 (P74–318)

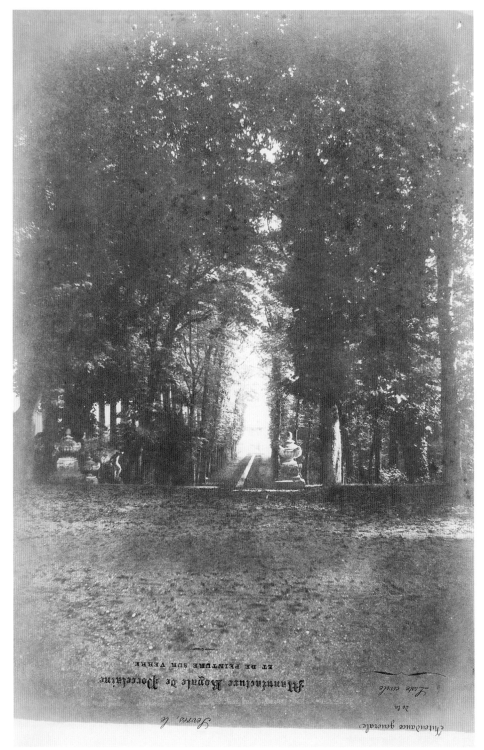

FIG. 7

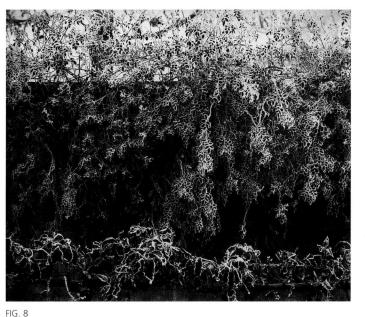

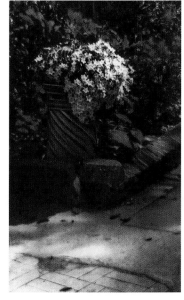

FIG. 8

FIG. 9

of photography. He followed in the footsteps of photographers such as Louis Robert, known for his calotypes published in *Souvenirs de Versailles* (fig. 7) decades earlier. Photography could faithfully document; it would also forever change the perception of the world in which we live. Thus, while Atget systematically chronicled the changing nature of the built environment in Paris and the deteriorating condition of these grand gardens—bold statements of the power and hubris of the French Golden Age—he also created a poetic visual postmortem on the ancien régime, which, in his photographs, clings tenuously to life at the dawn of a new century.

Gardens were also explored by many of the photographers loosely grouped under the term Pictorialists as part of their larger investigations of the landscape. These artists, who emerged in Europe and the United States beginning around 1890, were dedicated to creating a separate identity for art photography and to raising the status of the medium to equal that of painting and sculpture. Before that time, photography was considered largely the basis of study for painting, or as a means of documentation. The growing popularity and technical sophistication of photography, as well as its commercial applications, led the Pictorialist artists—among them, F. Holland Day, Edward Steichen (fig. 8), and Alfred Stieglitz in the United States and James Craig Annan, Alvin Langdon Coburn (fig. 9), Robert Demachy, Frederick H. Evans, Charles Job, Adolph de Meyer, and Francis James Mortimer working in the United Kingdom and Europe—to distinguish themselves through the creation of a more emotive

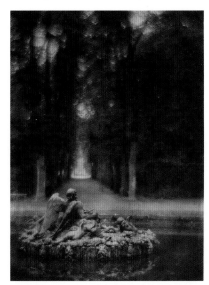

FIG. 10

visual language and rarefied printing techniques. The Pictorialists were concerned foremost with the beauty of an image, rather than its power to document, and adopted a painterly approach to photography. Beginning with an extreme soft-focus, they also freely manipulated the photographic image: altering, removing, or adding details and introducing decorative tones and highlights to enhance what were often unique images. A photograph of Versailles taken by Adolph de Meyer (fig. 10) and reproduced in Stieglitz's publication *Camera Work* in 1912 epitomizes the poetic, highly atmospheric landscapes created by the Pictorialists. In keeping with their penchant for Arcadian scenes, however, pastoral landscapes, rather than gardens specifically, predominate in the Pictorialist canon.

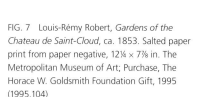

FIG. 7 Louis-Rémy Robert, *Gardens of the Chateau de Saint-Cloud*, ca. 1853. Salted paper print from paper negative, 12¼ × 7⅞ in. The Metropolitan Museum of Art; Purchase, The Horace W. Goldsmith Foundation Gift, 1995 (1995.104)

FIG. 8 Edward Steichen, *Frost on Rambler Roses, Voulangis, France*, 1920. Gelatin silver contact print, 7⅔ × 9⅔ in. George Eastman House, New York; Bequest of Edward Steichen by Direction of Joanna T. Steichen (79.2025.0001). Photo Carousel Research, Steichen Estate. Reprinted with permission of Joanna T. Steichen

FIG. 9 Alvin Langdon Coburn, *Cascade of Flowers in Urn*, 1906. Photogravure print, 5½ × 3⅜ in. George Eastman House, New York (67.0152.0002)

FIG. 10 Adolf de Meyer, *The Fountain of Saturn, Versailles*, 1912. Photogravure, 8½ × 6⅜ in. Kuyten Collection, Canada

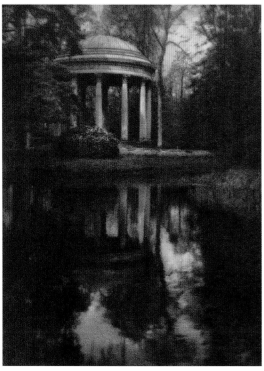

FIG. 11

Yet as Maria Morris Hambourg has observed, "the age of electricity, the telephone, and the airplane would not recognize itself in the contemplative cast of the Pictorialists"; and after World War I photographers defined a new sensibility.[5] Differences between photography and painting were now asserted rather than sublimated. Artists dispensed with soft-focus and the pursuit of tonal delicacy in search of a more direct, "straight," approach to photography. Instead of creating moody landscapes and painterly portraits, artists embraced signs of modernity and urban life.

In the pursuit of the modern, gardens—rife with soft, sentimental form and rooted in the past—were left behind. The very concept of a garden was too associated with the past, the spaces too complex, to suit the new reductive approach that mirrored developments in abstract painting. So it would be for decades to come.

Though a comprehensive examination of twentieth-century photography is not practical within the confines of this essay, it suffices to say that gardens did not feature in the surrealist-inspired photography and Neue Sachlichkeit of the 1920s and early 1930s; in the social documentary of artists such as August Sander, Walker Evans, Robert Frank, and Henri Cartier-Bresson (working from the late 1920s to late 1950s, respectively). Despite a number of highly reductive explorations of natural form, gardens were not treated in the work of artists such as Edward Weston or Minor White (working from the 1920s through the 1960s, respectively). Gardens are also completely absent from the tradition of street photography that arose in the 1950s, as exemplified by Garry Winogrand and Lee Friedlander; in photography related to the development of pop art of the 1960s (though artists creating earthworks beginning in the '60s, such as Robert Smithson, did use photography to document interventions in the landscape); and conceptual art of the 1970s. From the end of the Pictorialist era, in fact, to the late 1970s, gardens were almost completely ignored in photography as a subject of ongoing investigation. Paul Strand is an interesting exception. One of the founders of modernist photography and an artist known for his contribution to the development of the New Objectivity, Strand's remarkably long career was bracketed by work having gardens as its subject. As a twenty-two-year-old working in the Pictorialist vein, he created *Garden of Dreams, Temple of Love* (fig. 11), a prize-winning photograph of Versailles. In the two decades before his death in 1976 he shot numerous straightforward photographs of his own garden in France (fig. 12). Also working throughout the 1950s and '60s was Georgina Masson, the British-born author and photographer who moved to Italy after World War II and thoroughly documented its villas and gardens.[6] In a work such as *Roma, Terme di Diocleziano* (fig. 13), Masson's predilection for oblique vantage points and theatrical lighting are both evident. In a photograph unusual for its depiction of a garden after sunset, Masson here combined ambient light, as well as that of her flash to exaggerate the looming presence of the flanking sculptures here in this surreal nocturnal scene.

As the work in this catalogue attests, the garden has, since the mid-1980s, once again provided artists with a rich subject. A survey rather than a comprehensive examination, *Contemporary Photography and the Garden* includes the work of sixteen American and European artists whose plurality of styles represents a wide range of responses to the physical and conceptual structure of the garden. These artists see gardens as an apt symbol of the

increasingly ambiguous relationship of man to nature, part of the growing environmental concerns of the 1970s and 1980s. They explore the dialogue between man and nature at the heart of every garden and look at the tension between the human impulse to shape and control primordial forces. The artists mine the garden as a potent visual representation of culture—an imprint, at once beautiful and artificial, that reveals much about the time and the place it was made. As they explore these sites, the artists simultaneously explore our own ambitions and follies. Unlike many contemporary artists and critics uncomfortable with the very notion of beauty, these artists embrace, indeed at times embellish, the sublimity they often find in their subject, while exploring multivalent levels of meaning that their visual investigations lend to gardens.

 ⁓

Several of the artists in this exhibition—Jean Rault, Erica Lennard, and Lynn Geesaman—subvert the idea of the garden as a bucolic symbol of nature; their images play against the notion of a garden as an idyllic site for the pursuit of pleasure. In their focus on the insistent artificiality of gardens, these three artists, more overtly than others in the exhibition, expose the human impulse to shape nature to its will. Their photographs provide a haunting, dark metaphor for the manipulation of nature. Working with a diffused light, a rich tonal palette, and idiosyncratic perspectives recalling Atget, these artists have created photographs that also fall comfortably within his stark documentary mode. French artist Jean Rault was intensely drawn to the Potager du Roi, the vegetable and fruit garden created by Louis XIV at Versailles for his own table and largely ignored by other photographers drawn inexorably to the visual pomposity of the chateau's adjacent main gardens. Emphasizing the large walls that surround it, Rault presents the Potager du Roi as a prison—a pitiless place where the iron rule of the Sun King has literally sculpted nature into austere, rigidly patterned forms. The entire enclosure was designed to accommodate the weekly procession of Louis XIV and his entourage to mass at the Cathedral of Saint Louis (seen in the background of *Vue 19 du Potager du Roi* [p. 131]) and his inspection of the garden. Working in winter and early spring from 1993 to 1997, Rault created a series of one hundred prints that the artist says constitute a "portrait" of this austere place, as well as its vainglorious patron.[7] Control is particularly insidious in *Vue 48 du Potager du Roi* (p. 135), in which a vernal cloak of leaves contrasts with the seemingly innocuous yet intricately knotted base of the espaliered tree, the result of decades of precise training. The photograph speaks volumes about the decadence of a garden in which fruit trees could grow no higher than the king's reach. With his emphasis on the garden as an enclosed, claustrophobic space, Rault creates an ominous mood in which nature was and is under surveillance. Geometric patterns and deep shadows only underscore the heavy hand of human intervention in these photographs that clearly speak of pretension and conceit.

Beginning in 1989, Erica Lennard began photographing gardens in Japan, expanding upon the major explorations she had undertaken of classical European gardens. She found Japanese gardens compelling because they were designed as places of both physical beauty and spiritual transcendence. The religious and philosophical views that have shaped the cultures of

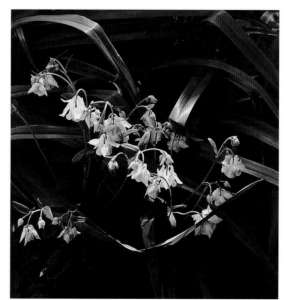

FIG. 11 Paul Strand, *Garden of Dreams, Temple of Love, Versailles, France*, 1911. Vintage gum-bichromate print, 13¼ × 10 in., unsigned. Courtesy Stockeregg Gallery, Zurich, Switzerland. Copyright Aperture Foundation Inc., Paul Strand Archive

FIG. 12 Paul Strand, *Columbine, Orgeval*, 1974. Gelatin silver print, 11⅜ × 10⅞ in. Copyright Aperture Foundation Inc., Paul Strand Archive

FIG. 12

the East led to the development of gardens distinctly different from their Western counterparts. Adopting a starkly frontal format, Lennard seeks out and emphasizes those contrarieties by isolating the signature features of some of the country's most celebrated gardens. In *Ginkagu-ji* (p. 97), for example, her tight focus separates the packed-sand mound (*kogetsudai*) from the other elements of the garden and surrounding architecture. By making the *kogetsudai* almost completely fill the foreground in this image, or through her elevated perspective of the two mountains of sand (surrounded by an expansive sea of gravel) in *Daisen-In* (p. 96), Lennard creates an ambiguity of scale that is itself a characteristic of Japanese garden design. The insistent graininess of her black and white tones and the eerily flat light under which she chose to work both recall Atget and impart a contemplative quality that distances these gardens—whose precincts in actuality can only be looked upon, not entered—from the viewer. Her distillation of each garden to its most expressive physical gesture amplifies both the metaphorical power of each sculptural form and the emphatic artifice of the endeavor.

Lynn Geesaman has photographed gardens throughout Western Europe and the United States. Like Atget, she seeks unusual points of view within the landscape; the artist has said she uses "surprise and incongruity to challenge the authority of carefully planned spaces."[8] In the formal gardens to which she is drawn, she creates photographs of austere beauty in which she emphasizes the high artifice behind these tightly controlled landscapes. The vigilance and brute force exerted in the attempt to keep nature under control in the sites she photographs finds visual equivalent in the exquisite tension she creates in her compositions. Geesaman carefully frames each work, creating an area of lighter tones at center, surrounded by dramatic darker contrasts. In *Theater House, Peover Gardens, Knutsford, Cheshire, England* (p. 59), for instance, the garden pavilion is exactly centered, its decrepit, pallid walls providing a tonal foil to the dense velvety black of the crenellated hedges that almost threaten to constrict the structure. Working from sharply focused negatives, Geesaman creates a visual dissonance during the printing process, making slight off-register effects that enliven the outlines between objects. She presents gardens as somber, silent, dreamlike spaces; like dreams, her photographs can have multiple readings. In *Huntington Gardens, San Marino, California* (p. 67), an ancient tree, its spiny silhouette bristling self-consciously against an almost apocalyptic sky, stands at center. The dramatic cant of plant life toward the path, that path's visual blockage just ahead, and the brooding, almost aqueous atmosphere provoke a visceral feeling of entrapment. Yet beauty abounds, here, too. This work, like so many of Geesaman's brilliantly balanced photographs, has what Robert Adams called "a tension so exact that it is peace." Combining a detached visual approach with a soft, almost Pictorialist focus, Geesaman creates images that separate the sublime from the merely beautiful.

In stark contrast to Geesaman is Geoffrey James, who creates, with preternatural clarity, a compact, precisely rendered universe of minute detail in each photograph. James exults in the theatrical quality inherent in gardens, specifically those of the Baroque period in Italy where he lived briefly as a child. He shares with Atget an intense ardor for formal gardens and a predilection for expansive, sweeping views. In 1978 he began using an antique panoramic camera to deal with the complex spatial constructions and multiple points of view contained within a garden. The range of this camera, more analogous to human vision than a conventional one, enables him to create contact prints that, despite their diminutive size, make tangible the physical grandeur of these poetic spaces—once the venue of spectacle and entertainment. Ignoring hierarchies of height, the camera, in its automatic sweep, crops any tall foreground object. In *Villa Medici, at the Base of the Obelisk, Courtyard Garden* (p. 85), the upper portion of the large obelisk is ignored, the camera instead capturing the dramatic horizon line at this hilltop site. In *Villa Brenzone, Over Lago di Garda* (p. 82) the camera's horizontal sweep almost makes abstract what falls in its path; in this arresting photograph, the biomorphic bushes (as much shaped by light as the human hand), the rock, the stone of the arcade in the distance, even the water seem to meld into a single material under the intense

Italian sun. It is that brilliant, almost palpable, light that animates—completes, actually—these spaces and inspires James to explore the inherent sculptural qualities of gardens in and of themselves, as well as of individual elements within them, particularly garden statuary to whose "existential quality" he has referred. James has spoken of the fragility of gardens as works of art, yet his visually complex and technically superb photographs have a celebratory air that speaks of his ebullient view of harmony between man and nature.

Highly atmospheric gardens in lush, tropical settings are the subject of photographs by Sally Gall and Sally Mann. Using a soft focus and rich tonal effects recalling the Pictorialists, Gall and Mann emphasize the aggressive intensity of the abundant foliage and heavy, humid atmosphere in these frankly sensual landscapes. The photographs Sally Gall created in Brazil and Hawaii bring together gardens and bodies of water—two subjects she has investigated on an ongoing basis. In *Rio Botanical Garden #3* (p. 54) the artist captures in remarkable detail the myriad textures found in nature. Gall creates exceptionally rich tonal contrasts though a dense patterning of shadow and light. From the penumbra of the foreground, an arching limb and stone balustrade create a proscenium-like arc, highlighting the space beyond where a pool of light descends, drawing the eye into the background. As depicted by Gall, the garden is a beautiful dream bathed in an ethereal glow and suspended in time; even the fountain stream—underscoring her ongoing interest in water—appears frozen in mid-air. Man-made structures wear their coverings of vines, moss, and foliage comfortably, suggesting harmony rather than entropy. Yet paradise is presented at arm's length. In *Rio Botanical Garden #1* and *Rio Botanical Garden #3* (pp. 53 and 54), the viewer is prevented from entering the composition; in the former, by the surface of the murky lake; in the latter, by the balustrade closing off the foreground. The artificiality of this paradise is implied only by the distant edge of the shore, too highly groomed to be natural. In this photograph Gall exploits the reflective quality of water to create a masterful image in which the garden and the brilliant light illuminating it meld together in an apotheosis of nature.

Sally Mann began making landscapes in 1997, with photographs taken throughout Mississippi and Georgia. Commissioned for *Contemporary Photography and the Garden* to travel to Las Pozas (The Pools)—the fanciful garden built by poet and surrealist patron and collector Edward James (1907–1984)—Mann photographed this delirium-dream of vertiginous concrete structures and columns designed by James and set against the dramatic landscape of the Sierra Madre Mountains in Central Mexico. Working frequently with a damaged lens (also used in her earlier landscapes) that lends a nineteenth-century air to the photographs, she sought to capture the essence of this large garden, now poised between the order James had attempted to impose on the land and the unruliness of nature that has altered since his death. Photography historian William Adams's statement regarding Atget—that he presented the garden "as an empty stage set"—has particular resonance here.[9] Though the human presence is absent from all of the work in the exhibition, this garden—its immense, fantastical structures and elaborate pools so clearly meant to accommodate large crowds—has a particularly desolate air. Ambiguity of scale abounds in the artist's often oblique views; the photograph on page 101, for instance, can be read as either a huge reservoir of water or a small diorama. Photographing at various times of day, Mann creates atmospheric effects reminiscent of moonlight. The untitled work on page 103 was shot at dusk with an almost ten-minute exposure. Exquisitely diffused light pools at the top of the composition; the absence of the middle range of the tonal scale erase the distinctions between forms. Her framing amplifies the anthropomorphic qualities she found in several man-made structures: on page 107 three columns are linked in an embrace as others (also grouped) "look on," while in the center of the photograph on page 105, a lone column resembling a standing figure with arms raised stands sentinel. If Gall presents images where the man-made and the natural peacefully co-exist, Mann

suggests that nature is more aggressively ascendant. A private narrative unfolds in Mann's photographs of a landscape that she says speaks of "nature's ultimate supremacy over man's futile efforts to make something lasting."

Sally Apfelbaum, Linda Hackett, Daniel Boudinet, and the collaborative team of Peter Fischli and David Weiss create photographs in which the temporal and sensory components of the garden are a primary concern. These artists explore formal investigations that circumvent the camera's ability to capture a single moment in time, dispelling the concept of the garden as a place of stasis. As part of a grant, Apfelbaum spent six months living on the grounds of Monet's famous garden in Giverny. She already had a strong interest in the artist—considering Monet to be the first environmental artist—and was intrigued by the challenge of exploring this garden where he immersed himself in nature so fully. Doubting that single images could ever capture the spatial complexity and lush abundance of the garden, Apfelbaum decided to work with a multiple-exposure format. Each of the works in the exhibition is composed of four consecutive exposures aligned with the cardinal points. As in *Orange Tulips, Giverny* (p. 31), the usual figure-ground relationship is overridden; instead, Apfelbaum creates overlapping layers that amplify the remarkable color range and tactile qualities of the garden. Ghost images—a portion of a metal gate (at center) and numerous trees in the background—read as so many pentimenti. If the lush juxtapositions and overlays (and resulting blurred focus) recall Monet's own impressionistic effects, they similarly animate the layering of the photograph, conveying through only the visual what the garden affords as a multisensory experience. Scale, too, facilitates the viewer's immersion. Apfelbaum printed these photographs in large format—then a significant departure for the artist. In *Giverny, Trellis Triptych* (pp. 32–34) she pushed scale even further, presenting the garden at almost a one-to-one ratio. The mural-size work presents three identical images of a single multiple-exposure photograph, with the right image printed in reverse. Just as in the garden itself, the viewer's eye is drawn across the large expanse (over twelve feet) of space she captured. Apfelbaum's frankly beautiful photographs convey the poetic resonance of this place, creating, as she says, "a recreation of a place, not literal, but visceral."

Linda Hackett began photographing an abandoned estate garden near her home in Southampton, New York, in the mid-1980s. In her hallucinatory images, color and unusual plants forms are exaggerated, and elements of air and light take on an almost physical presence. The extended exposure time of her pinhole camera records effects of wind moving through the garden, self-consciously calling attention to the photographic process. Hackett adopts a distinctive "plant's-eye" perspective of the garden. Focusing on a single flower (or type of flower), she often places her camera so close to her subject, as Edward Weston before her, that it would be unreadable were it not for her descriptive titles. In *Ipomoea* (p. 69), her reductive approach veers toward abstraction: soft, tightly focused shots of a flowering plant bracket a more extreme close-up of a single, ravishingly hued flower. Her unusual perspective in *Allium Giganteum* (p. 75) and the strangely compressed background (the result of the distortion of the pinhole camera's lens) create a haunting image in which a raggedy column of flowers—stretching to infinity—evanesce into an amorphous background. Hackett works exclusively at dawn or dusk, when longer exposure times are required. The camera distorts light, most noticeably in the sky, which, in this and in other photographs, ranges in appearance from day to night. That metamorphosis of light and the intense colors she achieves suffuse her work with a surrealist atmosphere and heighten the narrative quality already established by movement. She captures that moment in photography "when the objects, air, and dimension framed in a viewfinder are incorporated and fixed together in an unalterable mix by being exposed on film."[10] Hackett creates expressionistic landscapes in which the identity of individual plants is asserted and the fluxy atmosphere of the garden in which they live is brilliantly manifest.

The late Daniel Boudinet created a series of cibachrome photographs at Little Sparta, the much photographed garden in Scotland of sculptor and poet Ian Hamilton Finlay. As in his earlier photographs of architecture in and

FIG. 13

around Paris, Boudinet brought an expansive vision to this garden. In *Jardin de Ian Hamilton Finlay, Little Sparta, Stonypath* (pp. 40–42), the artist framed a column (a sculpture by Finlay) and shot it at different times of the day. Boudinet chose a vertical format that visually suspends the truncated, horizontal landscape between an enormous sweep of sky and its resplendent reflection in the lake. A mournful air derives from the dramatic solitude of this sculpture isolated on the far shore and from the sense of its vulnerability in the face of such powerful forces of nature as those suggested by the expressive dynamism of the clouds and the effects of wind on the water. In this narrative grouping, Boudinet creates a compelling allegory of the diminution of man and his creations (i.e., gardens) in the presence of nature's power. His strong interest in the relationship of the garden to the precincts beyond its boundaries can be seen in the photograph on page 39, in which a lushly textured path sculpted by Finlay parallels the edge of the garden, contrasting with the panorama just beyond, or in the image on page 37, in which a rickety fence strikes a discordant note in an otherwise bucolic composition. In these richly colored photographs, Boudinet expresses not only his passionate interest in the role of elements of nature as well as the temporal and spatial outside of the garden to shape the experience within it.

Projection 2 (Summer) (pp. 48–50) by Peter Fischli and David Weiss grew out of an earlier installation the artists had done for the *Münster Skulptur Projekte* in 1997.[11] Long interested in gardens (David Weiss recalls the powerful impression made by their 1988 visit to a garden in Alsace that "brought together beauty and necessity"), the artists planted a flower and vegetable garden on the site they were given. They repeatedly photographed this installation, but it was not until the next year that they started investigating gardens systematically. Working with a double-exposure format, the artists spent more than a year traveling in Switzerland, making hundreds of color photographs of flowers, mushrooms, and berry-laden plants. They then created an installation in which the images were compiled into three groups of slides (some were also printed as independent ink-jet prints) and projected on three gallery walls. *Projection 2 (Summer)*, one part of that original installation, presents 162 of these double-exposure photographs continually projected, dissolving one into the other. Chance plays a role in

FIG. 14

the work, both in the joining together of two unrelated plant forms in the original multiple-exposure photograph, and in the superimposition of slides (and consequently, plants) in the projection, creating unexpected juxtapositions of scale, form, and color. Just as in nature, some plants are banal, others ravishingly beautiful. The installation completely immerses the view in the artists' giddy, almost psychedelic vision of the multiplicity of nature. Fischli and Weiss distill the very essence of the garden. As their cinematic vision unfolds, the artists' interest in sequences of season in nature and the cycle of life and death they represent becomes evident.

Len Jenshel, Catherine Opie, and Jack Pierson capture the beauty of the garden but also seek ironic visual moments or evidence of the ordinary within it. By exposing these elements, the artists deflate the pretensions and seriousness of purpose some associate with gardens. Perhaps not surprisingly, then, they were not drawn to grand, formal spaces. Though Len Jenshel has been photographing landscapes for over thirty years, he still retains what has been called "the street photographer's edgy view of culture."[12] He looks for the human imprint on the landscape. Seeing gardens as "attempted Edens," the artist investigates their cultural implications, as well as their physical beauty. In *Cypress Gardens, Charleston, South Carolina* (p. 87) a single azalea provides a riotous display of color amid a dull landscape still shedding the effects of winter. Jenshel's judicious framing highlights the artificiality of the scene, gently mocking the attempt to perfect nature in the self-conscious placement of this single plant on a barren, swamp-side knoll. In *Huntington Gardens, California* (p. 89) the artist inverts accepted hierarchies within the garden by focusing on an otherwise unremarkable ornamental grass plant. His interest is clearly in the spiny leaves that radiate out to fill the picture plane and create complex spatial relationships. In the background stands a garden statue whose downward gaze humorously suggests deep meditation on the garden lawn. Jenshel has spoken about his interest in statuary, saying, "it symbolizes not only human presence in the literal, physical sense, but in the sense that a person placed it there, in that particular spot." The photographs he made at Lotusland (pp. 91 and 92) at night using natural light capture transcendent moments in the garden. In *Lotusland, Montecito, California* (p. 91), an outrageously hued succulent, seemingly lit from within, hovers in the foreground, while beside it a silhouetted tree, worthy of a children's storybook, looms menacingly. In the background, the artist captures the chromatic subtlety of that ineffable moment when dusk turns to night. In another work by the same name (p. 92) Jenshel creates an image of stunning spatial complexity. A sinewy branch reaches lyrically across the foreground, emphasizing the depth of field behind it. The long exposure time gives physical presence to the moon-

light, which casts soft shadows, creates bold outlines that emphasize the diversity of plant forms in the garden, and, by pooling in the middle ground, exaggerates the deep recesses of space behind. Jenshel creates eerily beautiful evocations of the garden at a time of day when it is typically abandoned.

Jack Pierson examines the unremarkable in the garden, and in his large-scale color photographs the ordinary looms large. In *The Side of Tim's Barn* (p. 119) he presents a patch of wan flowers whose shabby gentility matches that of the rundown clapboard barn it borders. It is a garden that would seem to barely warrant the designation and to deserve to go unnoticed. An artist interested in details, Pierson presents tightly focused color photographs that isolate his subject from its surroundings. In *Untitled (Palm Leaf, Lisbon)* (p. 121) an immense leaf robustly fills the composition. Pierson has cropped out the sign identifying the plant species that would normally be seen in the botanical garden greenhouse in which the photograph was taken (its steel and glass roof visible in the background); instead, he focuses on the graphic quality of the leaf's bold stripe, as well as its rich texture and lustrous surface. *Grass* (p. 123) is an immense image of completely average turf. The artist fills the picture plane with the grass—weeds and all—creating a seductive, lushly textured image highlighting a ubiquitous, though largely overlooked, aspect of the garden. *Luxembourg* (p. 122) shows Pierson in a more exuberant mode. He frames an urn in Paris's Luxembourg Gardens, the intensity of its candy-colored blooms spilling over in a cliché of still-life abundance. People are absent, even from this garden, a place of constant human activity. As Pierson noted, "without people it becomes a portrait of the garden."

With a sharp sense of irony and the deadpan style of the "social documentary photographer" she avowed to be at the age of nine, Catherine Opie has investigated the idea of community in contemporary culture through distinct series that have examined the built environment in Los Angeles.[13] Commissioned for this exhibition, Opie chose to make photographs in a wide variety of public and private settings across the United States, ranging from Martha Stewart's celebrated garden at her Connecticut home to a garden inside the grounds of a men's prison in Minnesota. In photographing sites across the country she wished to see what commonalities would emerge in a construct as intellectually elevated as a garden. One equivalence was her belief that all gardens offer a sense of escape; the other was the "ordinary moment" she felt each garden presented. Opie emphasized the affinities between diverse locales by juxtaposing photographs from unrelated gardens. In her work, each image finds balance and, surprisingly, repose, in the other. The image of a lush garden on Long Island (p. 114), in which a memorial was placed by the owner in honor of his deceased partner, is paired with an image taken in a community garden in Harlem, its urbanity professed by the high metal fence and brownstones pushing up against the horizon. An untitled diptych (pp. 116 and 117) features a Zen community's decidedly modest garden center, the dull tones of the barren hillside exaggerated by the flat light under which Opie photographed it. She pairs it with a verdant, sun-dappled corner of an otherwise nondescript backyard garden in which the lawn and adjacent house (with the ivy wryly repeated in the patterned wallpaper visible through the glass) seem to strive for perfection. Opie's nonhierarchical approach culminates in the untitled photograph on page 109. In a single grid, images from community gardens in New York, estate gardens in the Northeast and California, and the aforementioned midwestern prison come together in a work of stunning beauty. Though signifiers of class are evident after closer inspection, the gardens are visually linked by the very "ordinary moment" she sought. Elements such as waste cans and electrical boxes—or the intractability of the setting for the prison garden itself (right center panel)—thwart the concept of the ideal landscape. Despite the enormous range of social classes and geographic locales represented here, Opie emphasizes the shared aspirations—if not shared aesthetic skill and resources—of these gardens and their makers, linking them together in her ongoing exploration of community.

In their conceptual approach, Marc Quinn and Gregory Crewdson deal more overtly with the insistent artificiality of gardens. Crewdson laboriously built by hand and then photographed a series of elaborate "gardens" in his studio in the early 1990s for the "Natural Wonders" series. Infused with lurid colors and replete with juxtapositions of seemingly organic forms, these works allude to the garden as a place where nature runs amok—where bizarre, and often sinister, elements lurk just below what at first glance is a bucolic surface. The artist has said that he sees himself "working within the tradition of photographers interested in reinventing the American landscape," mentioning Walker Evans and William Eggleston (fig. 14), though Robert Adams's fascination with suburbia too seems relevant.[14] Crewdson's document of landscapes he himself created separates him from that earlier tradition, as does his mordant humor in creating what he calls "an open-ended and ambiguous narrative."[15] Far from places even remotely related to pleasure, gardens emerge in his work ironically as hermetic sites where man's anxieties and fears of nature are played out. The untitled photograph on page 45 is one of the artist's typically enigmatic scenes. Braids of human hair sprawl disturbingly through a garden, covering the flowerbed and coiling upward beyond the frame of the photograph. Decaying petals strewn across the foreground heighten the menacing vigor of these animated braids that threaten to overtake the tulips. Cerulean butterflies add a note of both beauty and revulsion—are they eating or merely resting? Butterflies are the focus of the photograph on page 47. Hundreds of them cluster bizarrely in a large mound. As in much of Crewdson's work, a different reading can be had simply by looking at the image a moment longer. At first glance, the butterflies arrayed here constitute a spectacularly beautiful phenomenon. On second glance, however, the insects' insistent swarming speaks more of a frenzy of feeding or reproduction. Framing the mound are towering flowers, standing like sentinels or torches, while freshly cut flowers lie in front, as if in an offering. In "Natural Wonders" Crewdson darkly suggests that the outcome of the antagonistic relationship between man and nature—seemingly being won (at least for now) by man in work by artists such as Lynn Geesaman—may be shifting.

Like Crewdson, Marc Quinn also constructed a garden, though the dissimulation of his creation raises more profound philosophical questions. In earlier work the artist has used the human body to investigate themes relating to nature, mortality, beauty, and machines to symbolize man's increasing dependence on science. As part of an installation for the Prada Foundation, Milan, in 2000, Quinn created *Garden,* comprised of immense refrigerated cases into which he placed flowers gathered from around the world that he had frozen in liquid silicone. The artist said, "The idea of the perfect garden has always stood in as the idea of attaining a kind of spiritual perfection. . . . In this work, it seems at first that human will has prevailed over nature, but this is at the expense of life."[16] Indeed, the liquid silicone preserves each flower indefinitely (its permanence dependent now only upon constant refrigeration) yet kills it in the process. For the "Italian Landscape" series (pp. 125 and 127), Quinn photographed *Garden* and had the images transferred to canvases using permanent pigment. While the artist crops any overt reference to the threatening appearance of the refrigeration units, he nonetheless refers to the decadence underlying the endeavor in the strained "naturalism" of each flower's artful pose, the theatrical lighting—keying up the already brilliantly colored plants—and the faint reflection of the gallery ceiling bouncing off the back walls of the glass cases he photographed. Those subtle reflections nevertheless speak of the brutality and futility involved in the pursuit of (and here, also, preservation of) ideal beauty. Quinn seamlessly combines sculpture, photography, painting, and science and creates a complex meditation on the meaning of abstraction. This "garden" cannot be entered; the plants are not alive, and the entire conceit can be ended with the flip of a switch. In these remarkable photographs he offers "a primordial Eden where myths of origin coalesce with a preview of a parallel universe that is already charged with death."[17]

Edward Weston once said he wanted to see "the *Thing Itself* . . . the quintessence revealed . . . to photograph a rock, have it look like a rock, but be *more* than a rock."[18] Harry Callahan exhorted his students to "see things differently from the way [they] saw them before," noting that "when you see photographically you really *see*."[19] All of the artists whose work is represented here turn the familiar—a garden—into something further removed from reality; in so doing, they reveal it to us as if for the first time. Working in locations around the world and in sites that suggest the very diversity of the typology, the artists go far beyond literal description. The essence of the garden is distilled. In the photographs assembled here the artists give visual form to the full range of physical and emotional experiences a garden offers: the poetic possibilities, the lyrical beauty, the sensory richness, the temporal element, the sense of wonder.

The garden also emerges in these works as a place of inherent contradictions. It is a place of beauty born of brutal force, a place of repose requiring constant maintenance. People are not depicted in any of these photographs, yet the human presence is inescapable. In varying degrees the artists make evident the hand of man composing the landscape. The garden becomes a symbol of man's uneasy, at times antagonistic, relationship to nature. The artists explore the garden as a site where human desire is imprinted on the landscape, as an artifact of the culture in which it is made. While they embrace the evident beauty surrounding them, the artists are not necessarily seduced by it; they delve deeper into the conceptual structure of the garden. The remarkable photographs in this exhibition explore the relationship between man and nature, art and artifice, beauty and decay, just as Atget first did over one hundred years ago.

1. Charles A. Platt, *Italian Gardens* (New York: Harper & Brothers, 1913), 3.

2. Noguchi also created one around the same time in Shikoku, Japan.

3. "How Green Is His Valley," Alan Emmet, *House & Garden* (March 1999): 70.

4. Geoffrey James, *Entrances and Exits: The Garden as Theatre* (Kingston: Queens University, Kingston, Agnes Etherington Art Center, 1984), 118.

5. Pierre Apraxine, "Turn of the Century: Chrysalis of the Modern," in Maria Morris Hambourg, *The Waking Dream* (New York, The Metropolitan Museum of Art, 1993), 172.

6. Masson is best known for her idiosyncratic guidebook *The Companion Guide to Rome*, originally published in 1965 by Collins and Harper and Row and now available from Companion Guides. Masson's photographs of Italian villas and gardens were published in her books *Italian Villas and Palaces* and *Italian Gardens*.

7. And in this way, the artist feels the "Potager du Roi" series relates directly to "Du portrait," a collection of nude photographs begun in the mid-1980s. This, and all other quotations, unless otherwise indicated, is from conversations between the artist and the author in February 2002.

8 "Comments: Lynn Geesaman," The MacDowell Colony Annual Report 1984, 24.

9. William Howard Adams, *Atget's Gardens* (Garden City, N.Y.: Doubleday and Company, Inc., 1979), 10.

10. Tod Papageorge, "Robert Adams's "What We Bought: The New World," *Yale University Art Gallery Bulletin* (2001), unpaginated.

11. An international art exhibition held once every ten years in Münster, Germany. In 1997, Fishli and Weiss, along with sixty-seven other artists were commissioned to install new work in public spaces (which remained on view from June 22 to September 28) of their choosing throughout the city. Photographs of the garden made by Fishli and Weiss are included in the artist's book *Gärten* (Cologne: Oktagon Verlag, 1998).

12. Kim Sorvic, "Sharp Focus, Blurred Boundaries," *Landscape Architecture* (February 2003), 78.

13. "Freeway," 1994–95; "Houses and Landscapes," 1995; "Domestic," 1995–98; "Mini-mall," 1997.

14. Hilarie M. Sheets, "Gregory Crewdson: The Burbs and the Bees," *ARTnews* (October 1994): 98.

15. Bradford Morrow, interview with Gregory Crewdson, in *Bomb* (Fall 1997): 39.

16. Germano Celant, in *Marc Quinn* (Milan: Fondazione Prada, 2002), 215.

17. Pier Luigi Tazzi, "Marc Quinn: So Many Wonders," *Interview* (July 2000): 22.

18. Nancy Newhall, ed., *The Daybooks of Edward Weston,* 2 vols. (Millerton, N.Y.: Aperture, 1973), vol. 2, 154.

19. Sara Greenough, *Harry Callahan* (Washington, D.C.: National Gallery of Art and Bulfinch Press, 1996), 44.

SALLY APFELBAUM
DANIEL BOUDINET
GREGORY CREWDSON
PETER FISCHLI & DAVID WEISS
SALLY GALL
LYNN GEESAMAN
LINDA HACKETT
GEOFFREY JAMES
LEN JENSHEL
ERICA LENNARD
SALLY MANN
CATHERINE OPIE
JACK PIERSON
MARC QUINN
JEAN RAULT

SALLY APFELBAUM

Air, 1989
Chromogenic color print
40 × 30 inches
Courtesy the artist

Orange Tulips, Giverny, 1989
Chromogenic color print
30 × 40 inches
Courtesy the artist

Giverny, Trellis Triptych, 1989–92
Chromogenic color print
Triptych, 5 × 4 feet each
Courtesy the artist

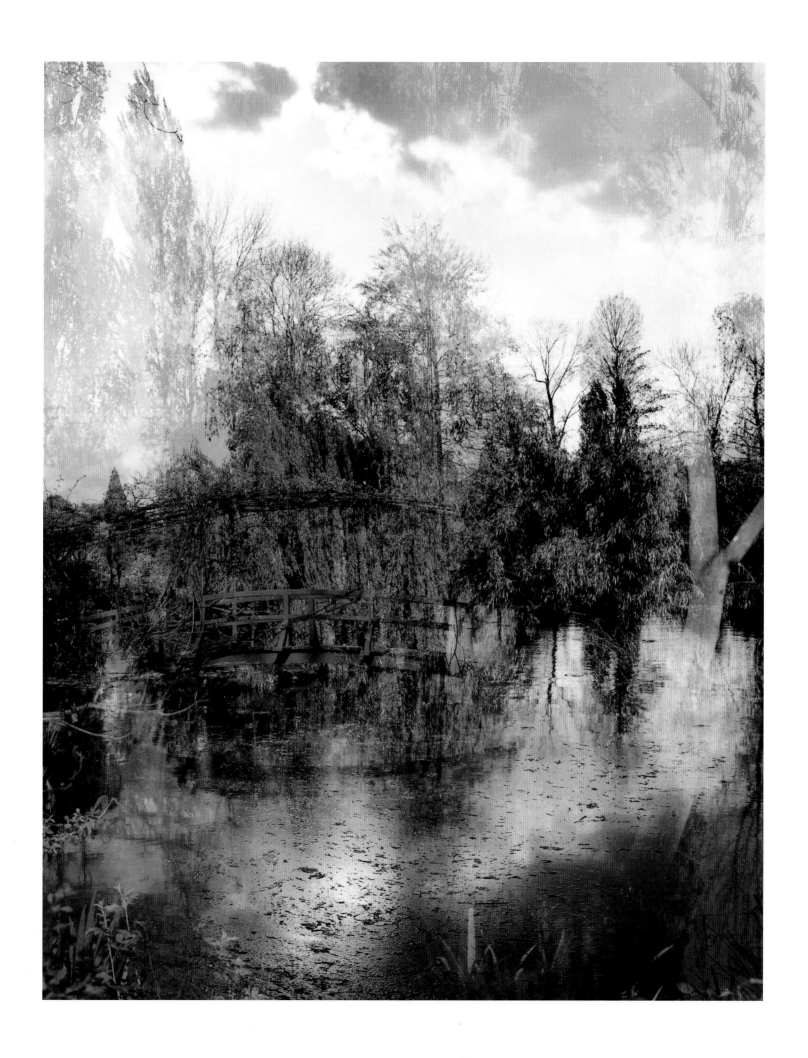

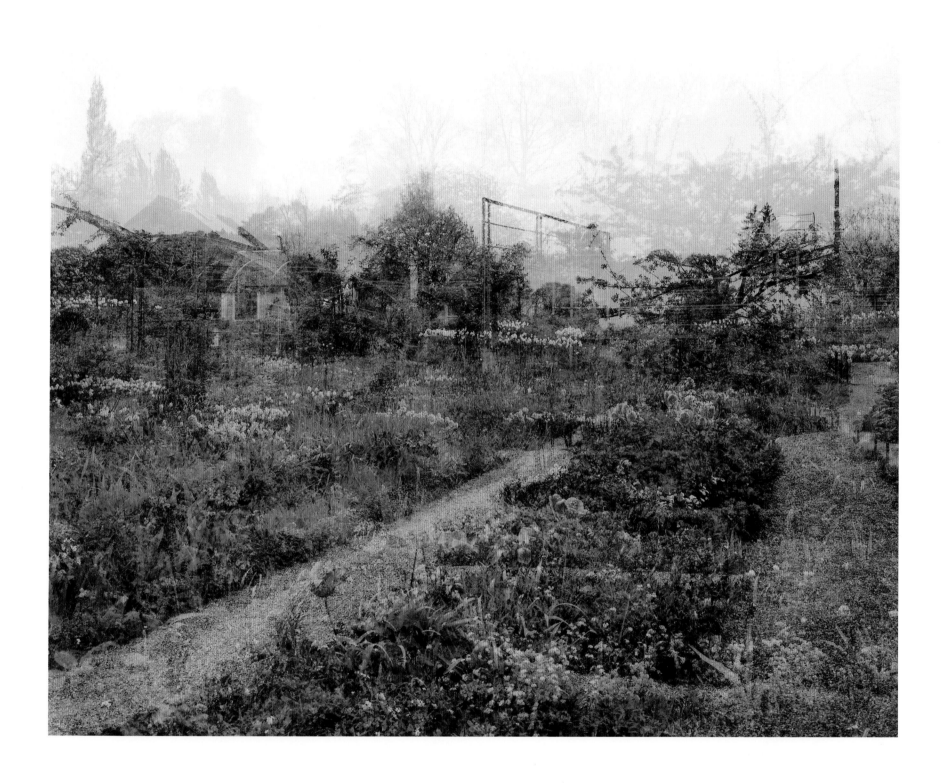

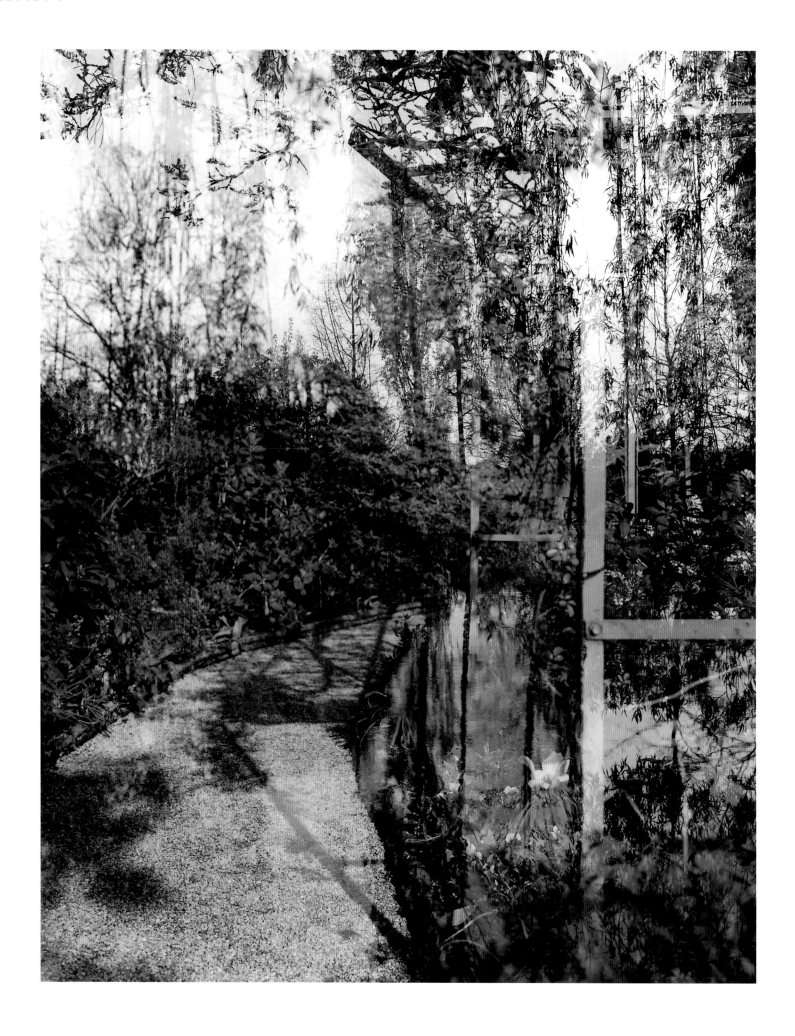

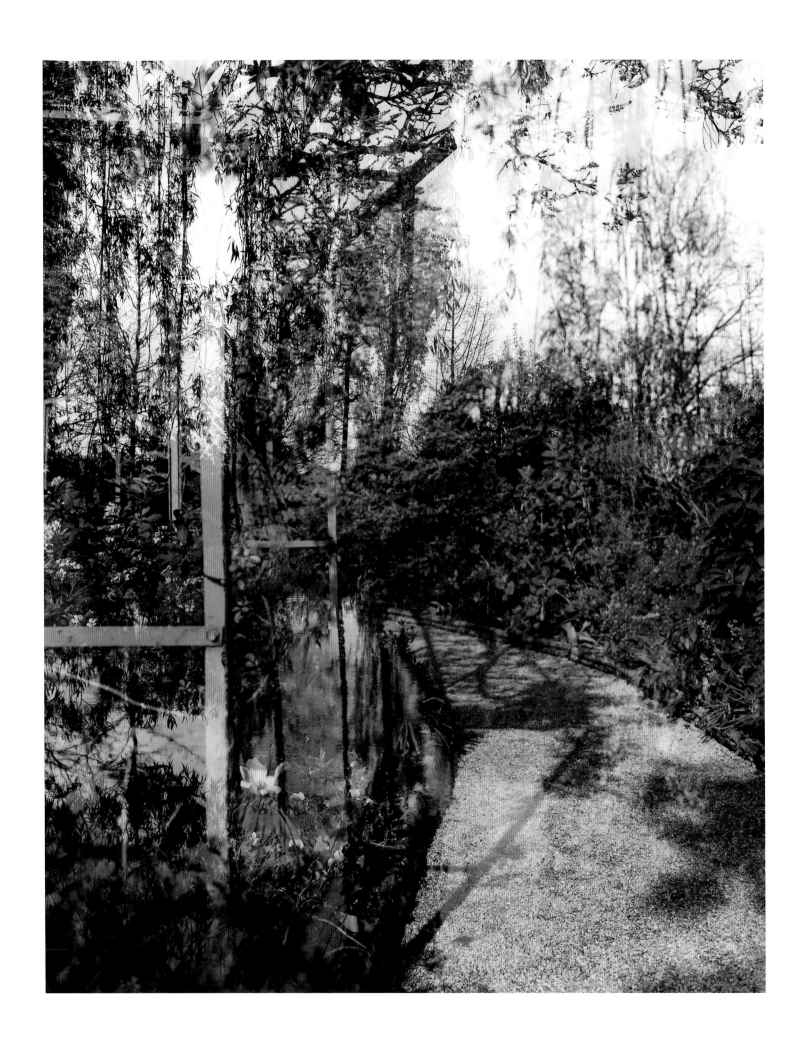

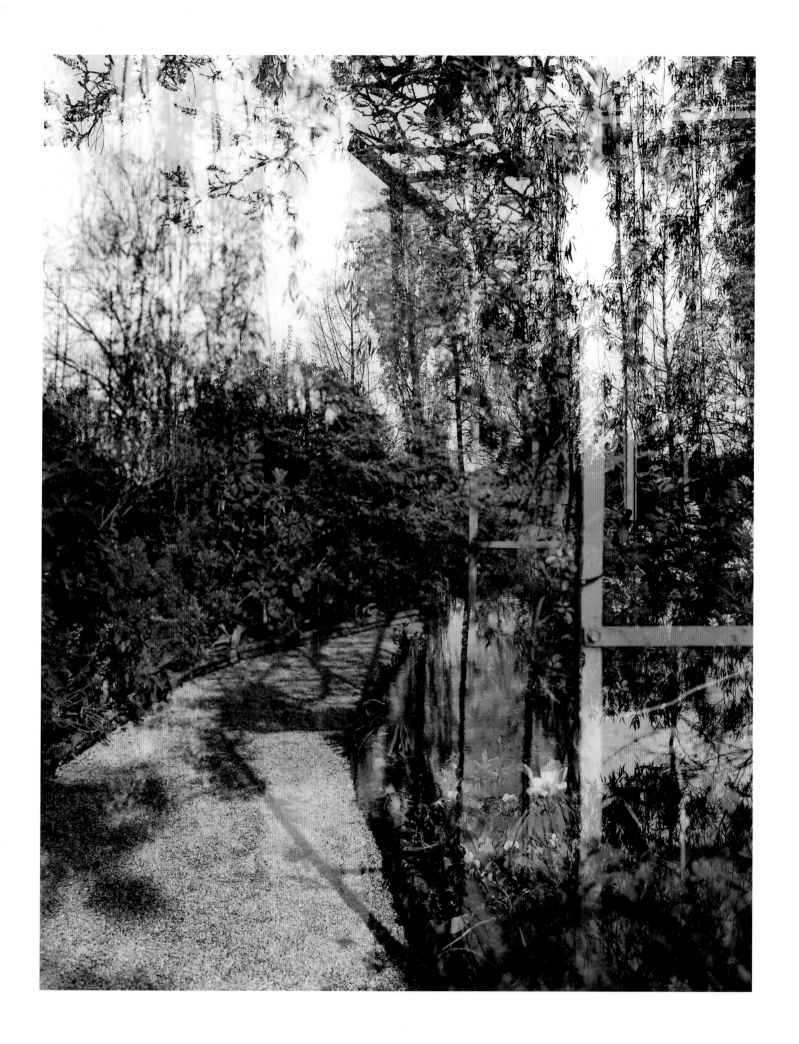

DANIEL BOUDINET

Jardin de Ian Hamilton Finlay, Little Sparta, Stonypath, 1987
Cibachrome print
12 × 16 inches
Daniel Boudinet/ministère de la Culture, France (BDN 3041)

Jardin de Ian Hamilton Finlay, Little Sparta, Stonypath, 1987
Cibachrome print
12 × 16 inches
Daniel Boudinet/ministère de la Culture, France (BDN 3085)

Jardin de Ian Hamilton Finlay, Little Sparta, Stonypath, 1987
Cibachrome print
12 × 16 inches
Daniel Boudinet/ministère de la Culture, France (BDN 343)

Jardin de Ian Hamilton Finlay, Little Sparta, Stonypath, 1987
Cibachrome print
12 × 16 inches
Daniel Boudinet/ministère de la Culture, France (BDN 350)

Jardin de Ian Hamilton Finlay, Little Sparta, Stonypath, 1987
Cibachrome print
12 × 16 inches
Daniel Boudinet/ministère de la Culture, France (BDN 363)

Jardin de Ian Hamilton Finlay, Little Sparta, Stonypath, 1987
Cibachrome print
12 × 16 inches
Daniel Boudinet/ministère de la Culture, France (BDN 382)

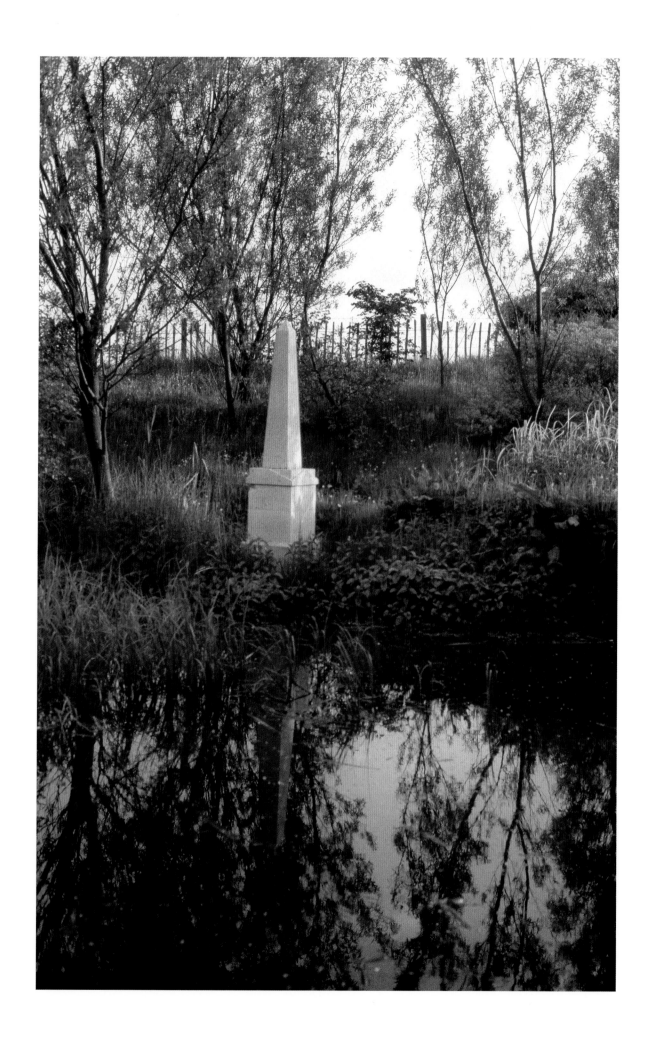

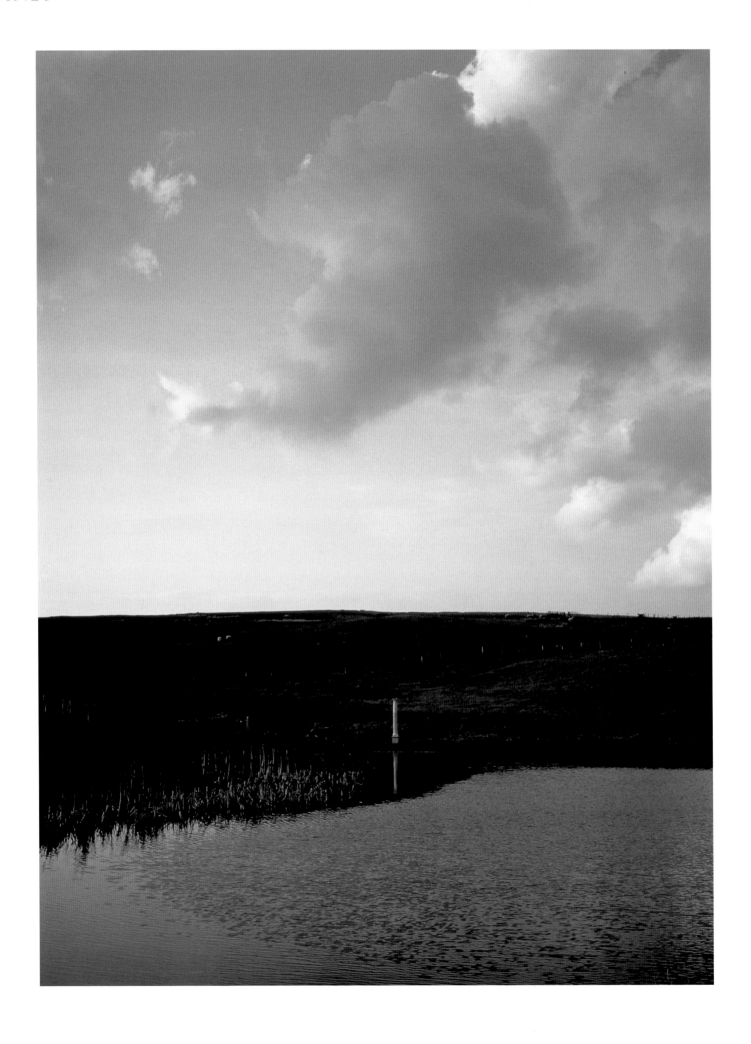

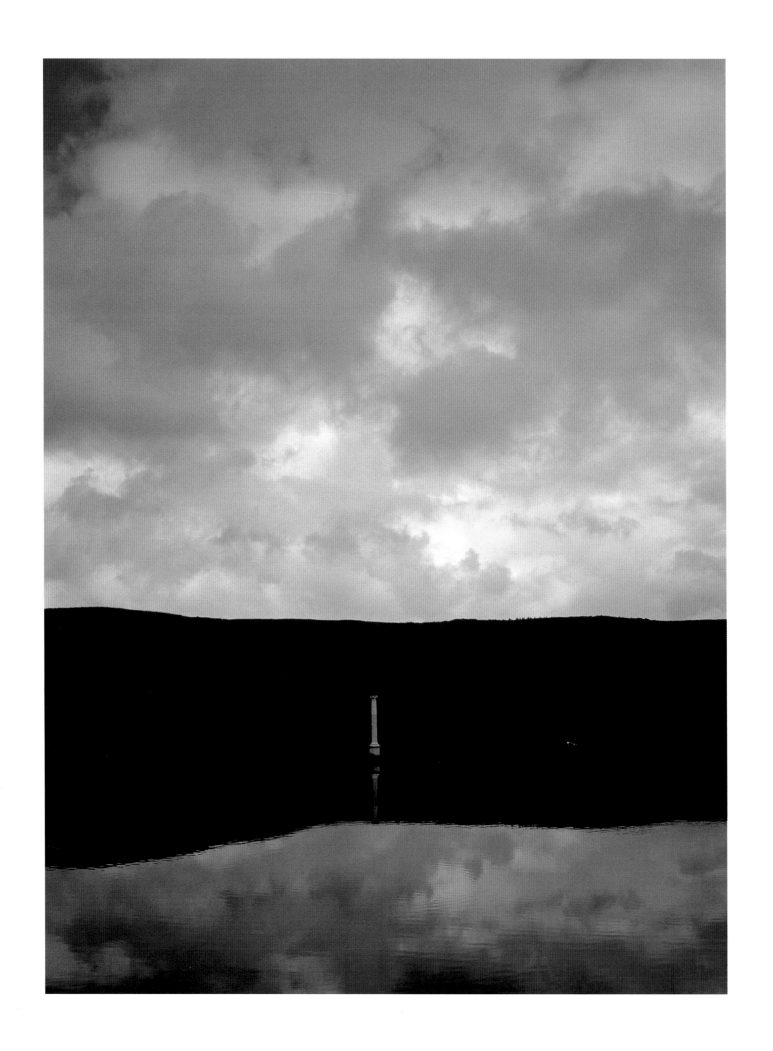

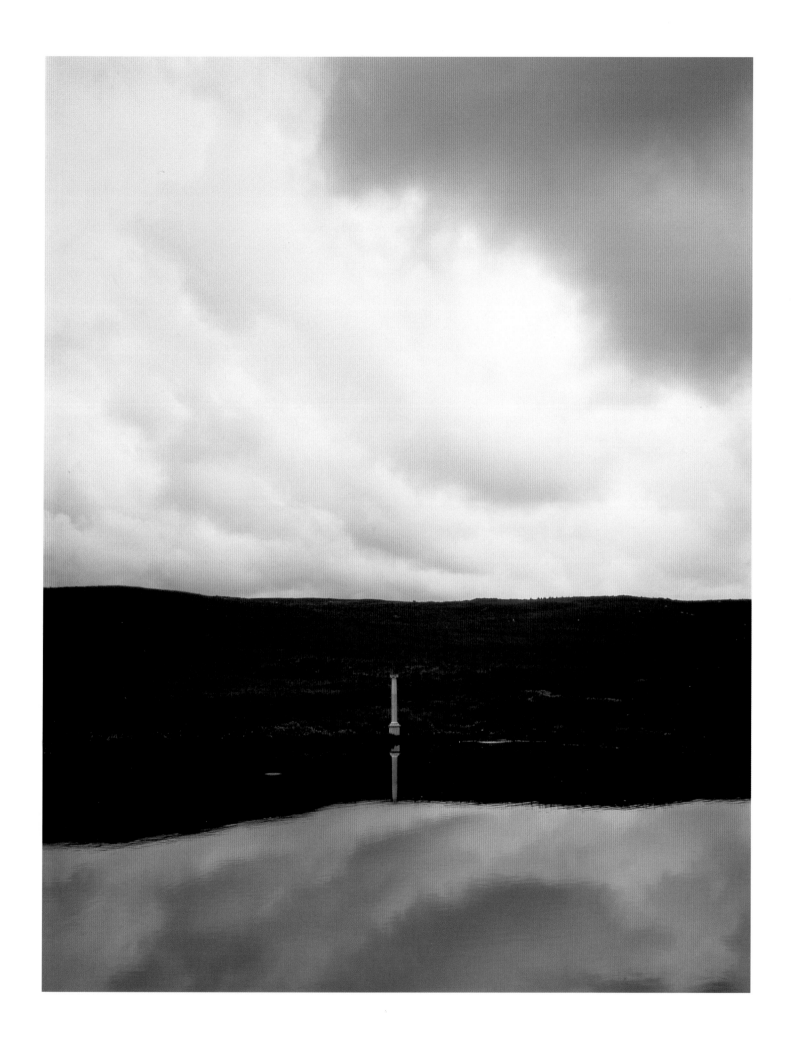

GREGORY CREWDSON

Untitled (butterflies and braids), 1994
Chromogenic color print
30 × 40 inches
Courtesy the artist and Luhring Augustine, New York

Untitled (mound of butterflies), 1994
Chromogenic color print
30 × 40 inches
Courtesy the artist and Luhring Augustine, New York

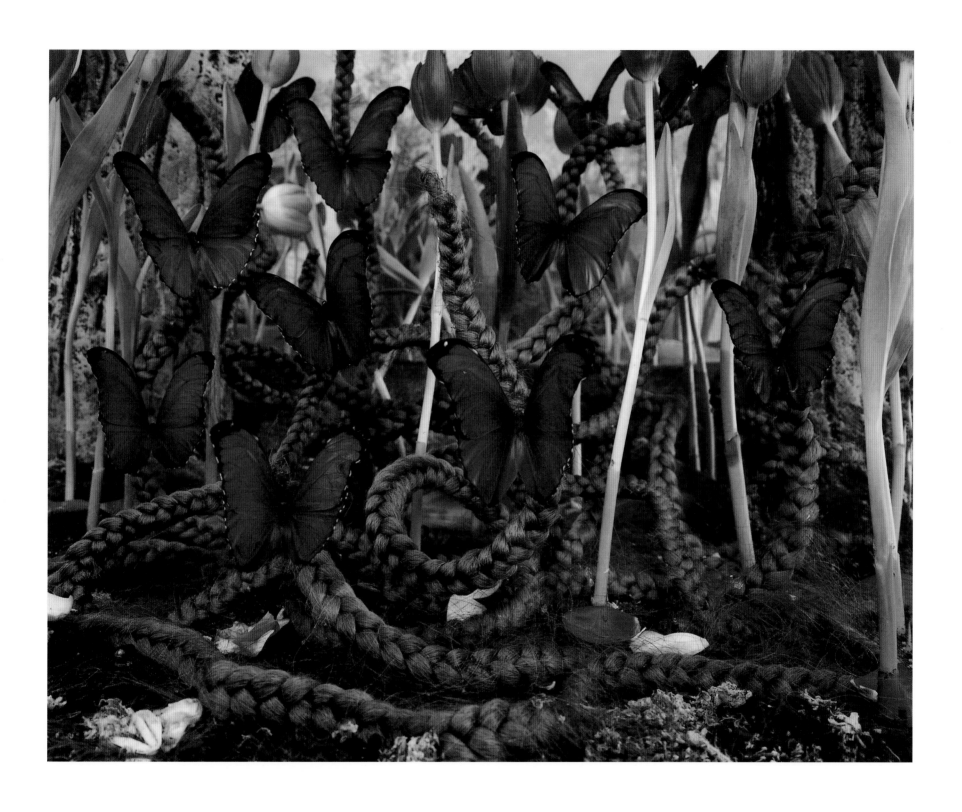

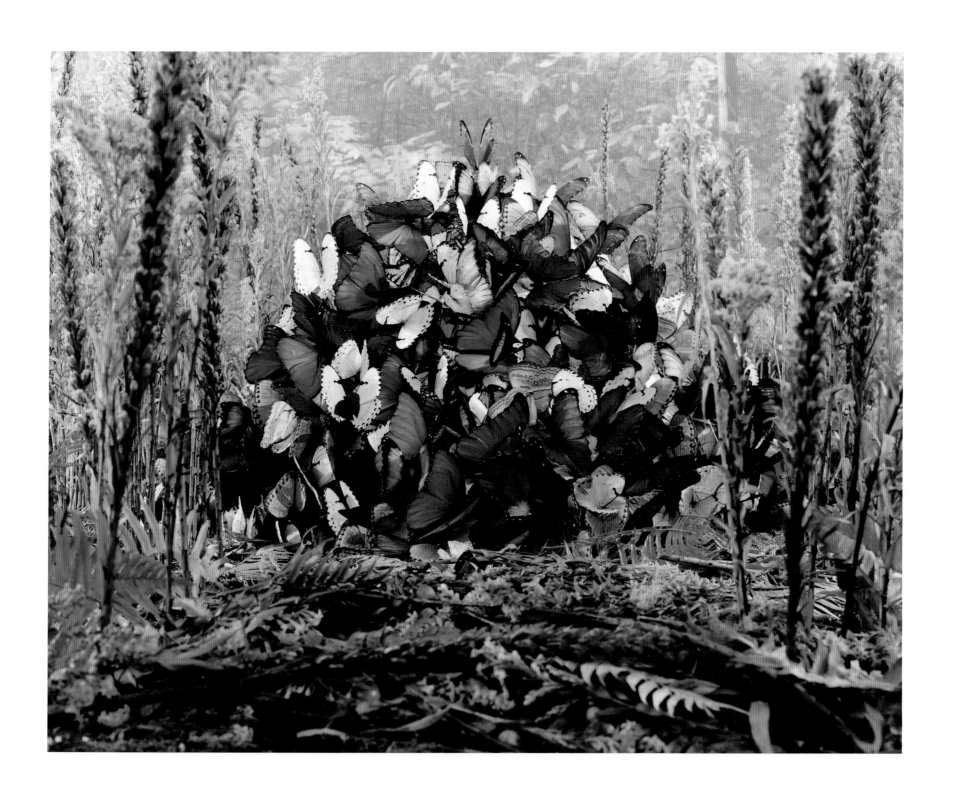

Projection 2 (Summer), 1997
Two sets of 162 color slides, two slide projectors, one dissolve machine,
wooden stand designed by artists
Dimensions variable
Courtesy Matthew Marks Gallery, New York

 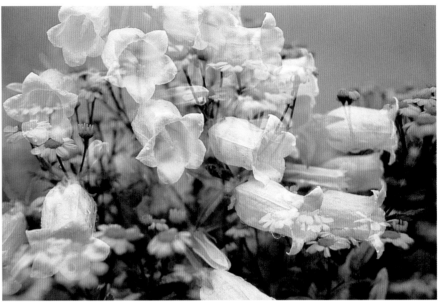

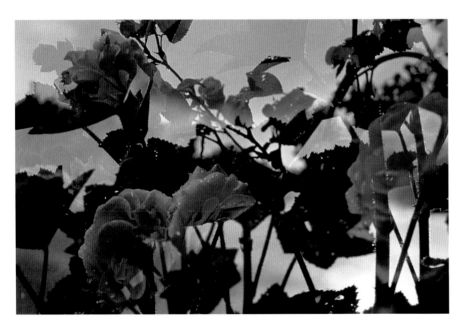 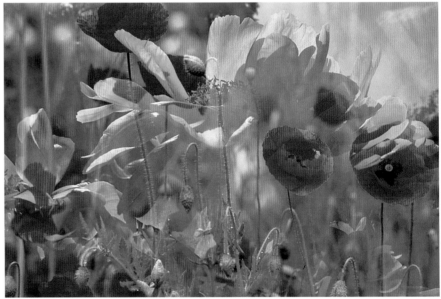

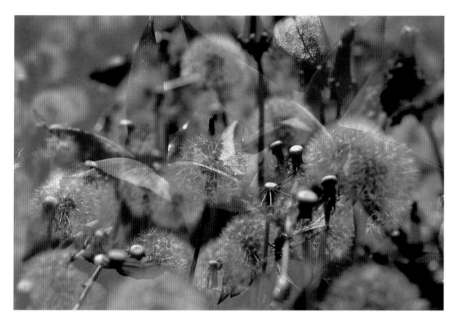
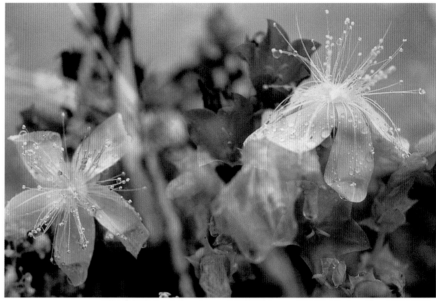
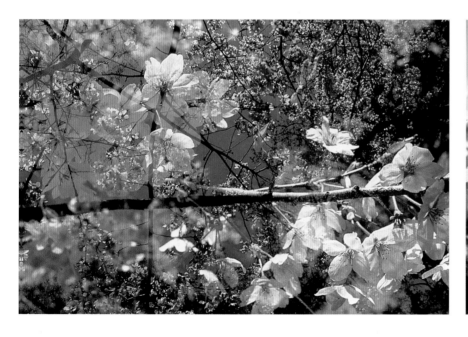
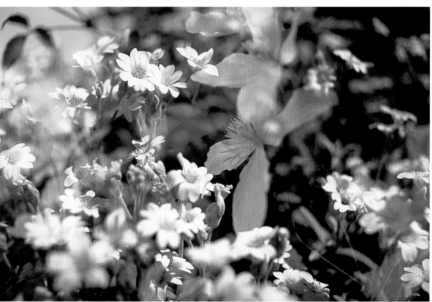

SALLY GALL

Rio Botanical Garden #1, 1986
Gelatin silver print
20 × 16 inches
Courtesy Julie Saul Gallery, New York

Rio Botanical Garden #3, 1986
Gelatin silver print
20 × 16 inches
Courtesy Julie Saul Gallery, New York

Palmetto, 1987
Gelatin silver print
20 × 16 inches
Courtesy Julie Saul Gallery, New York

Cherub, 1989
Gelatin silver print
20 × 16 inches
Courtesy Julie Saul Gallery, New York

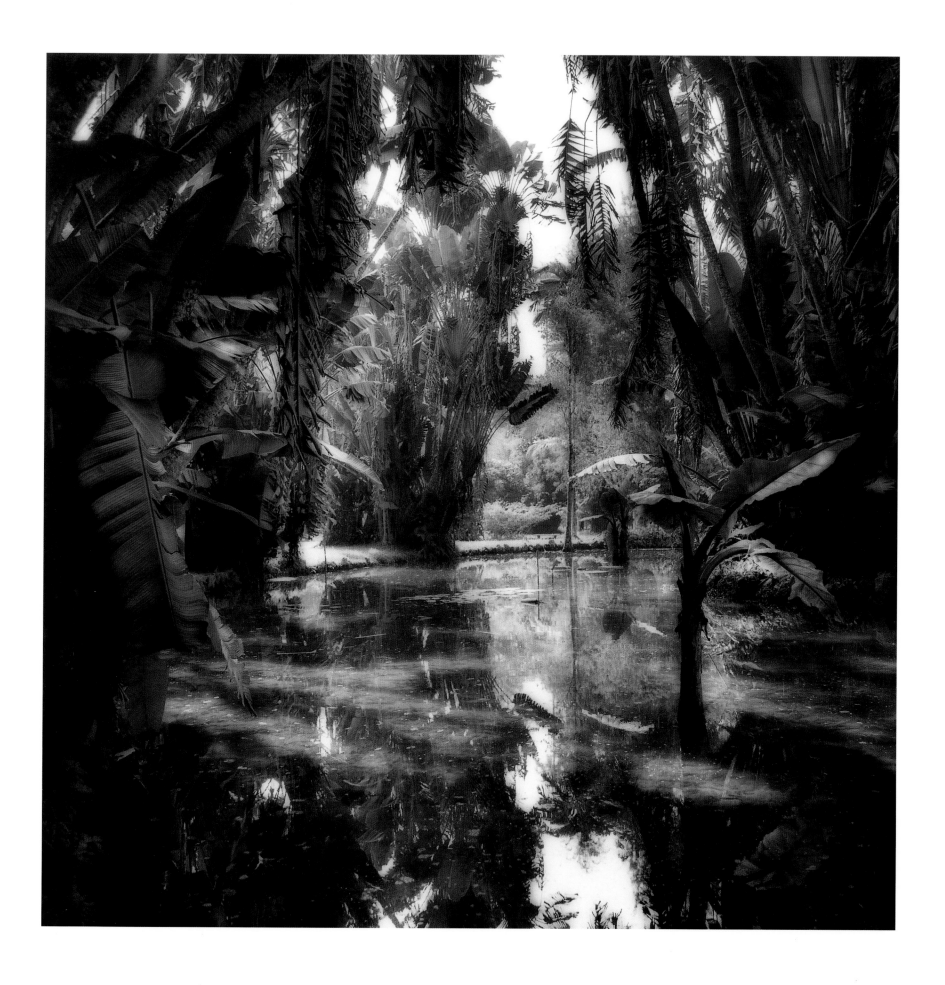

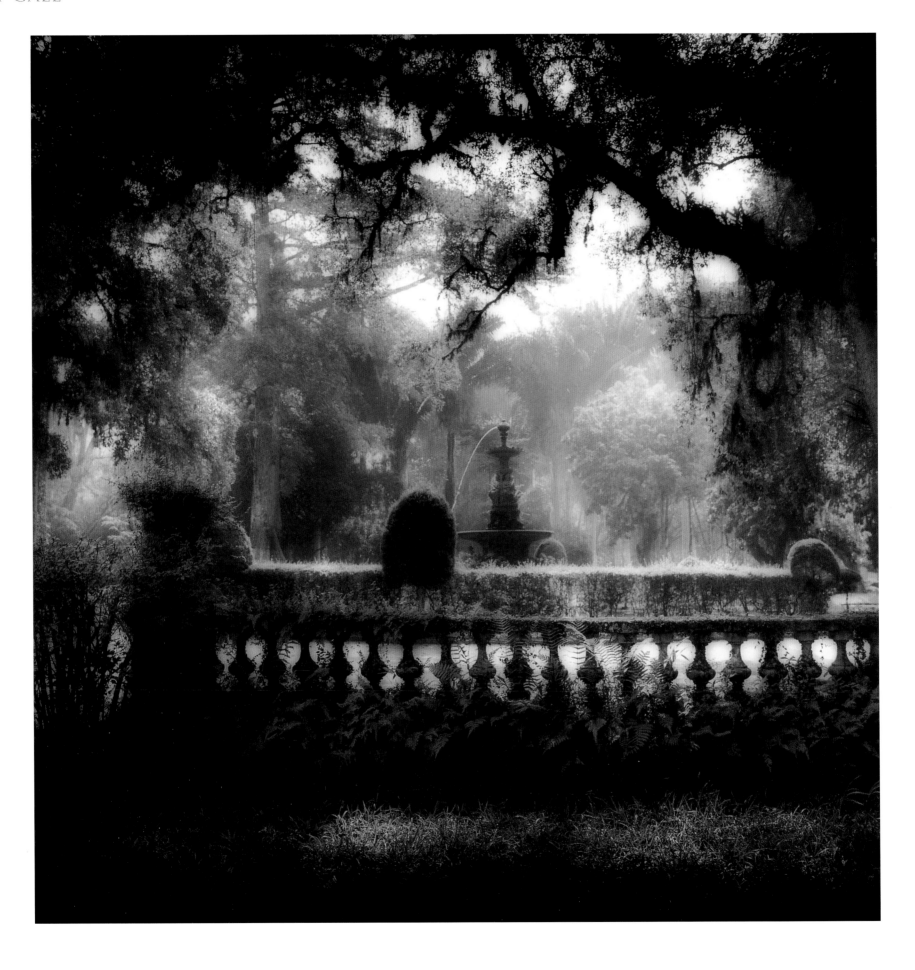

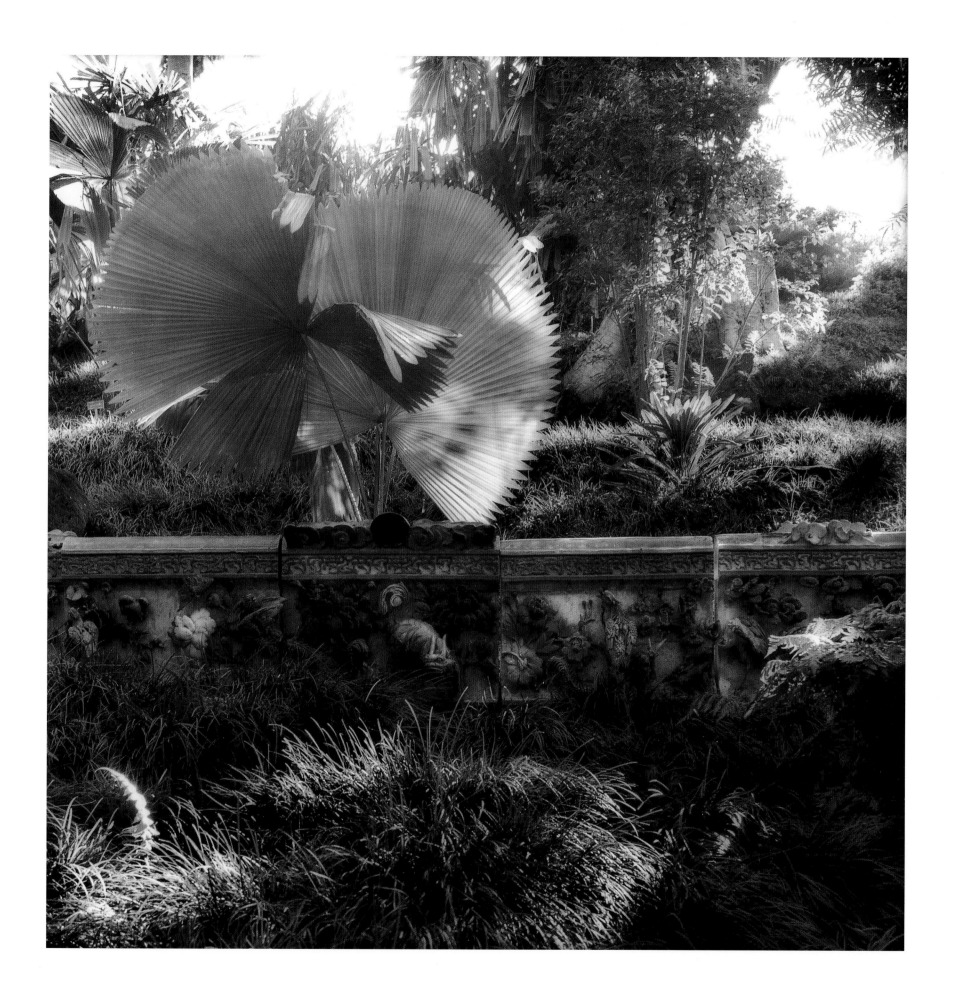

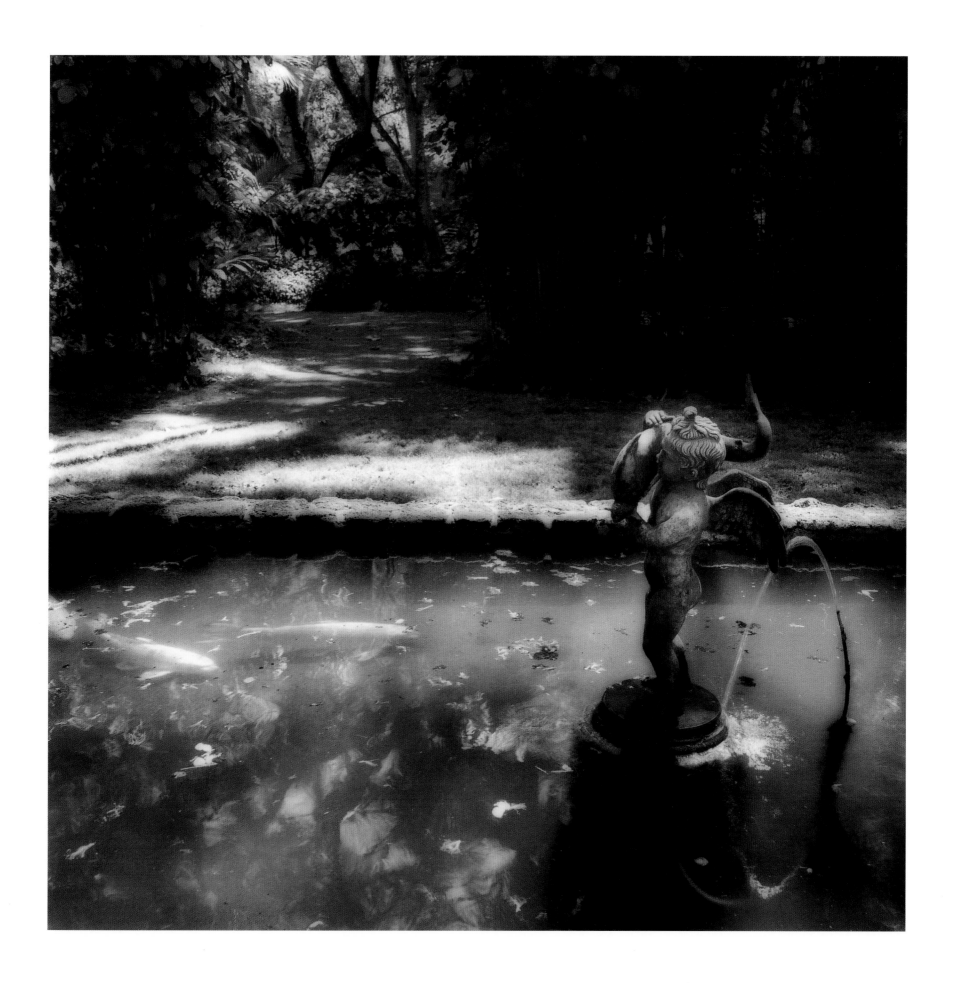

LYNN GEESAMAN

Theater House, Peover Gardens, Knutsford, Cheshire, England, 1987
Gelatin silver print
24 × 24 inches
Courtesy the artist and Yancey Richardson Gallery, New York

Hedge and Road, Villa Gamberaia, Settignano, Italy, 1990
Gelatin silver print
24 × 24 inches
Courtesy the artist and Yancey Richardson Gallery, New York

Trees, Villa Gamberaia, Settignano, Italy, 1990
Gelatin silver print
24 × 24 inches
Courtesy the artist and Yancey Richardson Gallery, New York

Hedge, Knightshayes Court, Devon, England, 1991
Gelatin silver print
24 × 24 inches
Courtesy the artist and Yancey Richardson Gallery, New York

Parc de Sceaux, France, 1995
Gelatin silver print
24 × 24 inches
Courtesy the artist and Yancey Richardson Gallery, New York

Huntington Gardens, San Marino, California, 1996
Gelatin silver print
24 × 24 inches
Courtesy the artist and Yancey Richardson Gallery, New York

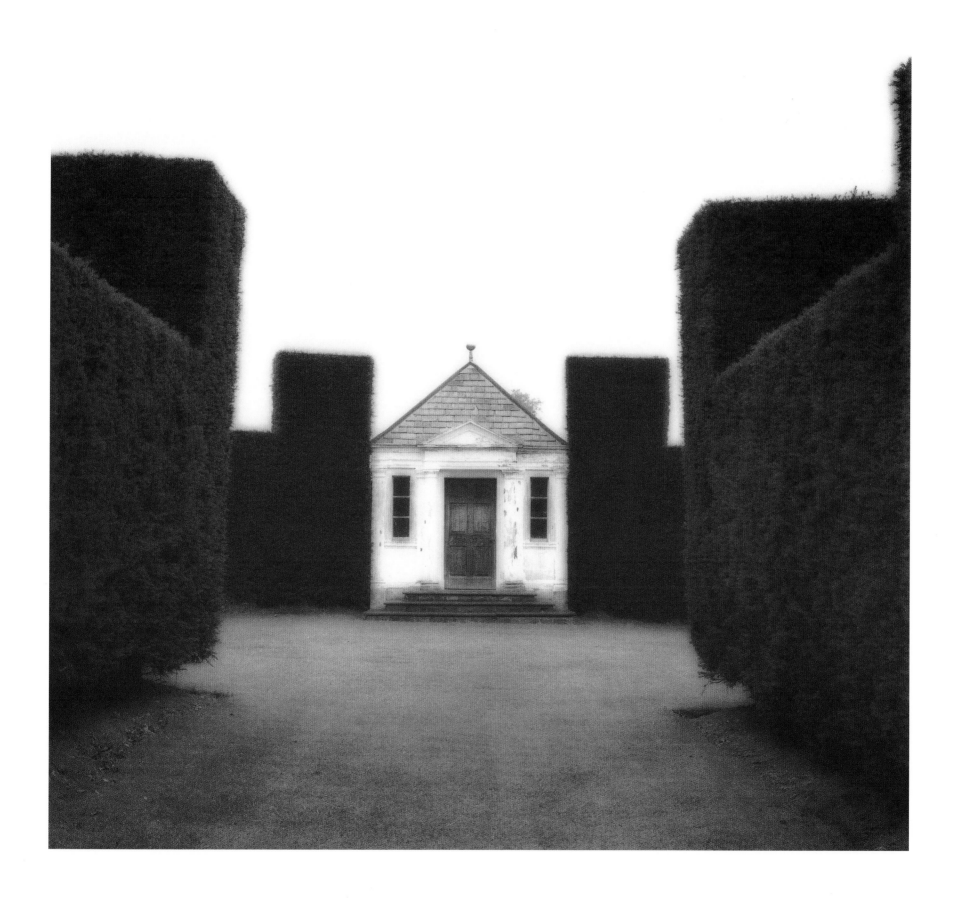

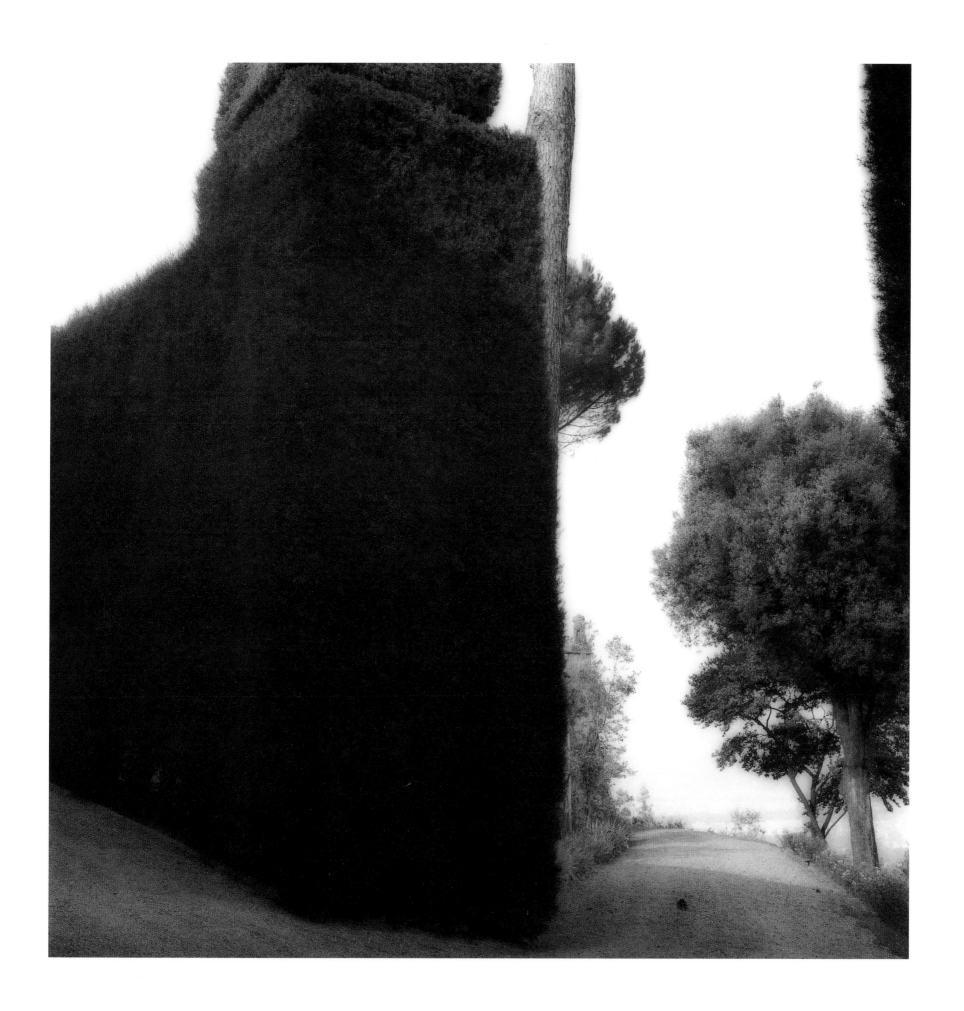

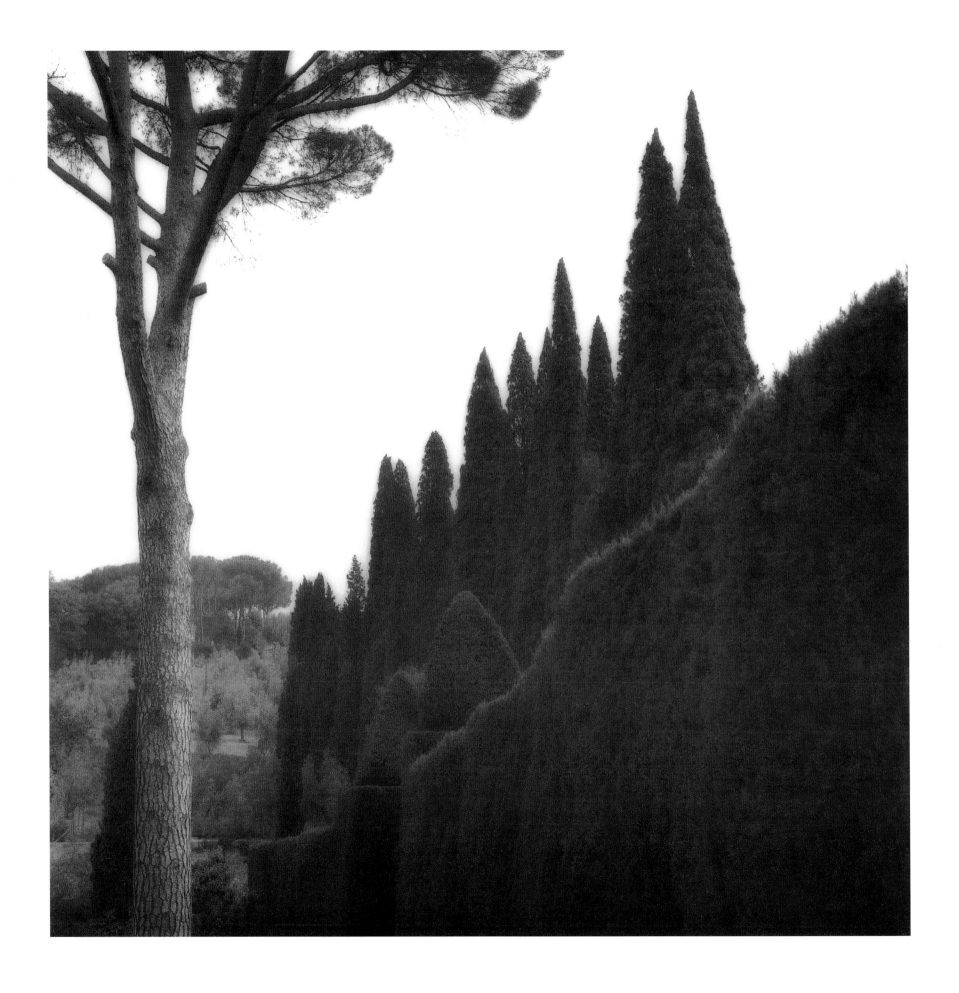

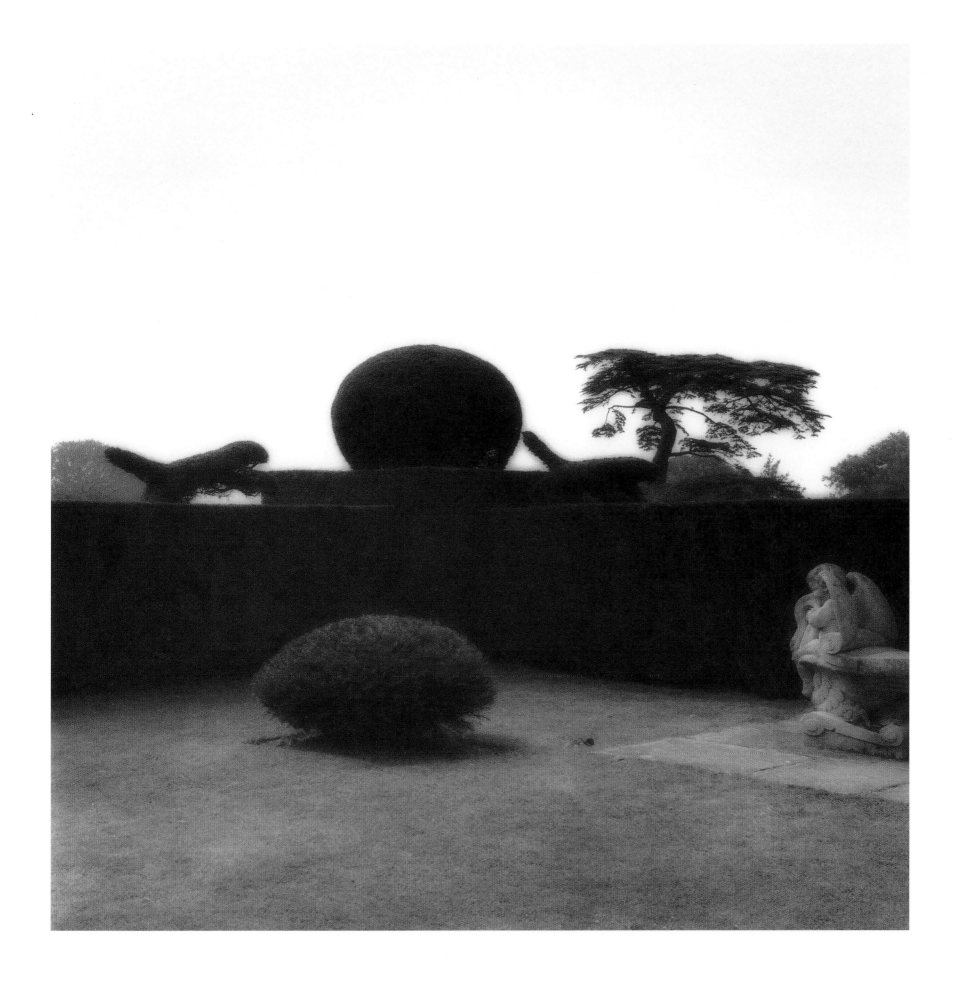

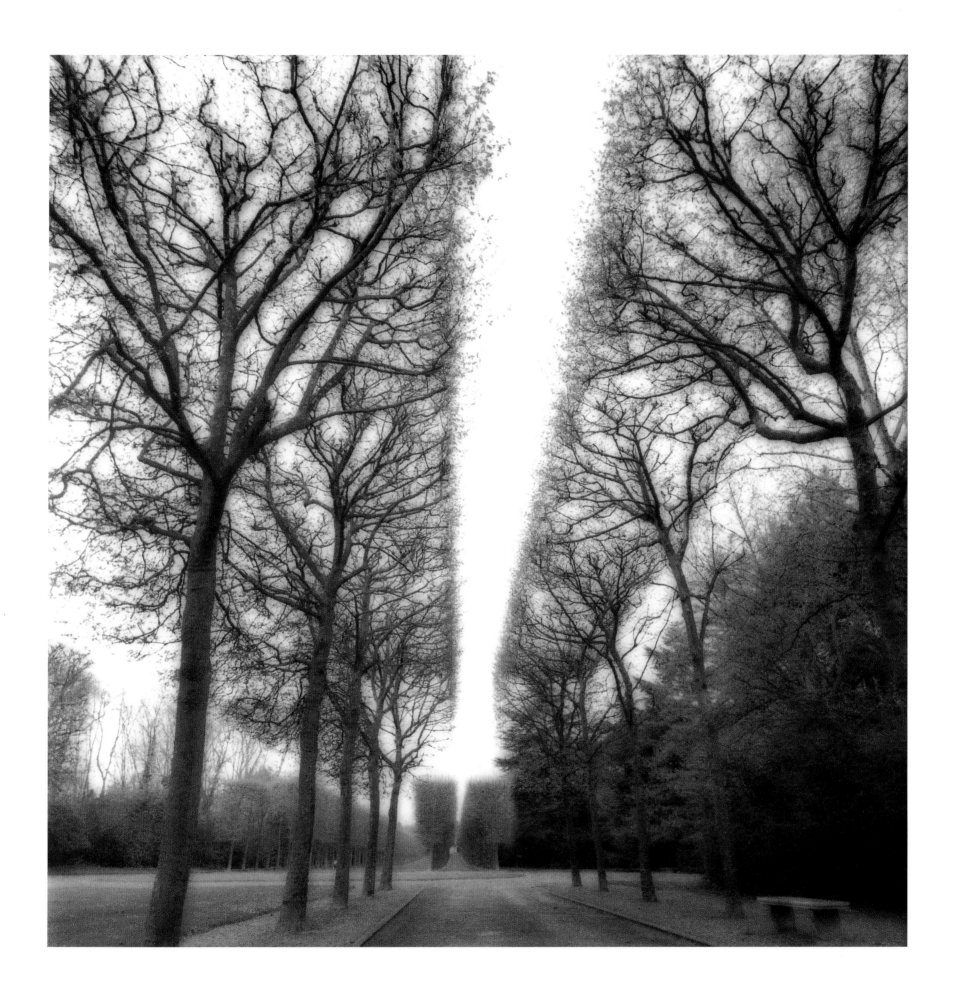

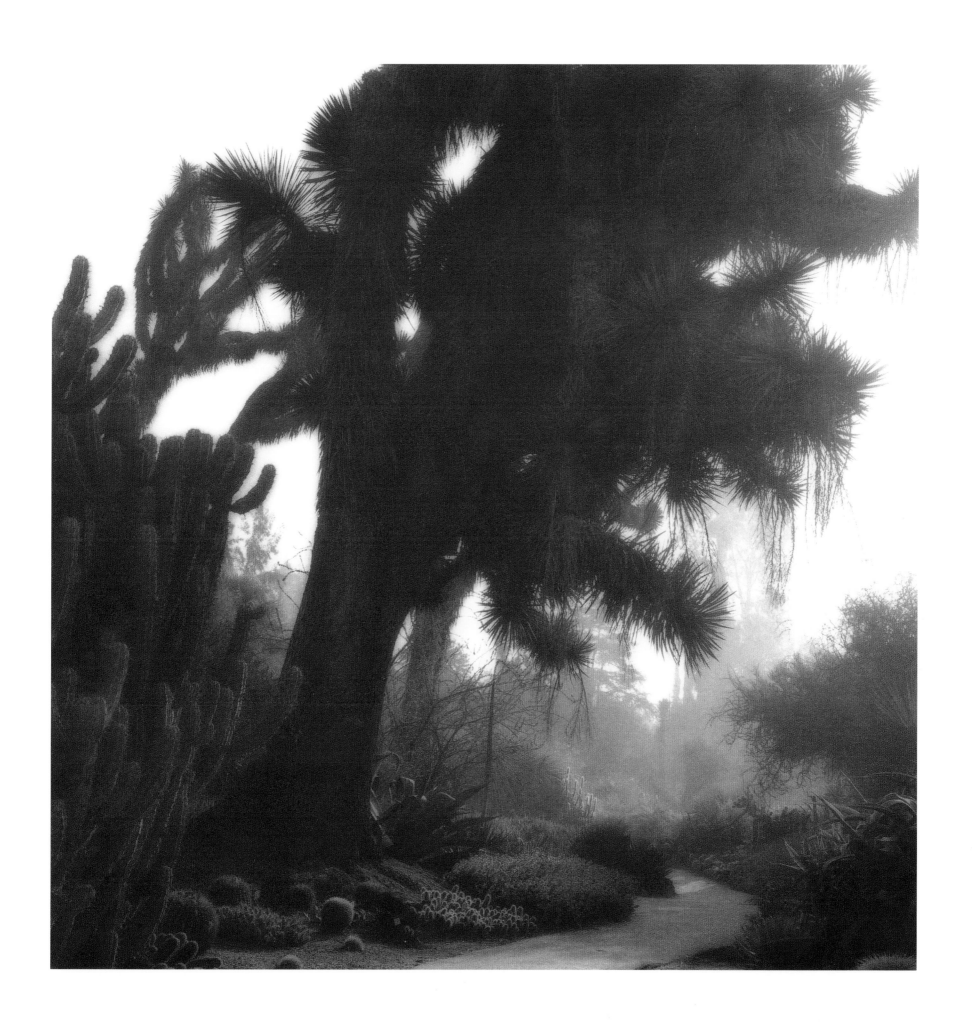

Ipomoea, 1990
Chromogenic color print
Triptych
9 × 19 inches each
Courtesy the artist, New York

Achillea, 1992
Chromogenic color print
9 × 19 inches
Courtesy the artist, New York

Allium Giganteum, 1992
Chromogenic color print
9 × 19 inches
Courtesy the artist, New York

Cleome, 1993
Chromogenic color print
12 × 19 inches
Courtesy the artist, New York

Rudbeckia, 1996
Chromogenic color print
4 × 6 inches
Courtesy the artist, New York

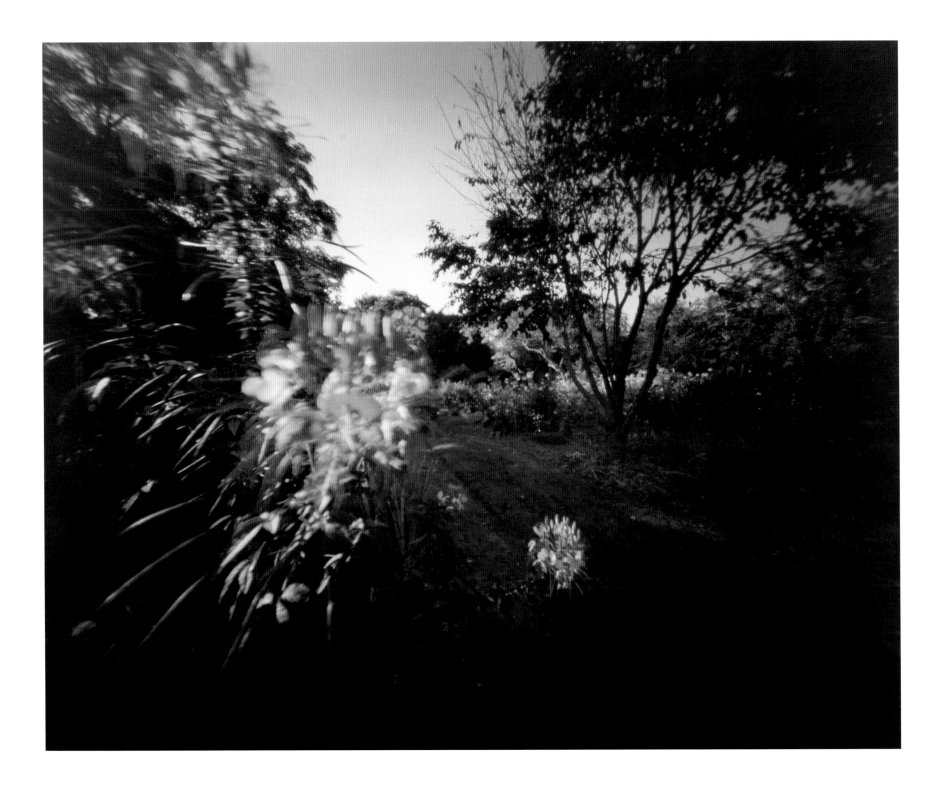

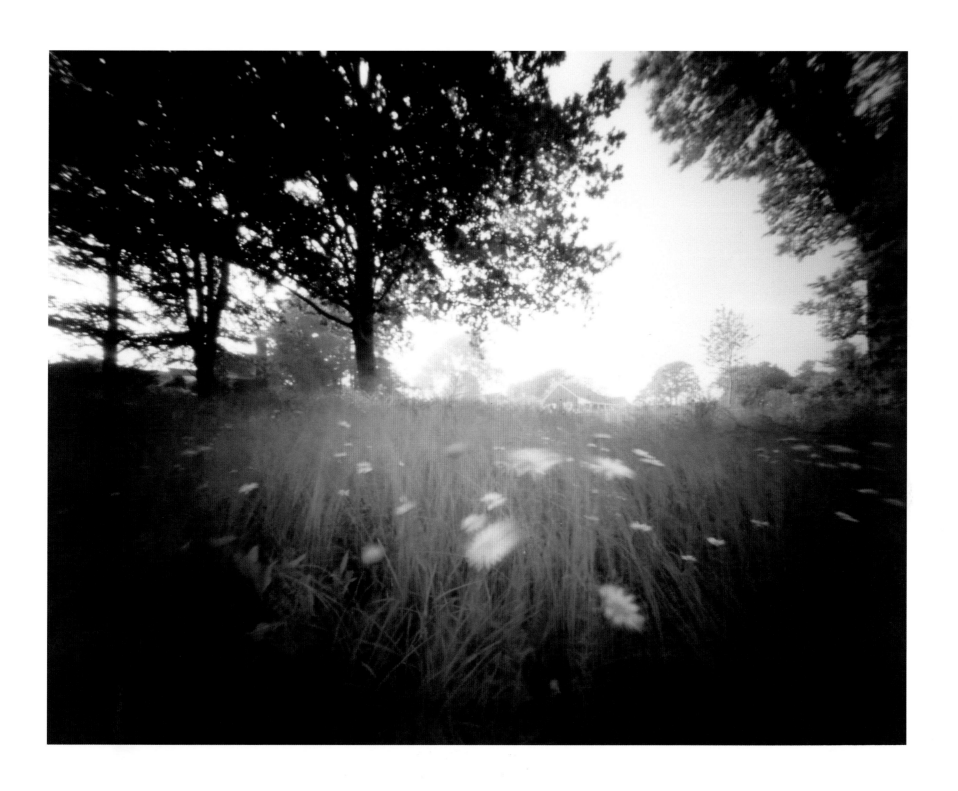

Villa Farnese, Caprarola, 1984
Gelatin silver print
3¾ × 10½ inches
Courtesy the artist, Toronto

Villa Aldobrandini, Frascati, 1984
Gelatin silver print
3¾ × 10½ inches
Courtesy the artist, Toronto

Villa Medici, Alley from the Pincio Wall to the Courtyard Garden, 1984
Gelatin silver print
3¾ × 10½ inches
Courtesy the artist, Toronto

Villa Brenzone, Over Lago di Garda, 1984
Gelatin silver print
3¾ × 10½ inches
Courtesy the artist, Toronto

Villa Barbarigo, The Water Entrance, 1984
Gelatin silver print
3¾ × 10½ inches
Courtesy the artist, Toronto

Castello Balduino, Above the Topiary Garden, 1990
Gelatin silver print
3¾ × 10½ inches
Courtesy the artist, Toronto

Villa Medici, at the Base of the Obelisk, Courtyard Garden, 1984
Gelatin silver print
3¾ × 10½ inches
Courtesy the artist, Toronto

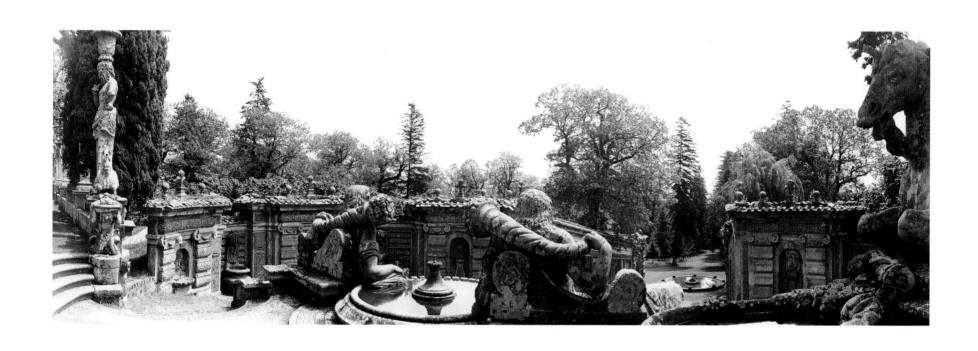

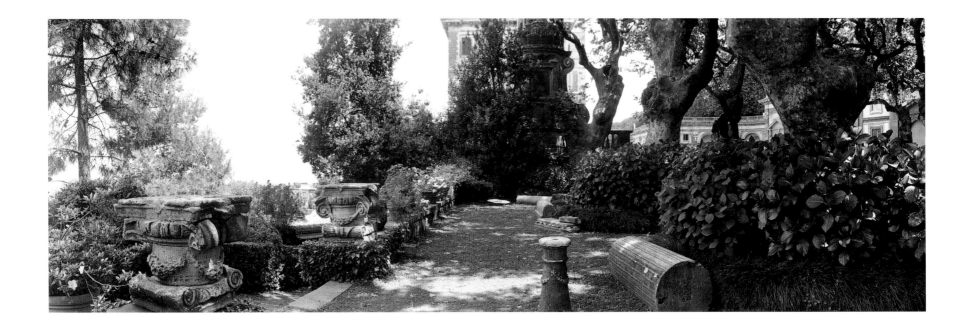

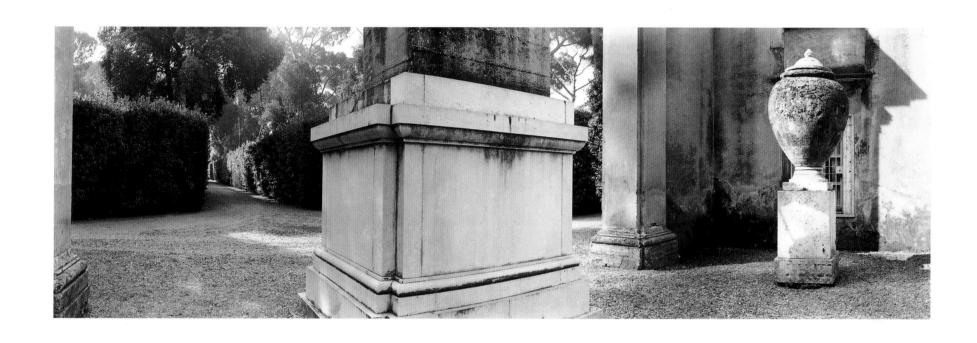

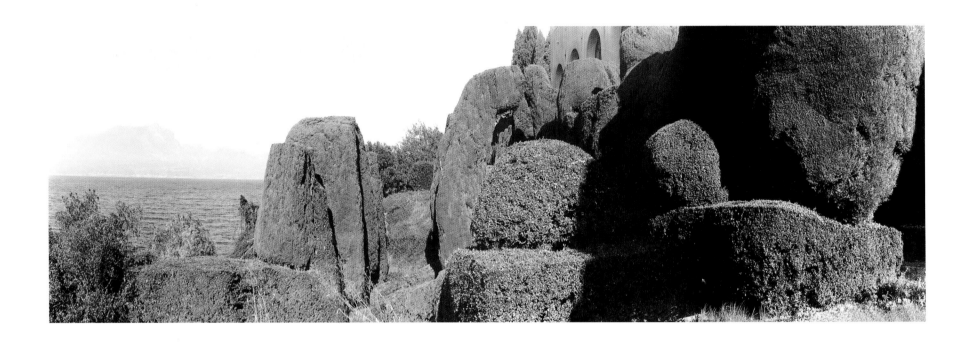

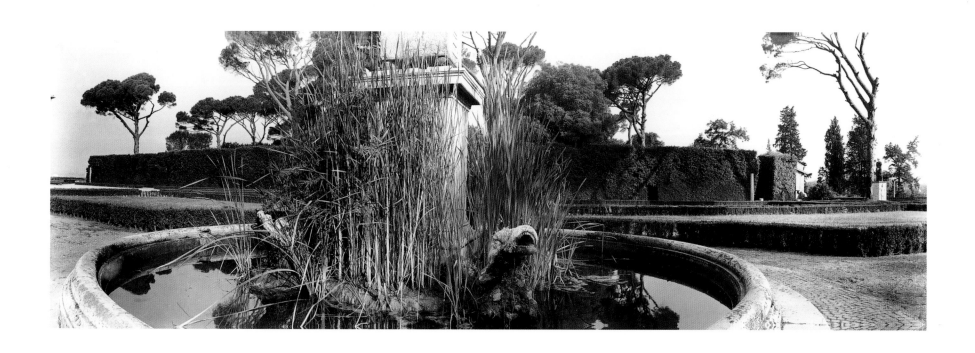

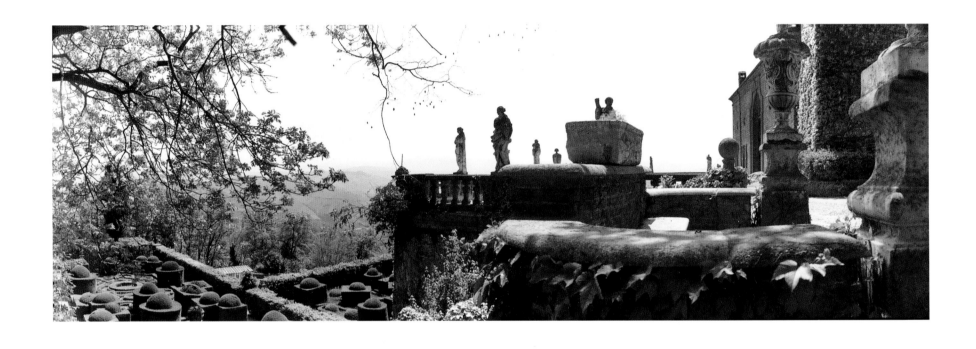

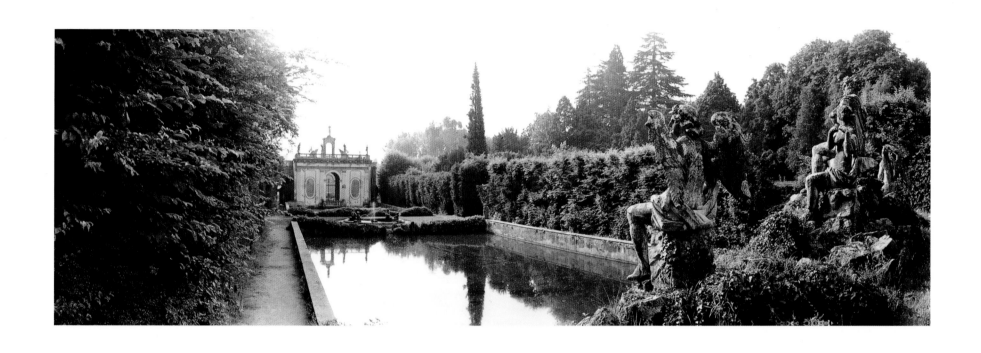

Cypress Gardens, Charleston, South Carolina, 1986
Chromogenic color print
20 × 24 inches
Courtesy Paul Kopeikin Gallery, Los Angeles, California

Fairchild Tropical Garden, Miami, Florida, 2001
Chromogenic color print
20 × 24 inches
Courtesy Paul Kopeikin Gallery, Los Angeles, California

Huntington Gardens, California, 1993
Chromogenic color print
20 × 24 inches
Courtesy Paul Kopeikin Gallery, Los Angeles, California

Lotusland, Montecito, California, 2001
Chromogenic color print
20 × 24 inches
Courtesy *House & Garden* (15506.1)

Lotusland, Montecito, California, 2001
Chromogenic color print
20 × 24 inches
Courtesy *House & Garden* (15526.1)

Shinjuku Gardens, Tokyo, Japan, 2001
Chromogenic color print
20 × 24 inches
Courtesy Paul Kopeikin Gallery, Los Angeles, California

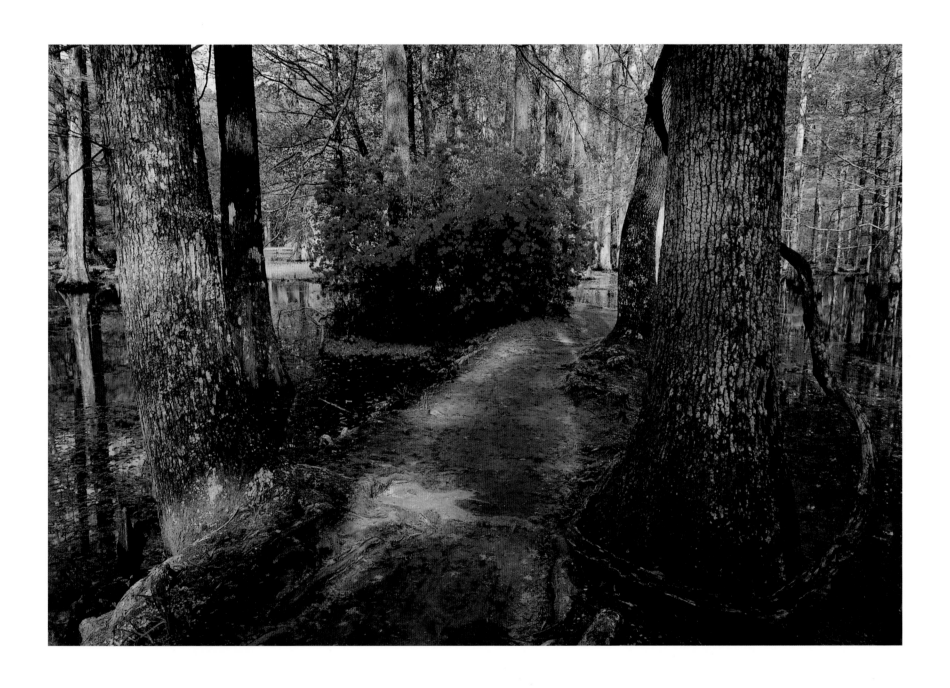

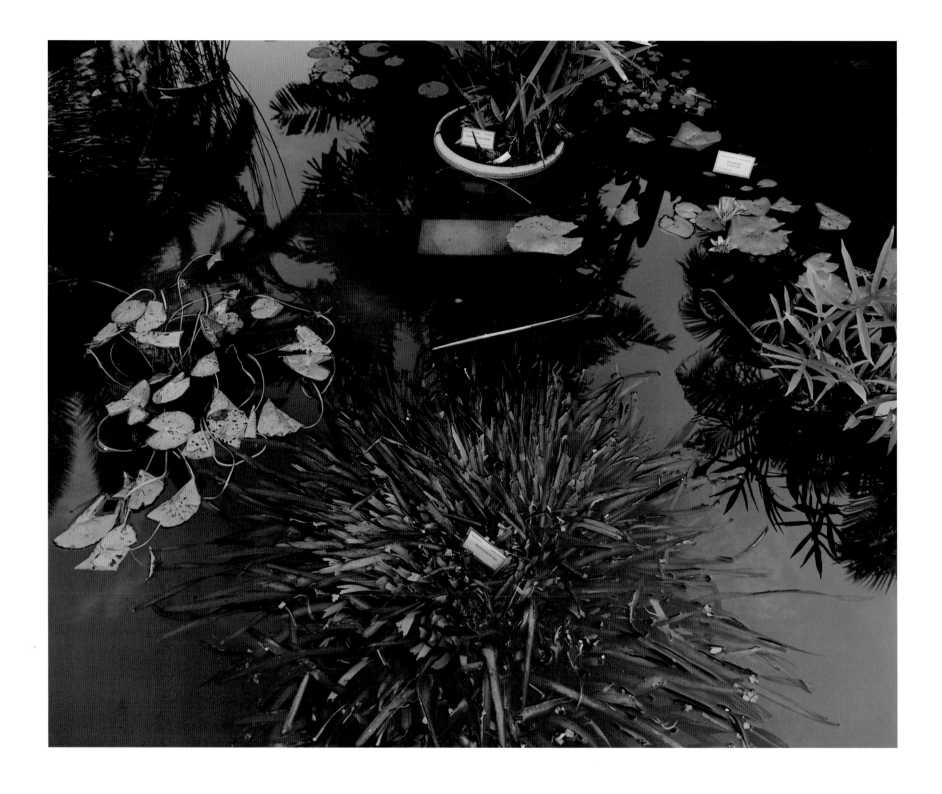

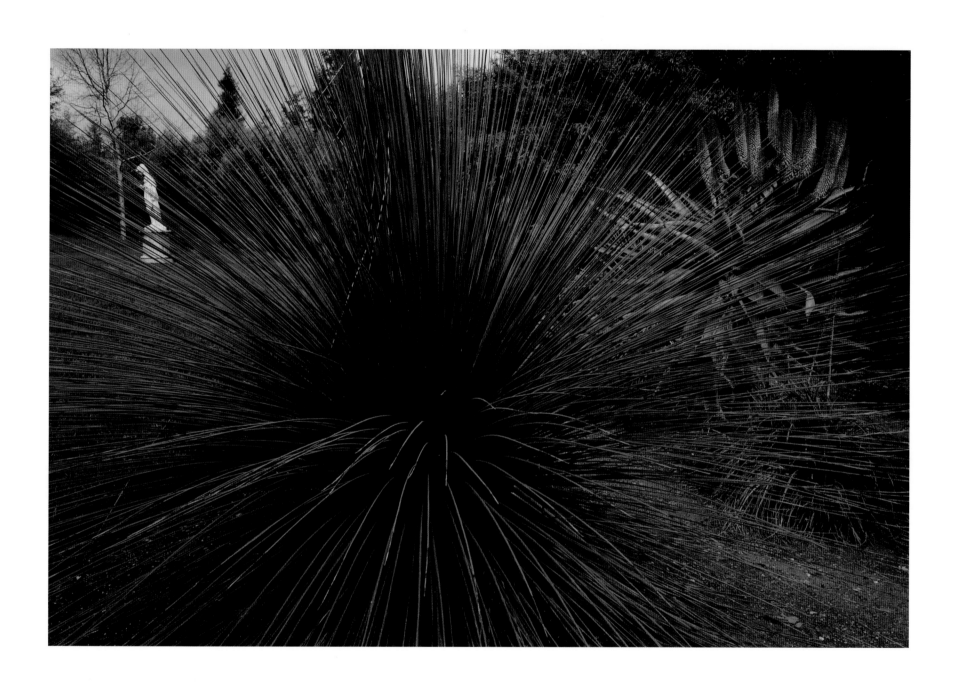

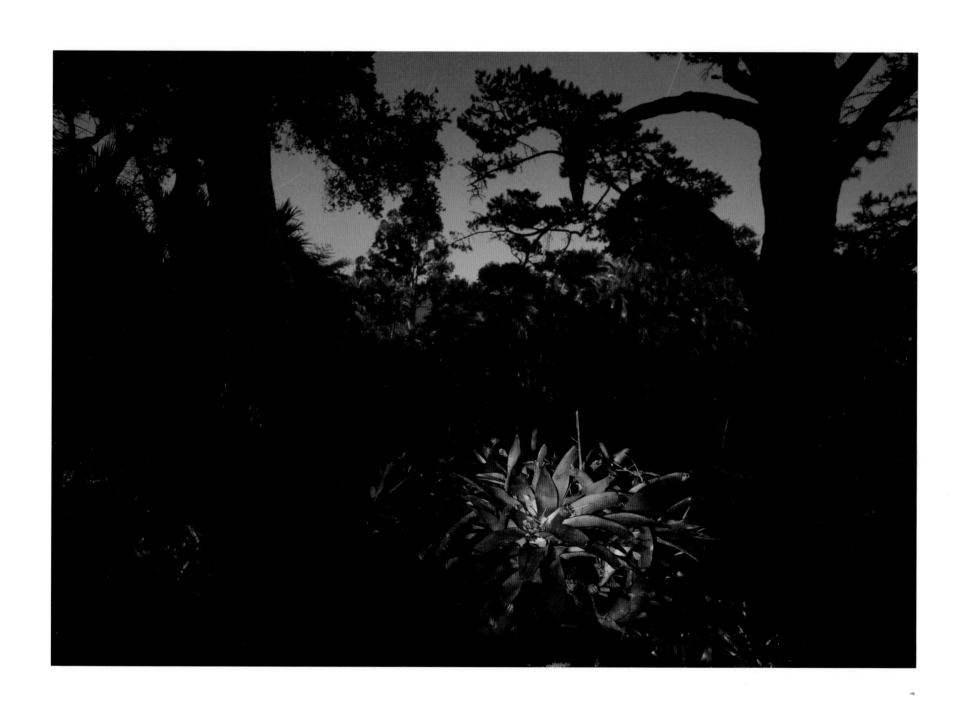

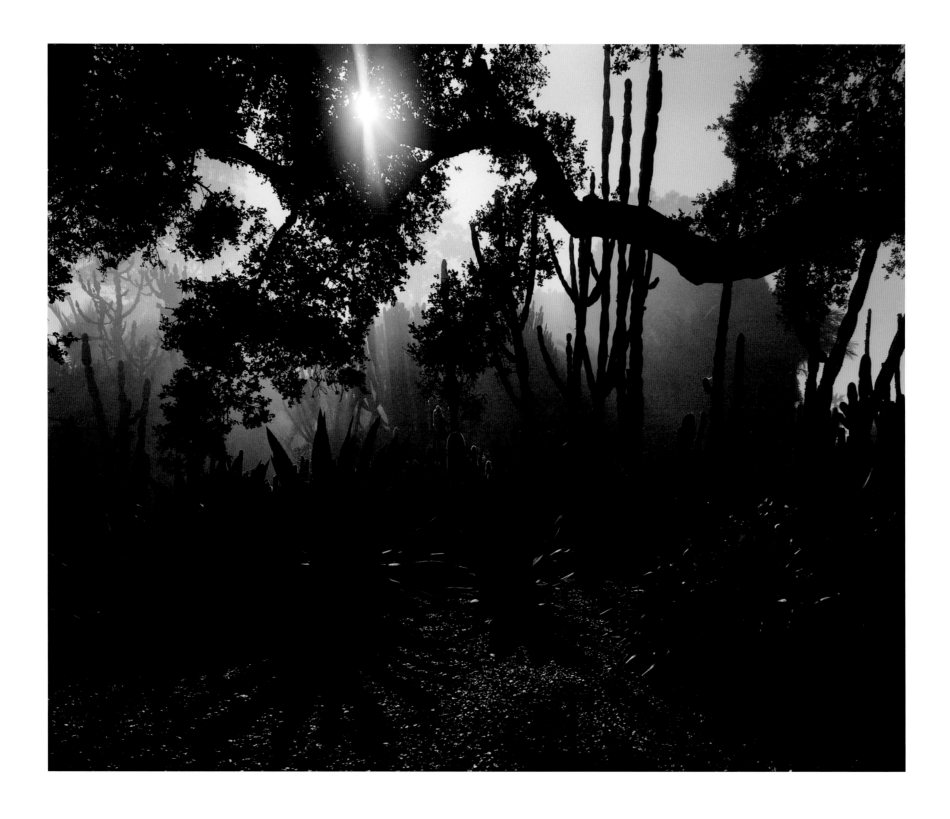

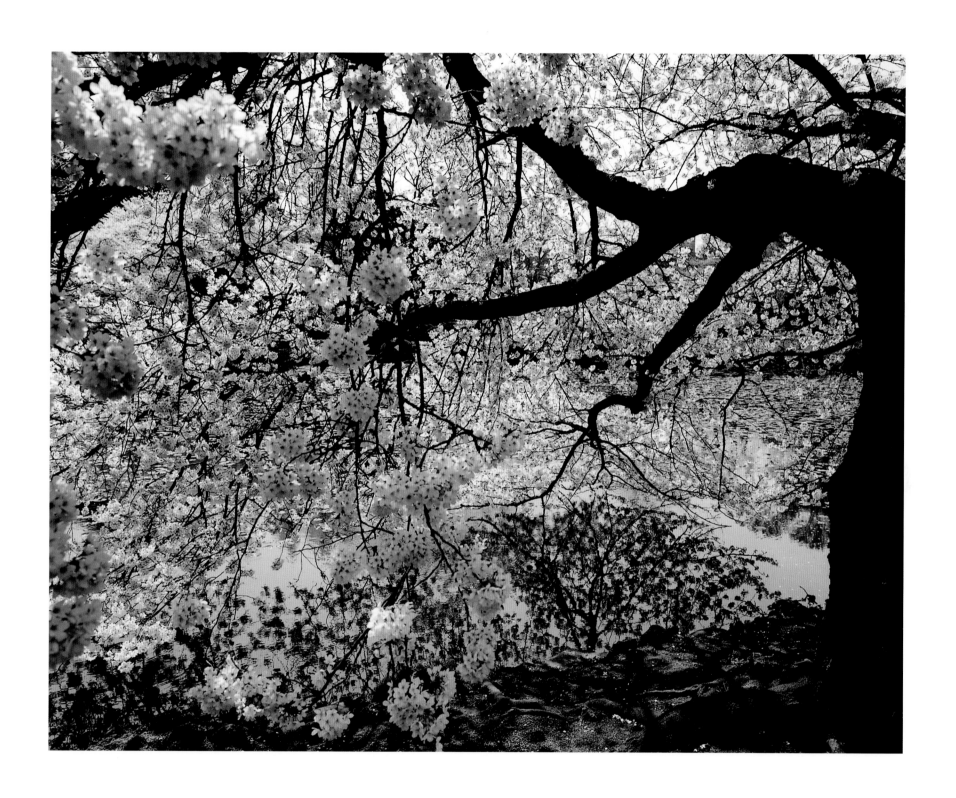

ERICA LENNARD

Daisen-In (*Sand and Stone*), 1989
Gelatin silver print
16 × 20 inches
Courtesy Staley-Wise Gallery, New York

Daisen-In (*Two Mountains in Sand*), 1989
Gelatin silver print
16 × 20 inches
Courtesy Staley-Wise Gallery, New York

Ginkagu-ji, 1989
Gelatin silver print
16 × 20 inches
Courtesy Staley-Wise Gallery, New York

Ryoan-ji, 1989
Gelatin silver print
16 × 20 inches
Courtesy Staley-Wise Gallery, New York

Isamu Noguchi Garden, Shikoku Island, Japan, 1991
Gelatin silver print
16 × 20 inches
Courtesy Staley-Wise Gallery, New York

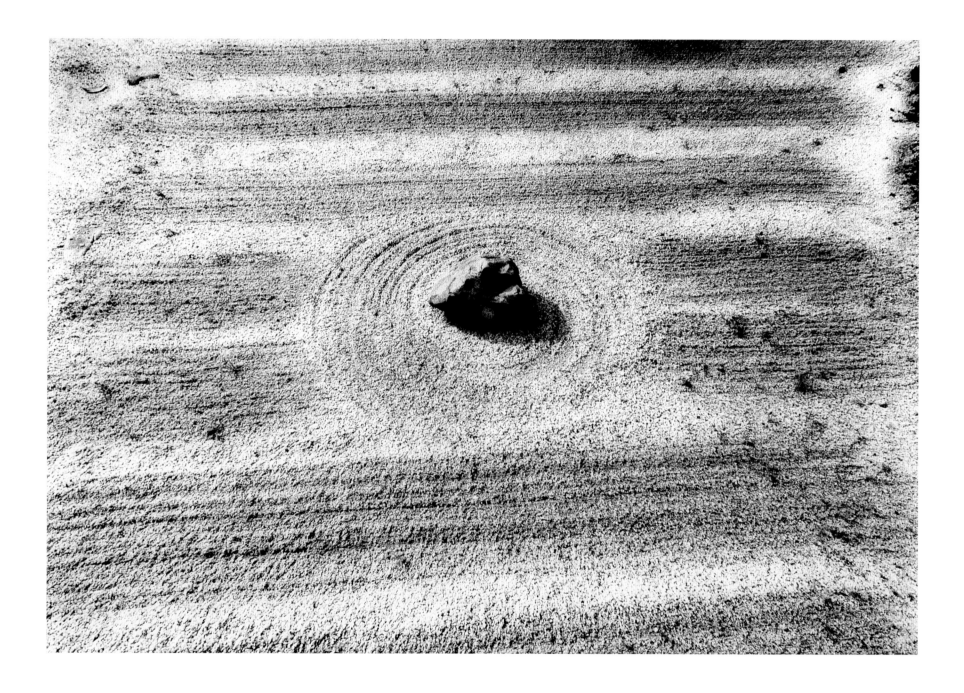

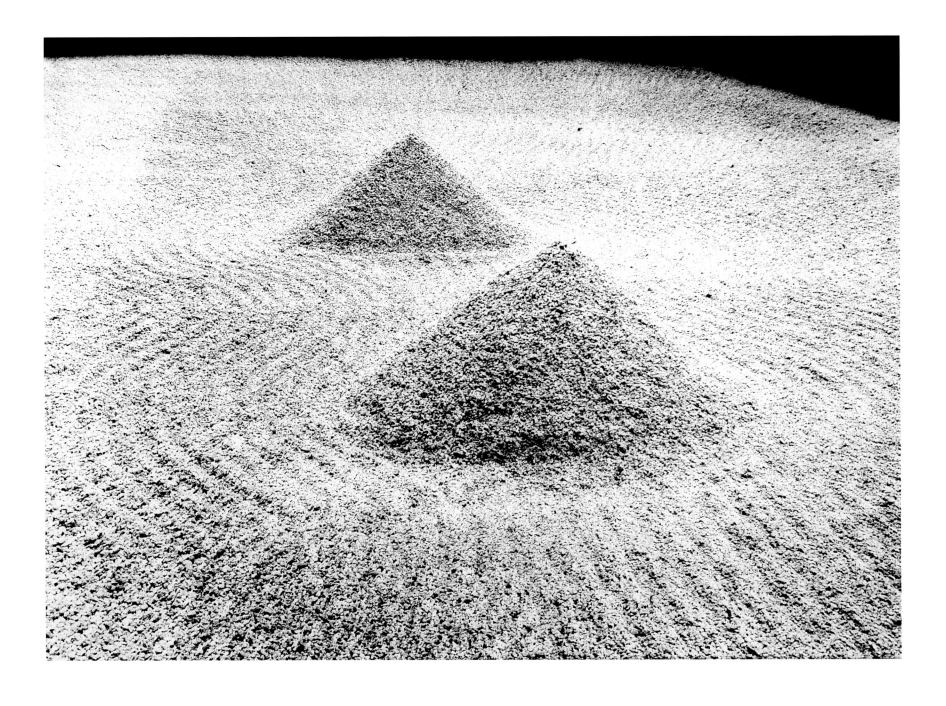

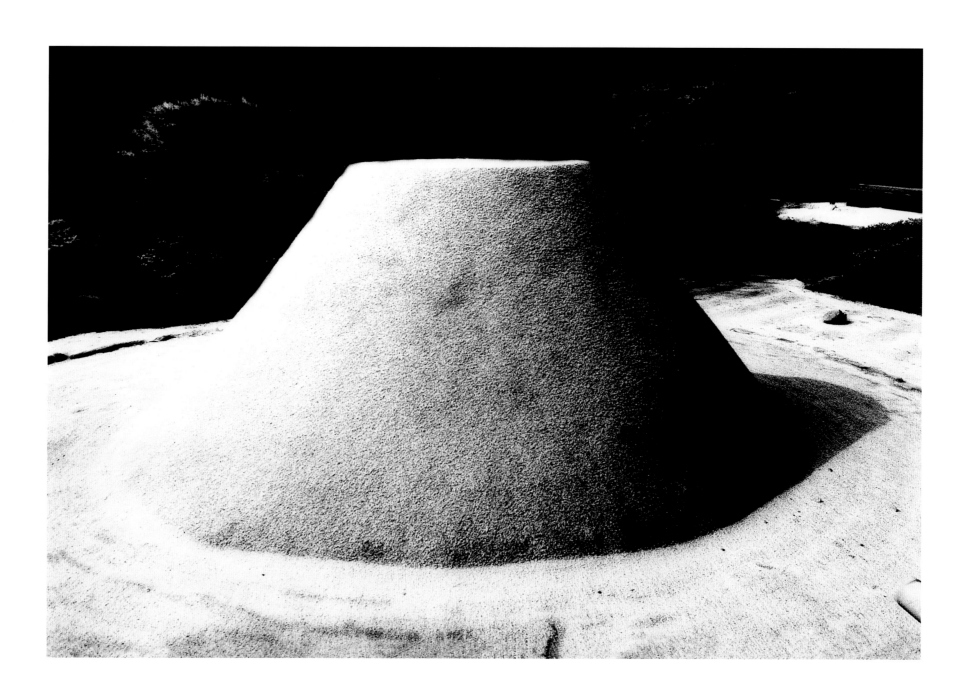

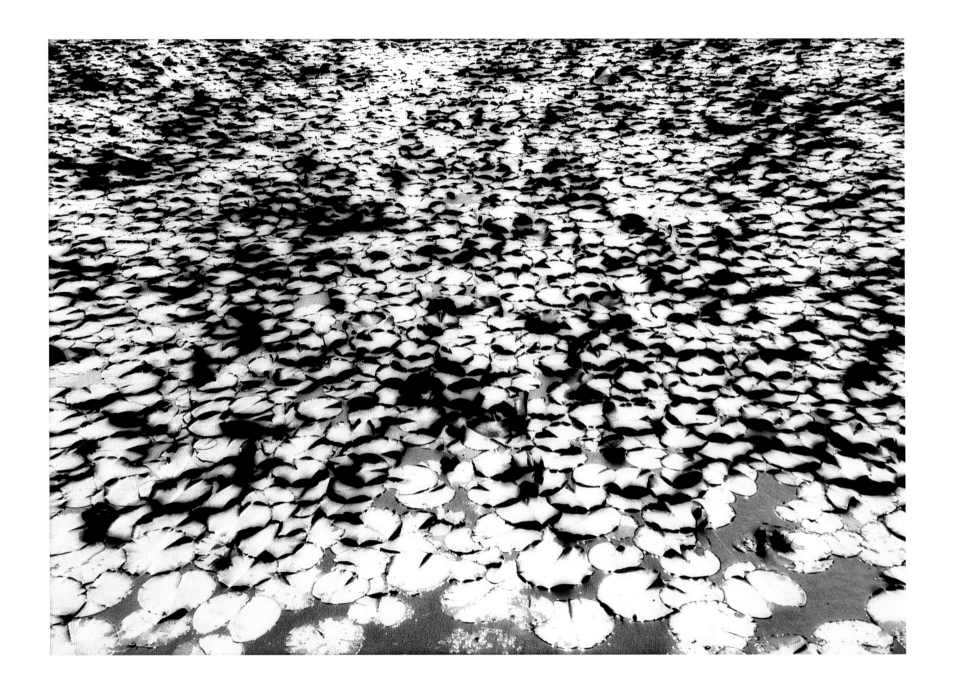

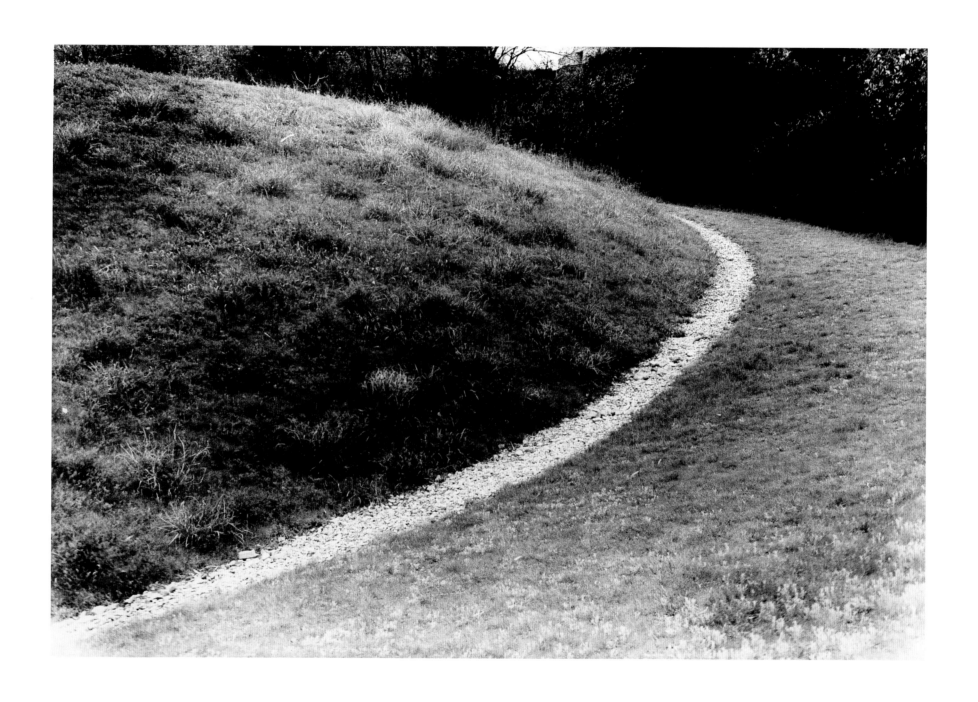

SALLY MANN

Untitled, 2001
Six photographs from Las Pozas, Mexico
Gelatin silver prints
40 × 50 inches each
Courtesy Edwynn Houk Gallery, New York

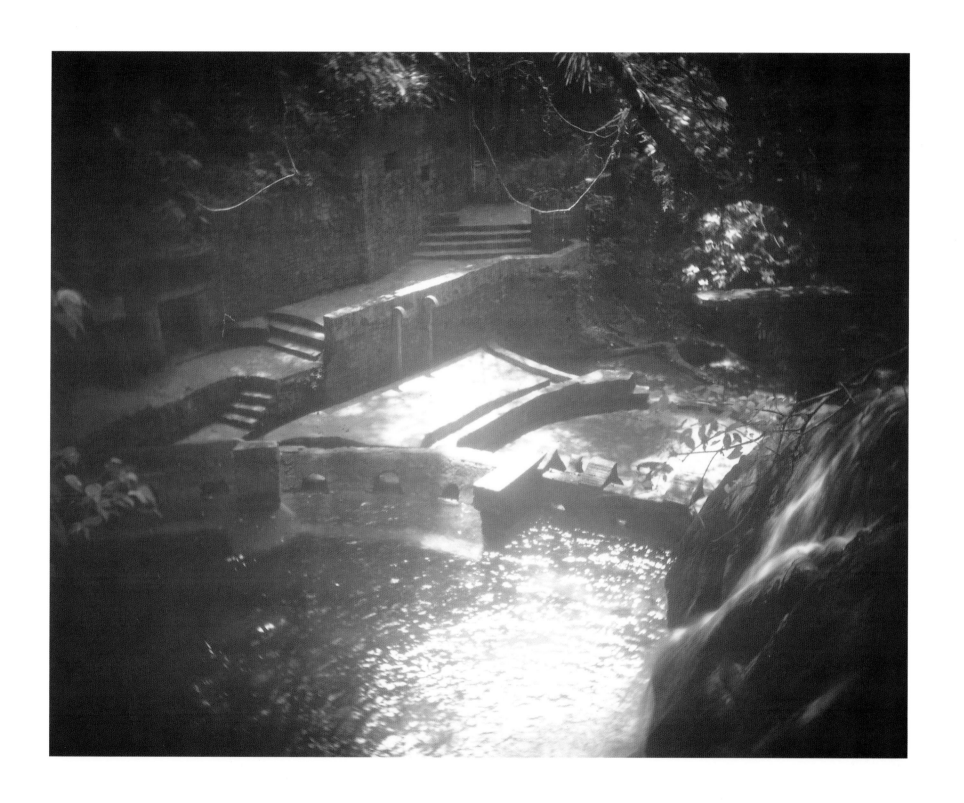

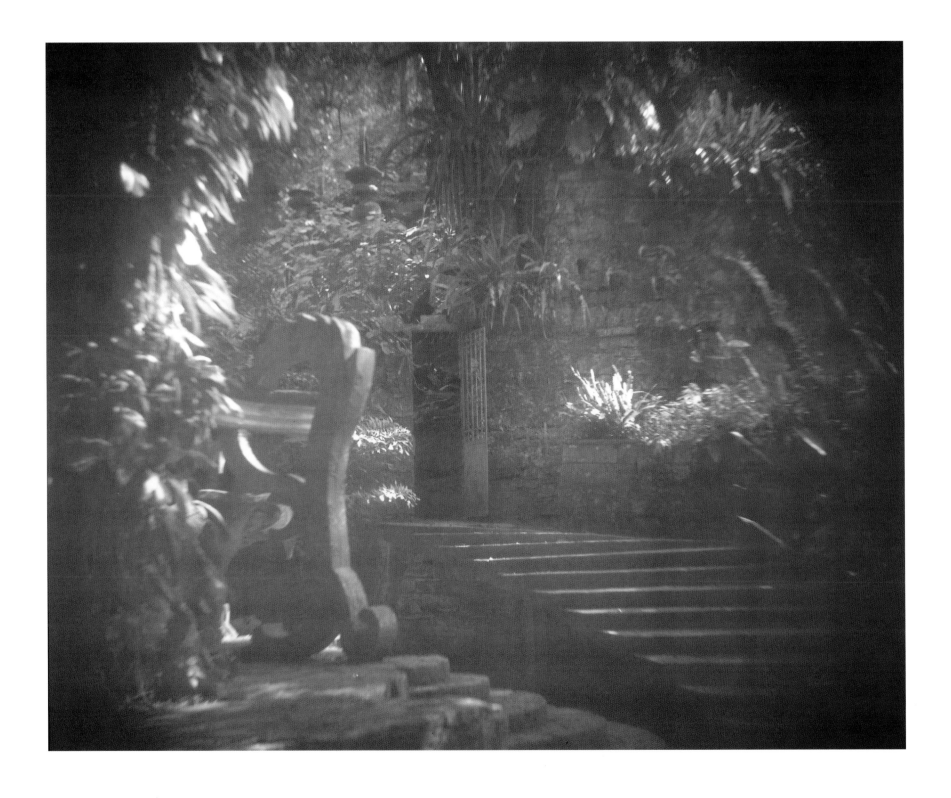

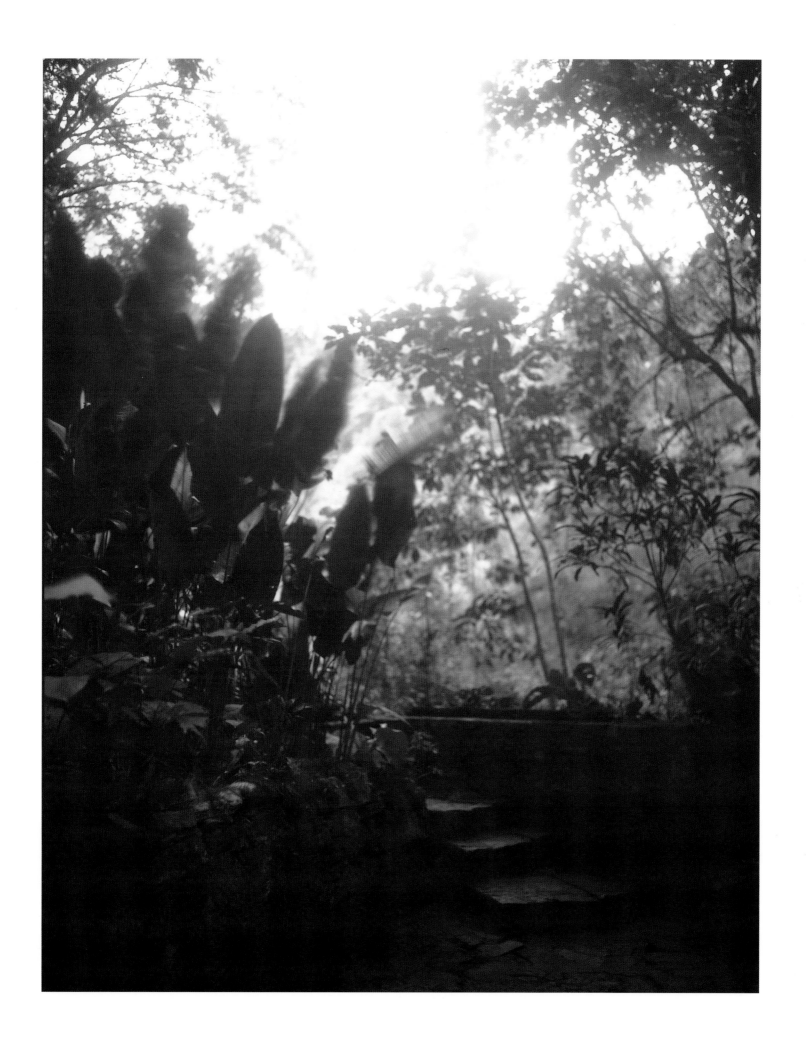

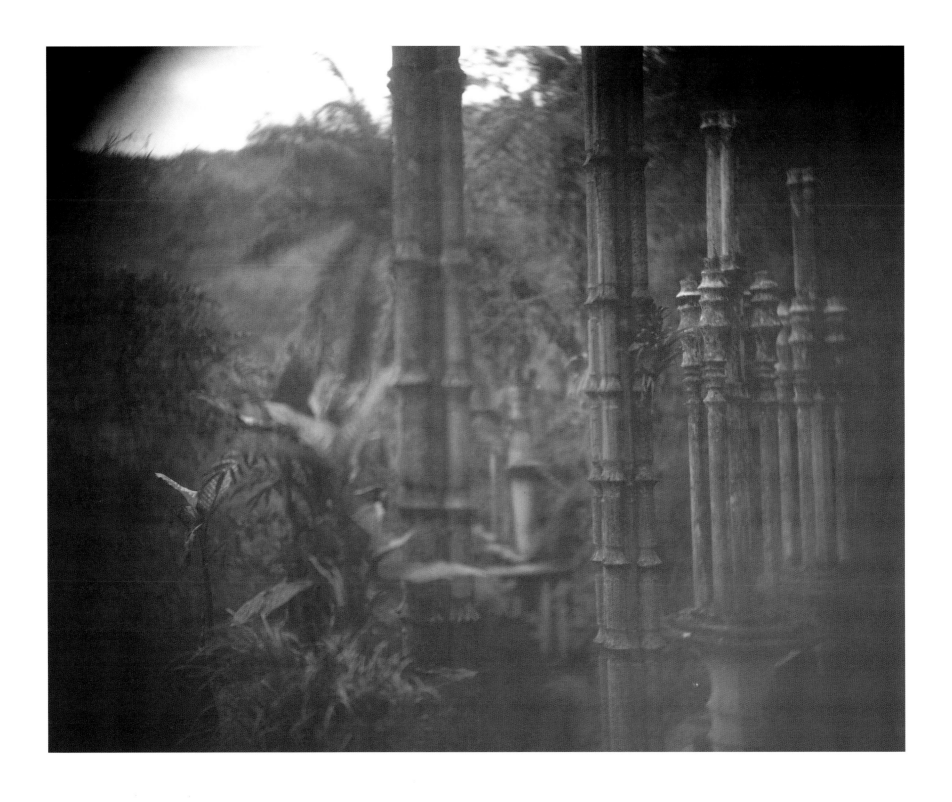

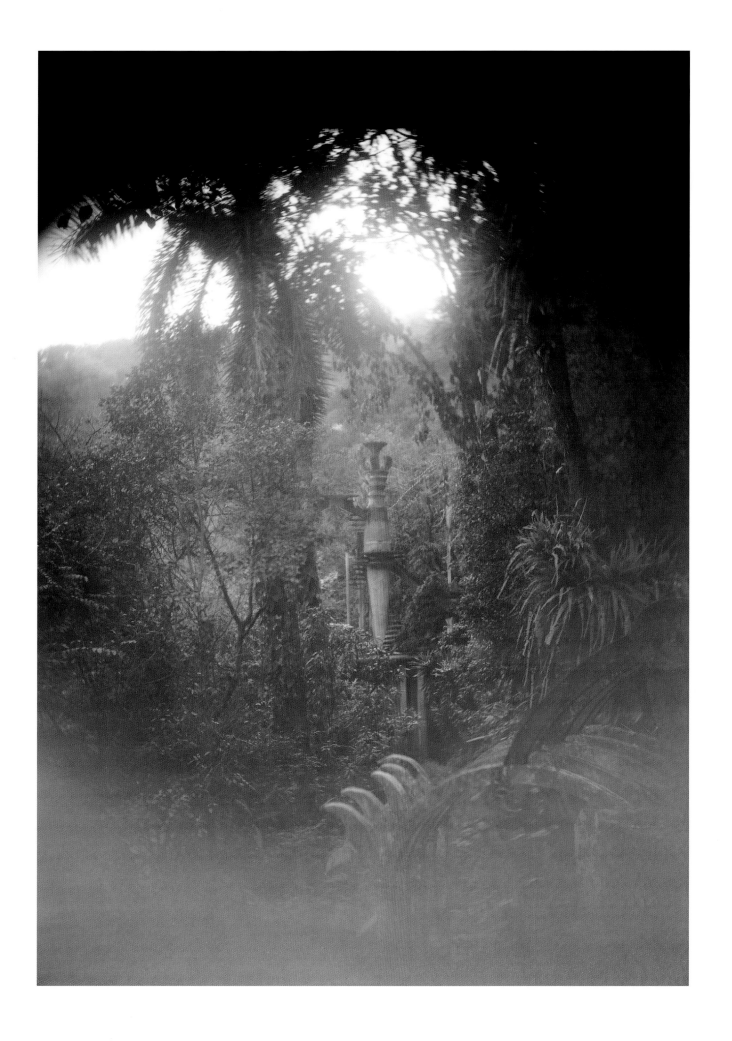

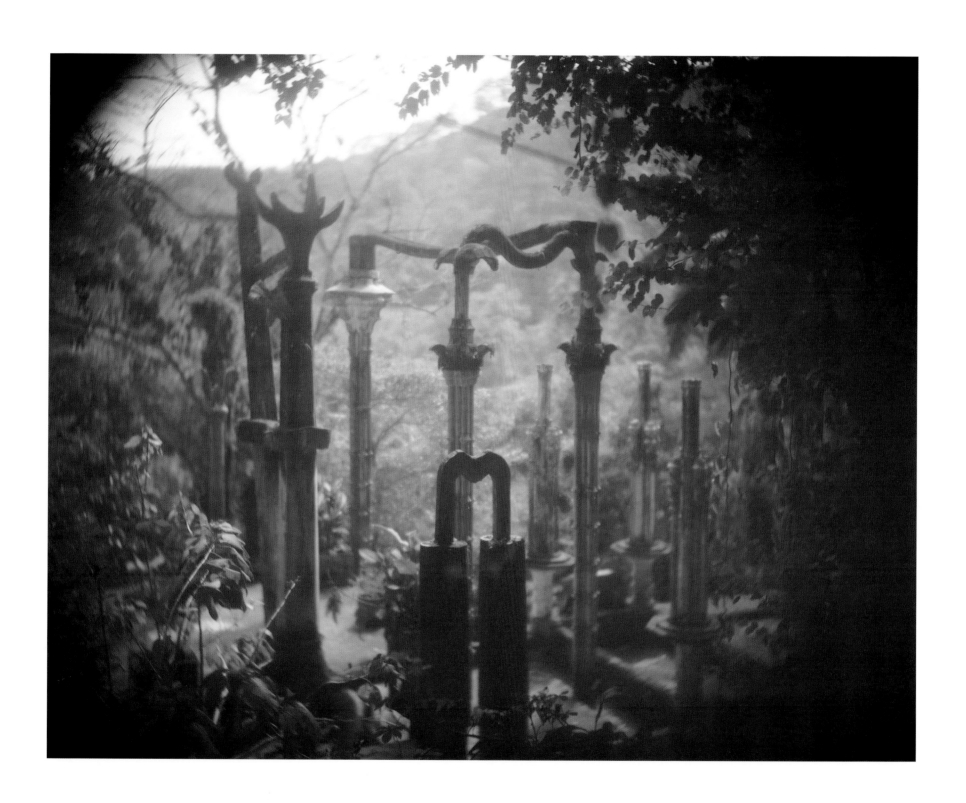

CATHERINE OPIE

Untitled, 2000
Chromogenic color print
Nine photographs in grid format, 20 × 24 inches each
Courtesy Regen Projects, Los Angeles, and Gorney, Bravin and Lee, New York

Untitled, 2000
Chromogenic color print
Triptych, 30 × 40 inches each
Courtesy Regen Projects, Los Angeles, and Gorney, Bravin and Lee, New York

Untitled, 2000
Chromogenic color print
Diptych, 30 × 40 inches each
Courtesy Regen Projects, Los Angeles, and Gorney, Bravin and Lee, New York

Untitled, 2000
Chromogenic color print
Diptych, 30 × 40 inches each
Courtesy Regen Projects, Los Angeles, and Gorney, Bravin and Lee, New York

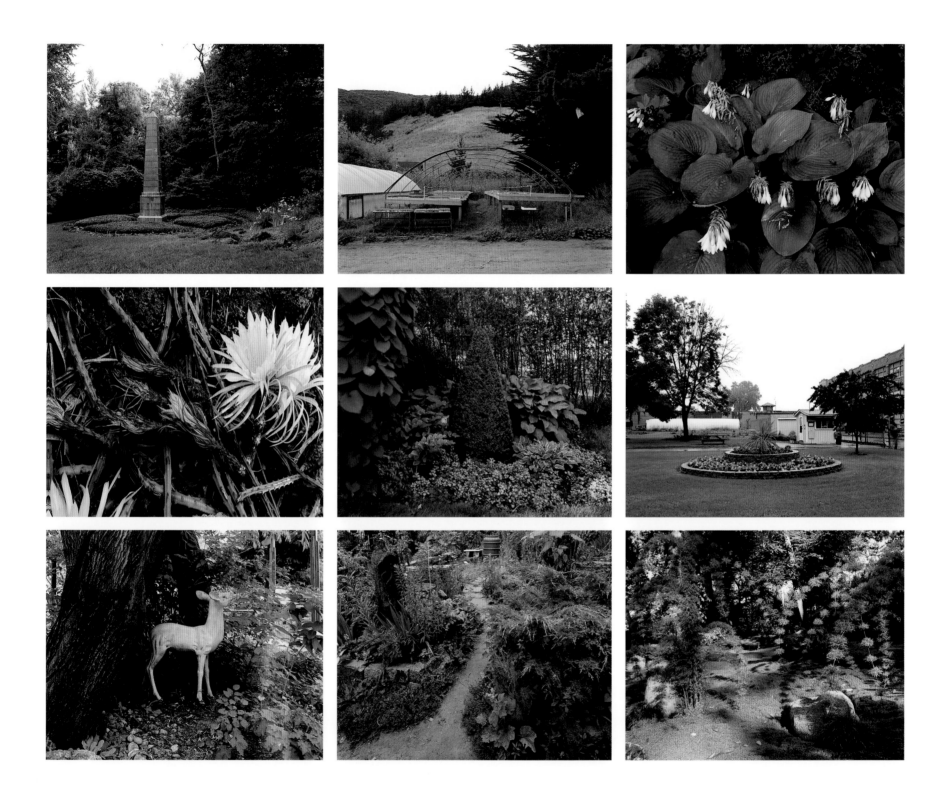

JACK PIERSON

The Side of Tim's Barn, 1995
Chromogenic color print
38 × 30 inches
Courtesy Cheim & Read, New York

Untitled (Palm Leaf, Lisbon), 1998
Chromogenic color print
30 × 40 inches
Courtesy Cheim & Read, New York

Luxembourg, 1999
Chromogenic color print
30 × 40 inches
Courtesy Cheim & Read, New York

Grass, 2000
Chromogenic color print
40 × 30 inches
Courtesy Cheim & Read, New York

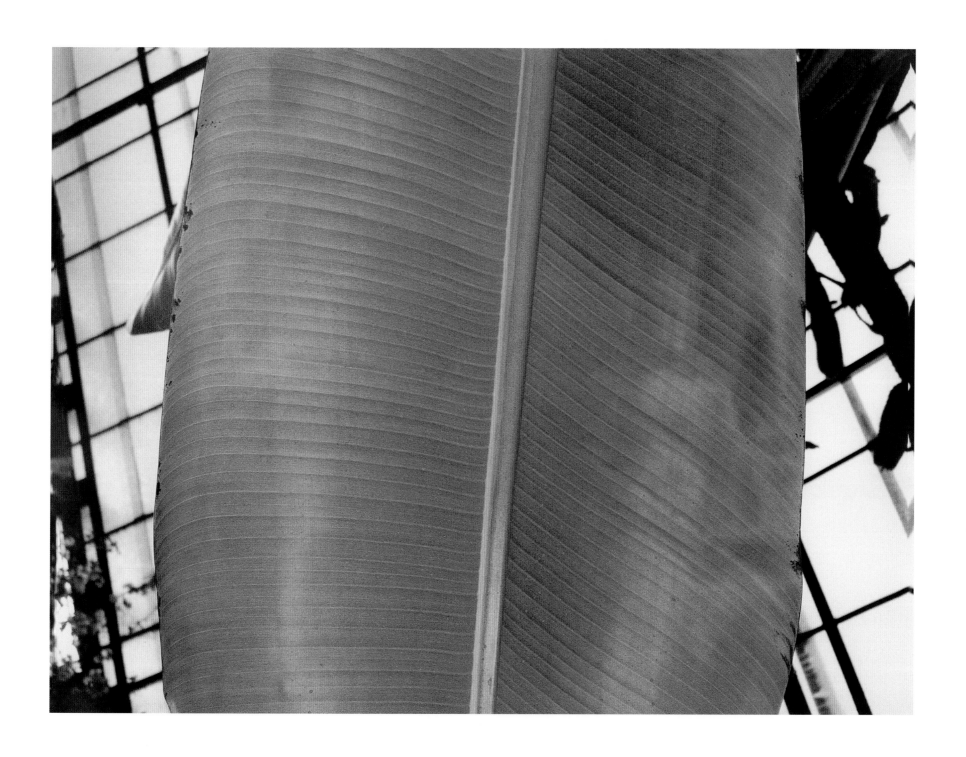

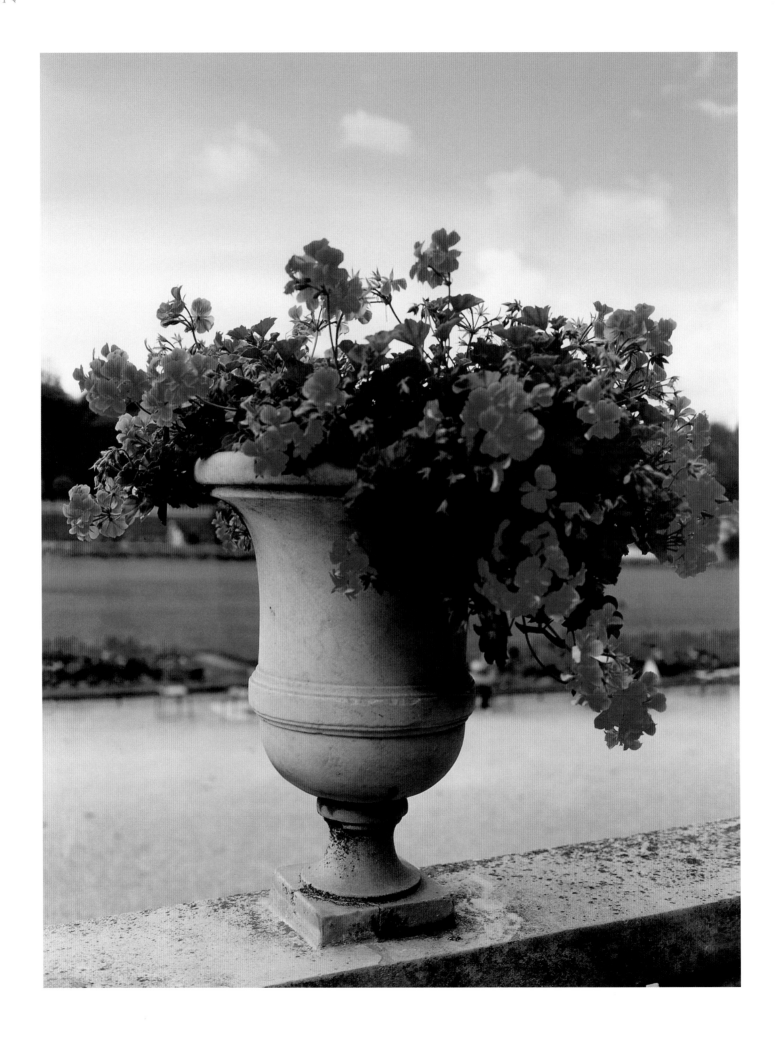

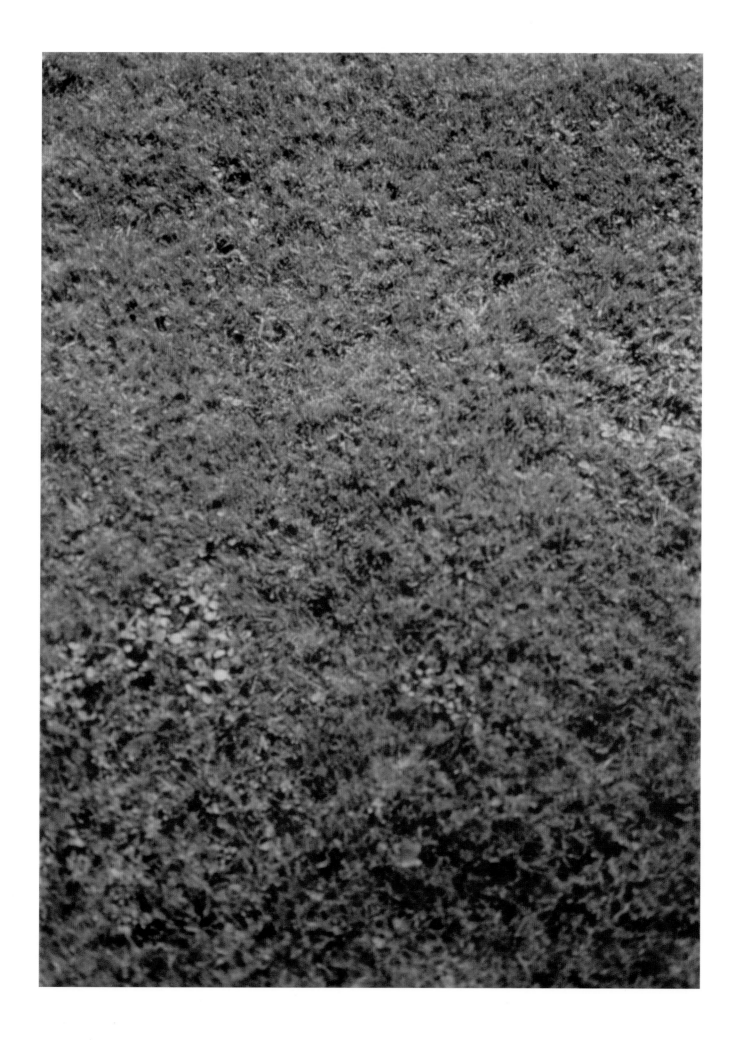

Italian Landscape (6), 2000
Permanent pigment on canvas
43¼ × 65½ × 1⅝ inches
Courtesy Jay Jopling, London

Italian Landscape (8), 2000
Permanent pigment on canvas
43¼ × 65½ × 1⅝ inches
Courtesy Jay Jopling, London

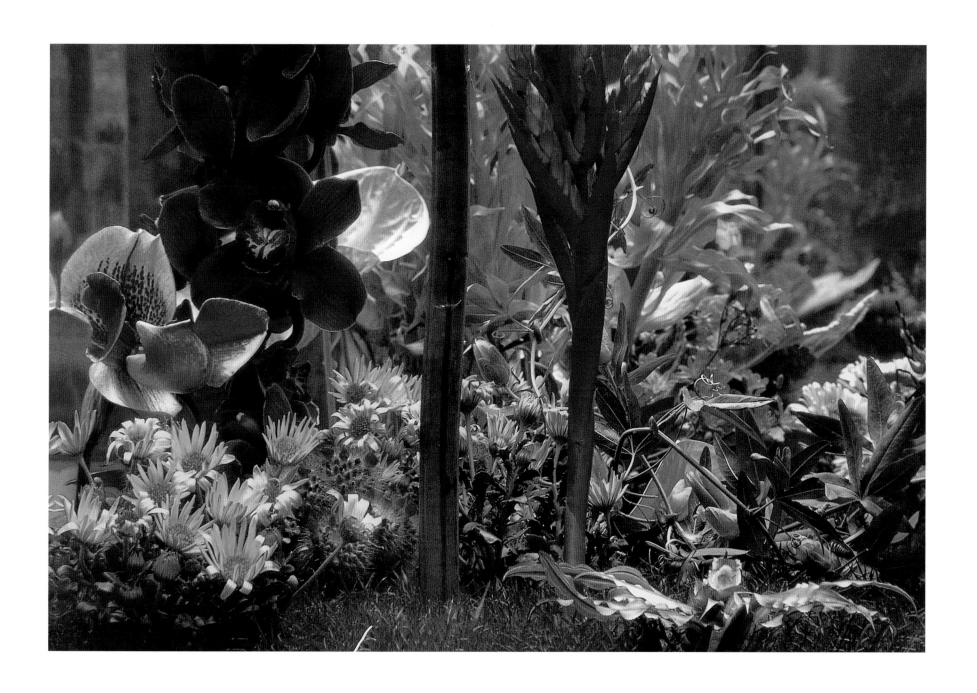

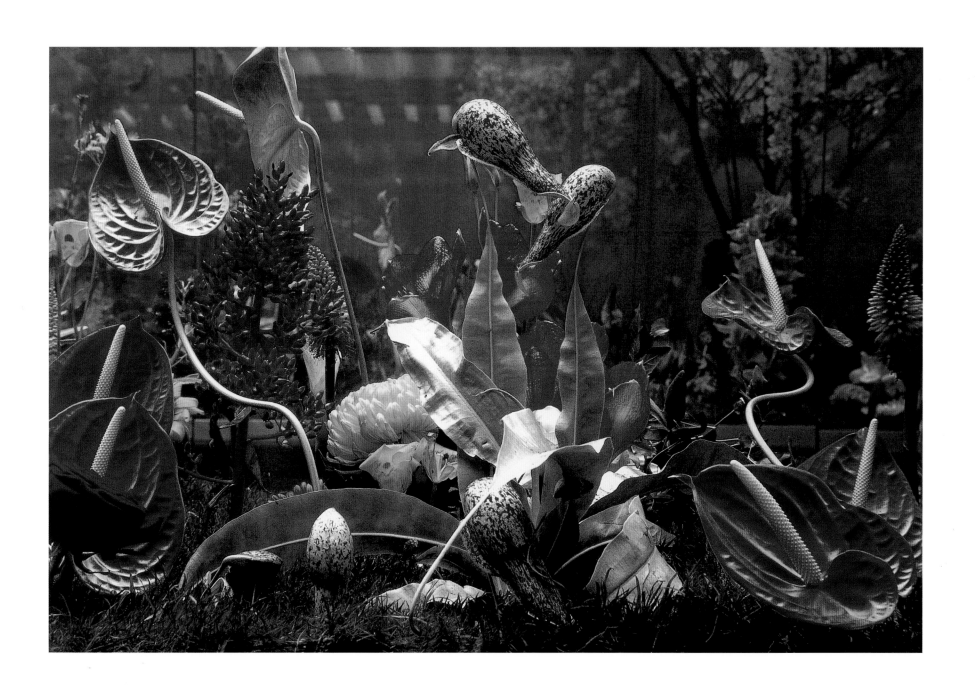

JEAN RAULT

Vue 4 du Potager du Roi, Versailles, 1993–97
Gelatin silver print
17¾ × 17¾ inches
Courtesy Galerie Michèle Chomette, Paris

Vue 17 du Potager du Roi, Versailles, 1993–97
Gelatin silver print
17¾ × 17¾ inches
Courtesy Galerie Michèle Chomette, Paris

Vue 19 du Potager du Roi, Versailles, 1993–97
Gelatin silver print
17¾ × 17¾ inches
Courtesy Galerie Michèle Chomette, Paris

Vue 31 du Potager du Roi, Versailles, 1993–97
Gelatin silver print
17¾ × 17¾ inches
Courtesy Galerie Michèle Chomette, Paris

Vue 36 du Potager du Roi, Versailles, 1993–97
Gelatin silver print
17¾ × 17¾ inches
Courtesy Galerie Michèle Chomette, Paris

Vue 48 du Potager du Roi, Versailles, 1993–97
Gelatin silver print
17¾ × 17¾ inches
Courtesy Galerie Michèle Chomette, Paris

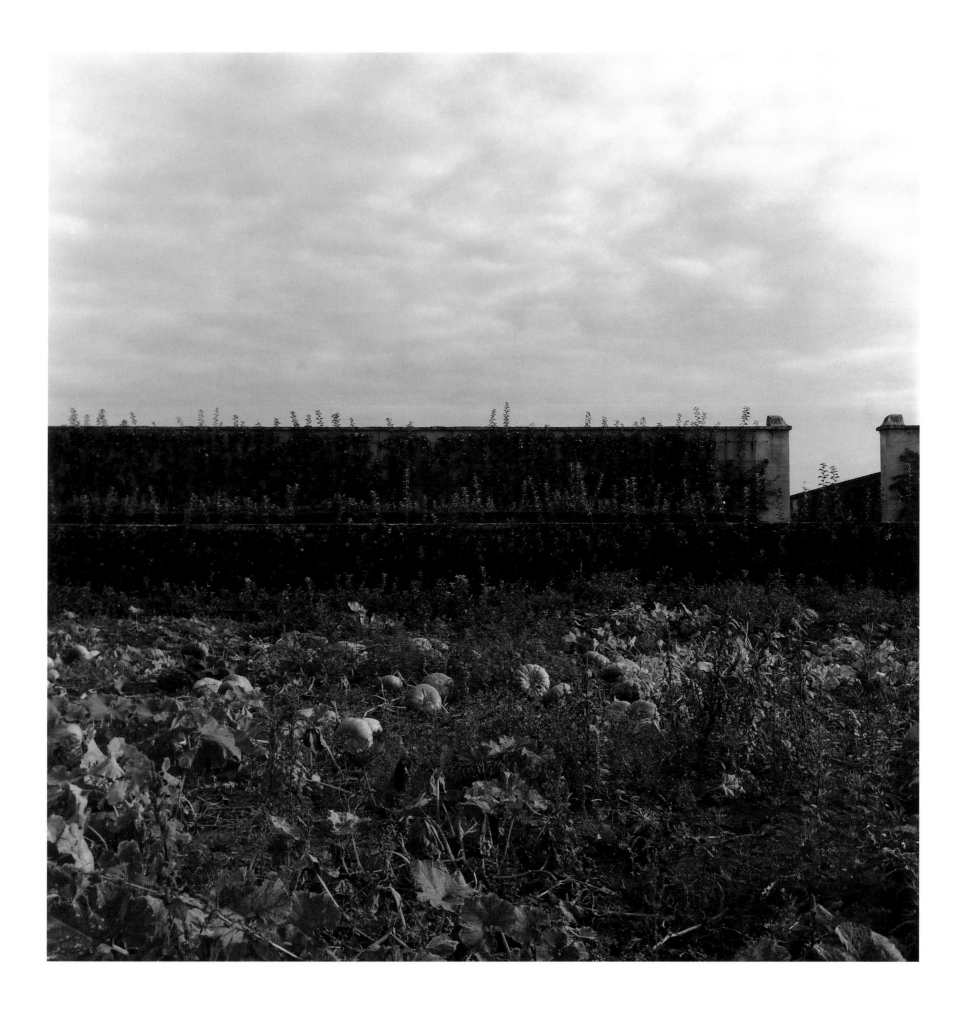

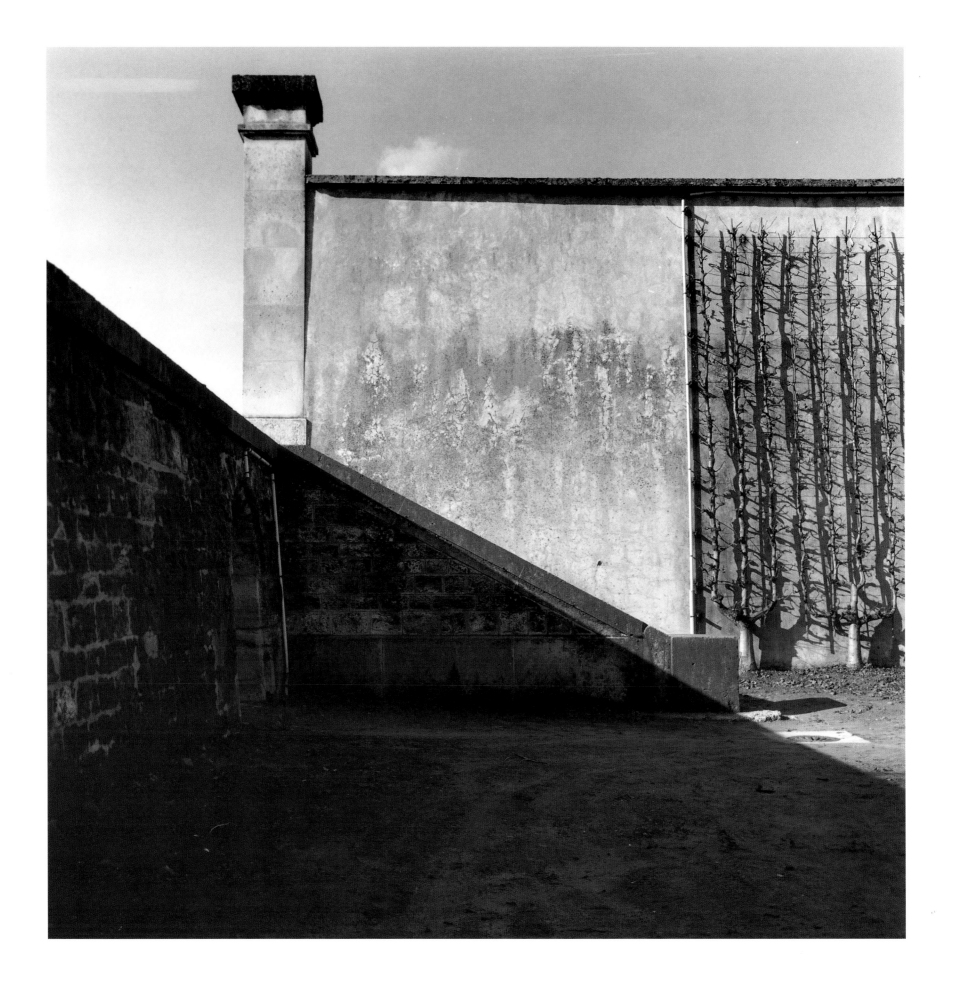

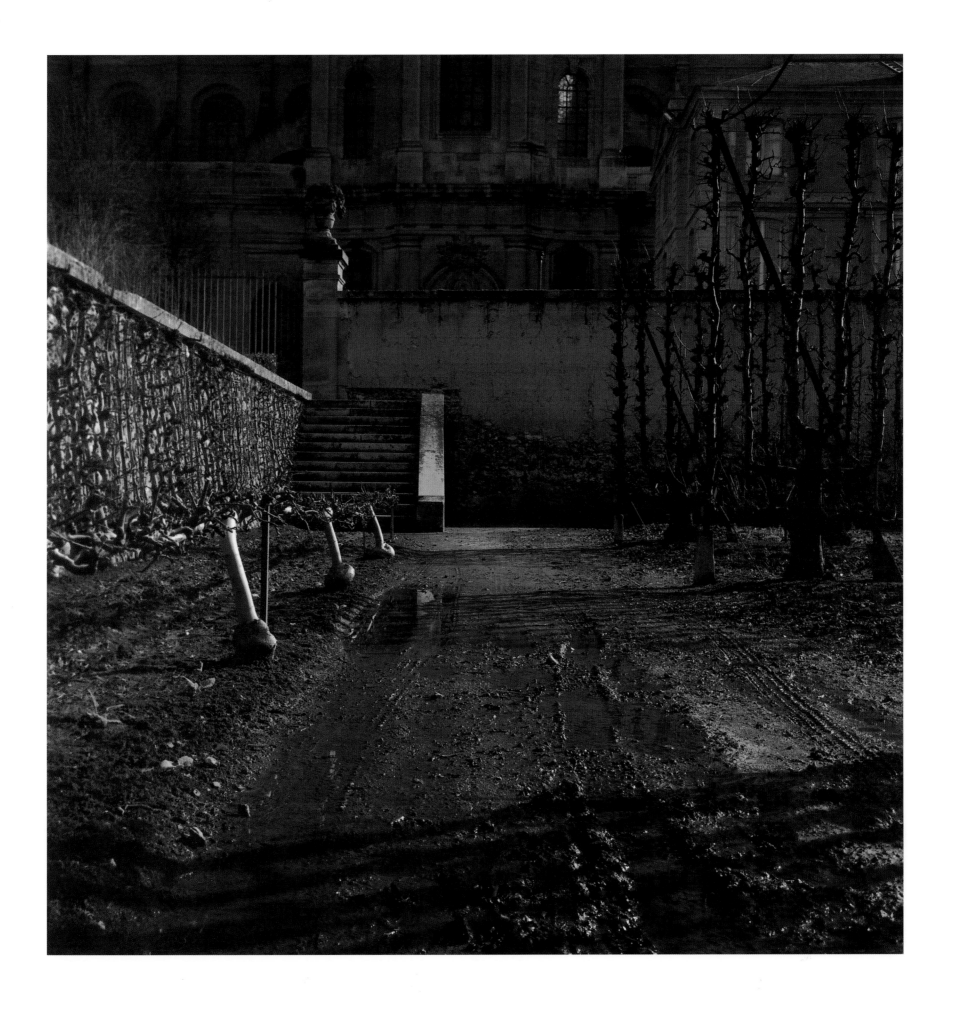

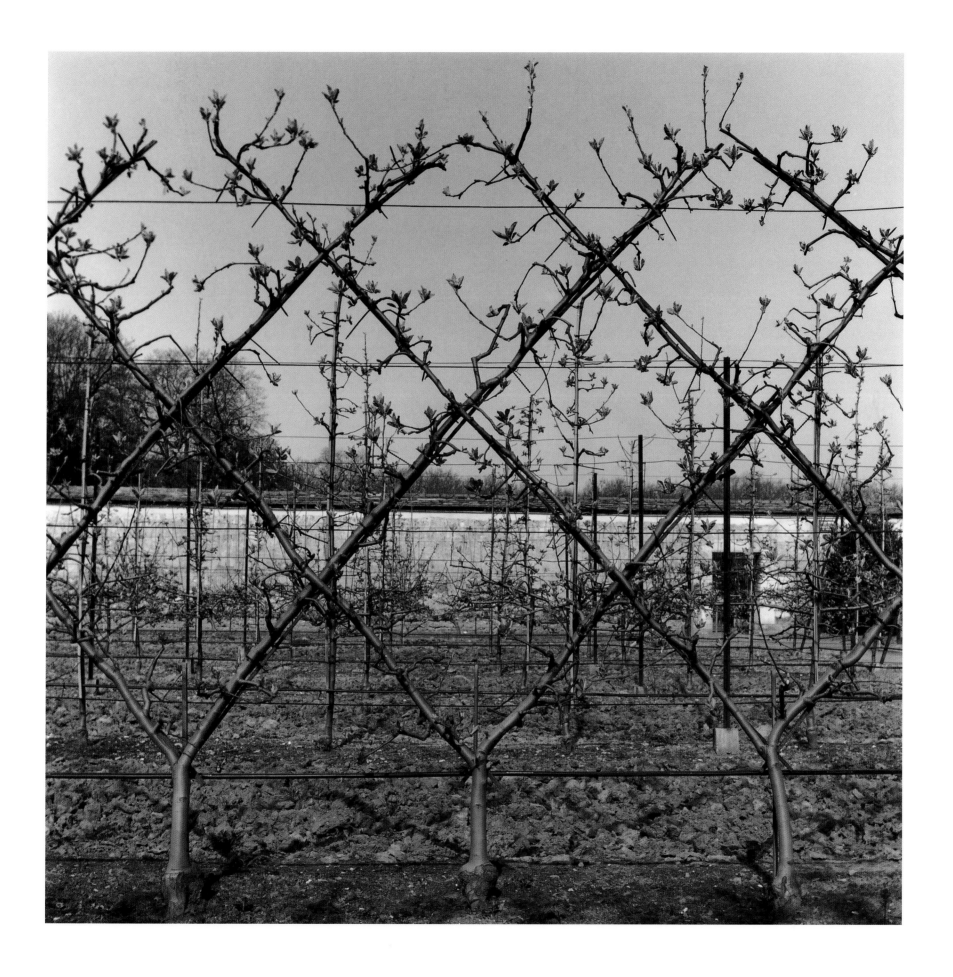

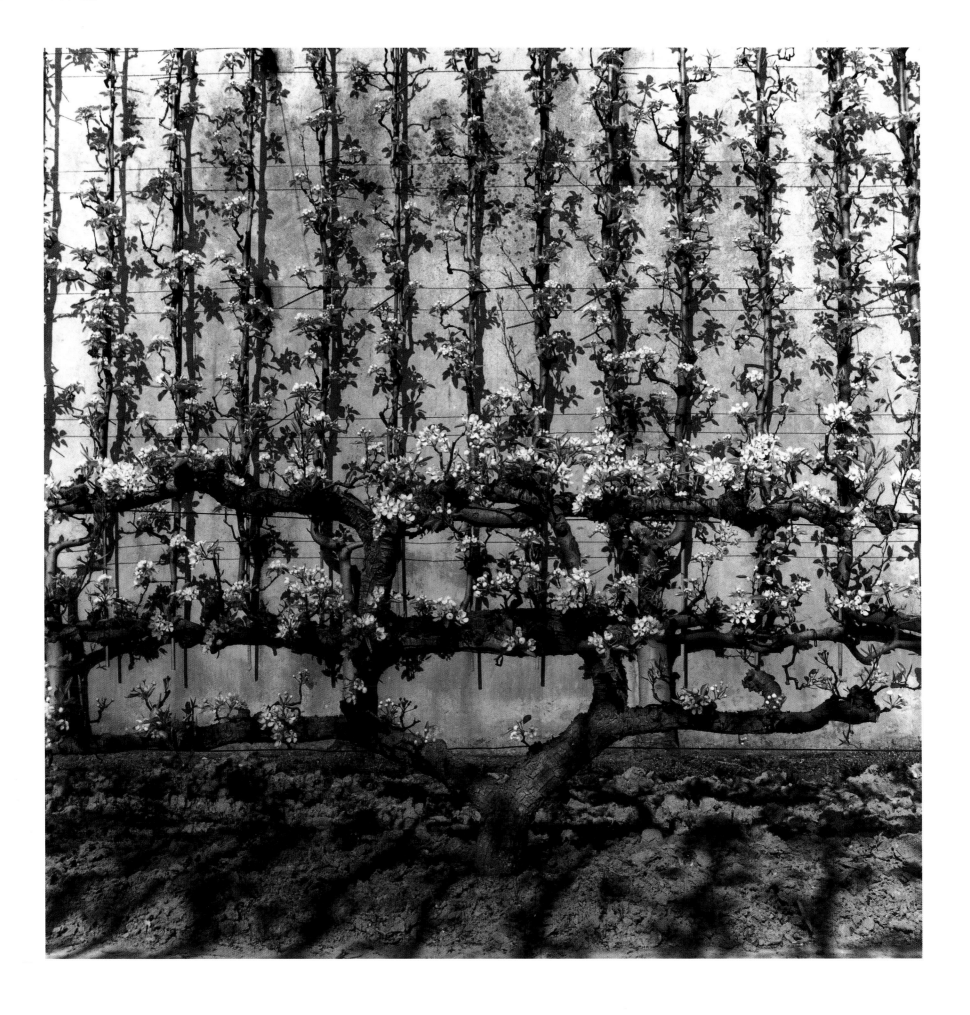

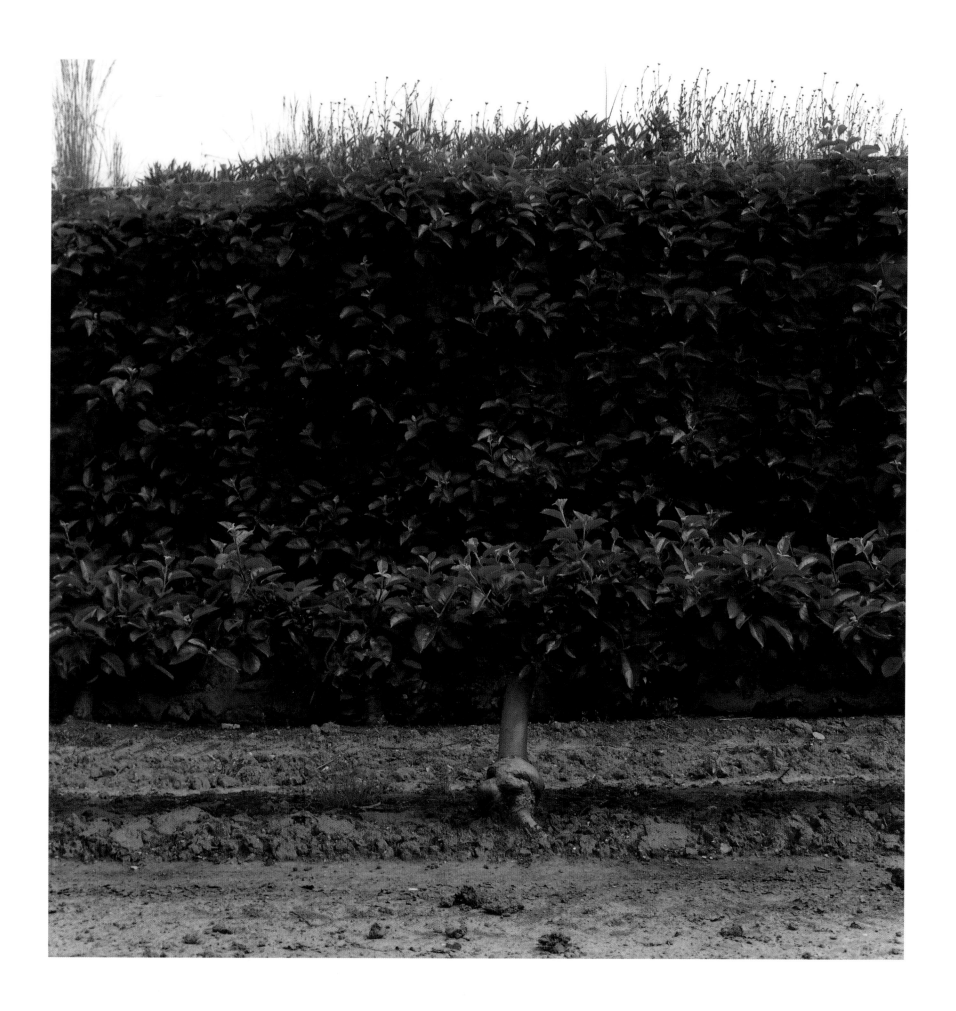

GARDENS AS METAPHORS

SHIRIN NESHAT

In my country, Iran, gardens are highly symbolic. In both Persian and Islamic traditions, gardens are significant both physically and metaphysically. Deserts occupy much of the Iranian geography, so the visual and physical experience of a green space in the midst of such landscape becomes extremely precious and psychologically intoxicating.

The great poets and mystics in Persian mystical literature, such as Hafiz or Rumi, have referred to the garden as "paradise," a space for spiritual transcendence where one becomes relieved from all worldly attachments and can truly seek union with God. Persian miniatures are direct visualizations of such literature, with the narratives often involving and depicting elaborate and exquisite gardens that suggest the image of paradise. Ironically, the metaphoric value of the garden is not confined to this mystical tradition; it commonly appears in our political terminology as well. We often refer to the garden as the place for freedom and/or independence.

In my brief film *Tooba*, I had in mind all the above associations. Most of all, however, I based the film on the myth of Tooba that originates from the Koran, where it is referred to as the "tree of paradise" or the "promised tree." We are told that Tooba has its roots in heaven and branches in the sky and that it dwells in three worlds: heaven, earth, and the underworld. As a commonly understood mythology within the popular culture, Tooba is also a female; therefore Iranians always discuss and imagine Tooba as a tree/woman.

Tooba conceptually evolves around a space—a garden—that has the tree of Tooba (tree/woman) at its center. This space is progressively threatened and eventually invaded by a large crowd of men and women. With minimal narrative, the film functions more as a visual poem than a narrative film. The dynamic here lies between the forces of the opposites—what lies inside (peace/serenity) and what waits outside (violence/reality). Eventually this leads to the disappearance of the female, the "magic" of the Tooba tree!

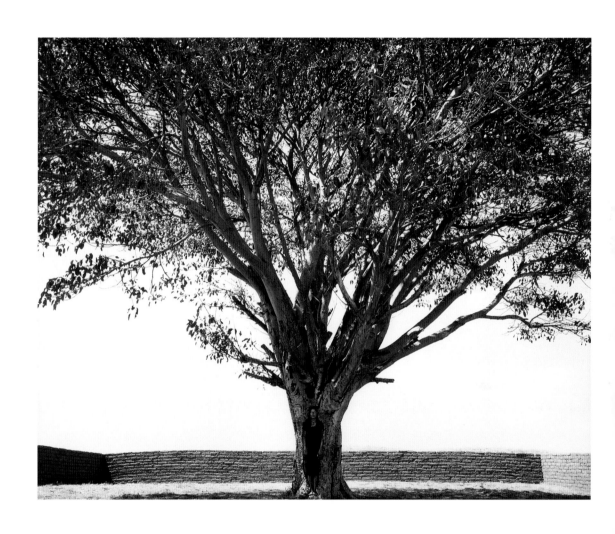

Shirin Neshat, *Tooba*, 2002. Production still.
Courtesy Barbara Gladstone. Copyright Shirin
Neshat. Photo Larry Burns

THE PROMISE OF A GARDEN

RONALD JONES

THE TREES ALONG THIS CITY STREET,
SAVE FOR THE TRAFFIC AND THE TRAINS,
WOULD MAKE A SOUND AS THIN AND SWEET
AS TREES IN COUNTRY LANES.

AND PEOPLE STANDING IN THEIR SHADE
OUT OF A SHOWER, UNDOUBTEDLY
WOULD HEAR SUCH MUSIC AS IS MADE
UPON A COUNTRY TREE.

OH, LITTLE LEAVES THAT ARE SO DUMB
AGAINST THE SHRIEKING CITY AIR,
I WATCH YOU WHEN THE WIND HAS COME,—
I KNOW WHAT SOUND IS THERE.

EDNA ST. VINCENT MILLAY, "CITY TREES"

Edna St. Vincent Millay designed and tended the gardens at the abandoned farm she bought in May of 1925. Extensive renovations were underway by July, when she christened her home Steepletop, a name taken from the common wildflower that grew up everywhere around the farmhouse. She designed her gardens to feature rose beds, harebell, Festiva Maxima, wild red columbine, and oriental poppies, with maples, evergreens, and apple trees edging the lawns. Millay had frequent visitors to Steepletop during the thirty or so years she lived there; being in Columbia County, it was convenient to New York. Every guest to Steepletop seemed to carry away more admiration than they arrived with; her gardens were in no small part responsible. Among her guests was Igor Stravinsky, whom she had met during a reception in her suite at the St. Regis Hotel when she traveled to New York to be elected into the Academy of Arts and Letters in November of 1940. She invited him to visit her at Steepletop later that month, which was opportune, because Stravinsky would be shortly visiting Cambridge, where he had delivered the Charles Eliot Norton Lectures at Harvard the year before. He would come to Steepletop straight from the college. Coincidentally, the day before the reception, Millay's husband, Eugen Boissevain, had been introduced to a composer from Seattle, John Cage—only twenty-eight at the time—and invited him to the estate. And so it was that Cage met Stravinsky for the first and only time.

By November of 1940 Millay was unwell, addicted to morphine, gin, and cigarettes, which fueled her unbridled obsession with the war in Europe. Yet the weekend arrival of the two composers offered her relief. Their conversations provided a diversion from her fanatical attention to the radio broadcasts from the front, though not

from the gin. From Friday afternoon until Sunday lunch, she and Eugen drank Gin Rickeys and smoked Egyptian cigarettes, immersed half in the alcohol, half in the conversations between Cage and Stravinsky.

A lengthy letter from Eugen to Arthur Ficke recounts this weekend visit to Steepletop, and especially the conversations that went on that Friday. My account is largely based on Eugen's letter.

Cage did not drink, but Stravinsky, who ignored the persistent offers of gin, managed to find some red wine in the house, and the foursome settled into the living room. Edna toasted her guests and then brought up the war, the Nazi bombing that had heightened over London in the summer just past, and all the rest, but Stravinsky, who had escaped Germany just the year before, found the conversation too unsettling. With a second glass of wine, the older composer, fresh from Harvard, came into a mood to lecture the others with wide-ranging and captivating topics. He was as winning as he was charming. *Authentistic* music, his immense respect for Balanchine, the present work on his new symphony—undoubtedly the Symphony in C Major—and the appeal of Hollywood, where he would soon move with his new wife, the artist Vera de Bosset, were only a few of the subjects he carried off. While Stravinsky filled another glass, Cage, who had studied with Arnold Schoenberg, offhandedly remarked that Los Angeles had somehow produced a remarkable and unforeseen effect on Schoenberg's compositions; he felt particularly so with regard to his teacher's realization of dissonant passages that seemed resolved to the ear. In a sense, he observed, they had become harmonic. Stravinsky immediately objected to the idea that dissonance could be harmonic. He asked Cage to admit that all of it was hardly clear. Ever since it appeared in the vocabulary—by now Stravinsky's voice was on the rise—the word "dissonance" carried with it a certain odor of sinfulness. Cage managed to get off a word or two of lackadaisical doubt before Stravinsky single-mindedly argued that consonance was the combination of several tones into a harmonic unit, while dissonance resulted from the deranging of this harmony by the addition of tones foreign to it. "Light your lantern," he told Cage. Dissonance is an element of transition, an interval of tones that is not complete in itself and that must be resolved to the ear's satisfaction into a perfect consonance.

But why can't the interval be complete as is, Cage asked. Although no one sitting in the living room at Steepletop could have known, Cage had begun lecturing on music to the Seattle Arts Society in 1937, and his ideas that would eventually become celebrated were already well formed. Not wanting to offend the distinguished composer, or his hosts, he made his points in the gentlest terms, slyly diverting the discussion toward what must have seemed more relevant to him at the time. Another way to think about dissonant harmony, Cage explained, is that wherever we are, what we hear mostly is noise. Granted, when we ignore it, it is because it disturbs us—it is, in a word, "dissonant"— but when we listen to it, we find it fascinating. He stood up and gave examples: the sound of a truck at fifty miles an hour, static between the radio stations, rain. I want to capture and control these sounds, to use them not as "sound effects" but as musical instruments. With a film phonograph, he went on, it is possible to control the amplitude and frequency of any one of these sounds and give to it rhythms within or beyond the reach of our imaginations! He walked over, emptying the bottle of red wine into Stravinsky's glass, to say with assurance that he would make music through the aid of electronic instruments and that it would be music where dissonance would not suffer from sin. Edna laughed out loud.

As Cage spoke, somehow Eugen managed to cross the room with another pitcher of Gin Rickeys. He lowered himself into position next to Edna, and began to pour once more. With time and nothing offered that would assuage the alcohol, the pacing of conversation began to stagger. Stravinsky went to a window, stared out across the elaborate rose beds, beyond the lines of fallen oriental poppies and surveyed Edna's sumptuous stretch of gardens. The November sun would set in little more than an hour. His eyes fell to the carved birdbath.

FIG. 1

Let me take the most banal examples, the natural sounds—your noise—he said directly to the window, and then stopped. With pause, he began once more. The song of a bird, the wind whispering through the trees on a country lane or city street, well, we may even say: What lovely music! Naturally we are speaking only in terms of comparison. But then, *comparison* is not *reason*. These natural sounds suggest music to us but are not yet themselves music. If we take pleasure in these sounds by imagining that on being exposed to them we become musicians and even momentarily creative musicians, we must admit that we are fooling ourselves. They are promises of music; it takes a human being to keep them: a human being who is sensitive to nature's many voices, of course, but who in addition feels the need of putting them in order and who is gifted for that task with a very special aptitude. Tonal elements become music only by virtue of their being organized; such organization presupposes a conscious human act. There was another extended pause while all four gazed through the bank of windows watching the long shadows reach out across the gardens.

So it is with Edna's splendid gardens, John, Stravinsky said, turning toward the young composer. The natural landscape there beyond the row of maples is not yet a garden; it is only the promise of a garden and through the selection and composition of their elements and materials gardens are made. To compose is to adjust the equilibrium and unpredictability between trees, poppies, the grasses, and human order, between light and shadow, between the breeze and calm—to create relations that provide meaning for those who can appreciate what Edna has created.

After a few moments, Cage broke the spell of the setting sun. Then which *is* to be appreciated more, Mr. Stravinsky: the wild red columbine Edna has planted around each of the maple trees, or the volunteers of wild red columbine that have sprung up there along the edge of the forest? Hush followed. And there is my point sir. Cage sat down. There was more tension in the room than anyone would have liked; and so with the sun nearly gone, Edna managed to stand, and erupting in the midst of the soothing twilight she delivered a spewing alcoholic toast in the form of a limerick dedicated to the sun, her gardens, and the forest just beyond. Everyone could giggle at the drunken rhyme; Stravinsky held the second bottle of red wine under one arm and raised his glass with the other. Cage had his cup of tap water in the air, and after the toast it was time for another pitcher of Gin Rickeys.

Into that evening and for the whole of the weekend, conversations drifted steadily from music toward the incongruity between Edna's gardens and the surrounding natural landscape. When they left Steepletop at Sunday

noon, Eugen reported to Ficke that the matter had not edged closer to a détente between the two, and notes that if the conversations about gardens had begun as veiled arguments over music, they did not end that way. On that weekend the key exchanges between Stravinsky and Cage were explicitly about creating artistic gardens, as opposed to the passive enjoyment of nature. Eugen's letter does not offer a complete account of those conversations, but acknowledges that gardens and landscapes centered every word.

∽

It is extraordinarily rare that someone can say precisely when an idea took hold of them, but as I sat in the St. Vincent Millay archives reading Eugen's letter narrating the Stravinsky/Cage encounter, it became apparent to me how gardens could provide a creative instrument for my practice as an artist. Gardens possess all of the elements any artist would likely be pleased with: Beauty, History, Eternalness. And of course they convey these qualities for precisely the reason Stravinsky drew the distinction between noise and music: they result from a conscious human act. While gardens are often miscalculated as merely the hosts of pleasurable pastimes, or worse, a kind of visual muzak, they exhibit artistic decisions that unfold with both an iconography and iconological meaning; they spring with creative expression, but as well with social, religious, or even political content. And so, while reading about the weekend at Steepletop, I realized that were this elapsed content suddenly brought forward, it would be magnified by its abrupt intrusion on an audience already secure that they had escaped the issues of the day by strolling or sunning themselves within the refuge of passive pleasure that gardens have come to embody.

Upon leaving the archive and walking downhill through the small park across the street, I thought back to the renowned botanic garden at Oxford. Cage would like to have known that the garden at Oxford was egalitarian; weeds were cultivated alongside the most enchanting plants. Botanic gardens are an index of discovery, an encyclopedia of plant life from every continent, and therefore a consummate expression of Stravinsky's *conscious act*. It is not surprising that botanic gardens were at their height just following the discovery of the New World, and the arrival of every new specimen was greeted with exhilaration. The garden at Oxford was opened in 1632, but some of the other celebrated botanic gardens, like those in Padua, Leyden, and Montpellier, were founded as early as the sixteenth century. In its original design, the botanic garden at Oxford was square and subdivided into quarters. This simple plan had symbolized the four corners of the earth for more than two thousand years, but this garden had to account for the discovery of America, and so the meaning of the plan was revised to represent the four known continents. Segregated within each of the quads were plants from Europe, Asia, Africa, and America, which were then further subdivided by family within narrow beds known as *pulvillus,* where the array, from exotic fruits to common weeds, could be studied or admired.

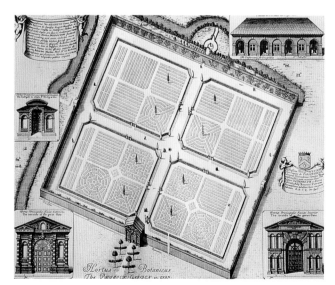

FIG. 1 University of Oxford Botanic Garden with Magdalen College Tower, Oxford, England. Courtesy University of Oxford Botanic Garden, England

FIG. 2 Plan of the University of Oxford Botanic Garden, Oxford, England. Courtesy University of Oxford Botanic Garden

FIG. 2

Today botanic gardens often survive as part scientific index and part pleasure grove, and so it would be natural for anyone to imagine that their origin was as a record of discovery created in the dawn of modern science

four hundred years ago. But in fact the original motivations for botanic gardens were wholly religious, rather than scientific. The first botanic gardens were founded to re-create Paradise, to reassemble the lost Garden of Eden. Oxford tutor John Prest neatly summarizes the facts: "Throughout the middle ages the Garden was believed, somehow, to have survived the Flood, and in the great age of geographical discoveries in the fifteenth century, navigators and explorers had hopes of finding it. When it turned out that neither East nor West Indies contained the Garden of Eden, men began to think, instead, in terms of bringing the scattered pieces of the creation together into a Botanic Garden, or new Garden of Eden." And so while the Oxford garden was an expression of the great age of discovery, it was only insofar as it served to recreate Eden's *perpetual Spring*, and show the face of God. Stravinsky would have approved.

In the case of the Oxford garden, the finger of history deftly moved the register of meaning from something apparently practical—a botanical inventory—to something seismic—Paradise—and all at once, truth was unveiled. The style of this garden: unforeseen and startling meaning springing from what appears routine, has recurred within my own artistic practice for years. I am thinking back to a particular sculptural tableau, *Untitled* (1990), where a table can no longer be the unremarkable table it is because it is revealed to be the very table that appears just behind the electric chair in Andy Warhol's fêted paintings. That celebrity status is tempered by the unnerving detail that it is therefore the table where 614 autopsies were performed immediately following 614 executions so that Sing Sing physicians could judge the degree of havoc the electricity had performed on internal organs. Those gory assessments took place during the "hit and miss" period of the electric chair's history, when it fell to physicians to settle on the most efficient voltage. For more than a few reasons I have always appended a passage from Albert Camus's savage essay, "Reflections on the Guillotine," to the meaning of this sculpture.

FIG. 3

In that essay, he writes about fracturing the pall of compliance we feel toward executions: "The survival of such a primitive rite has been made possible amongst us only by the thoughtlessness or ignorance of the public, which reacts only with the ceremonial phrases that have been drilled into it. When imagination sleeps, words are emptied of their meaning . . . But if people are shown the machine, made to touch the wood and steel and to hear the sound of the head falling, then public imagination, suddenly awakened, will repudiate both the vocabulary and the penalty." It seems true enough that the complete horror of a bloody head dropping to the floor is a consequence art is not prepared for, but as the table in the tableau makes evident, there are other means available to suddenly awaken the experience of truth Camus aspired to, and transform meaning.

Gardens are just such a means. Of the nine parks and gardens I have designed since that day in the archives, the one I have had in mind while writing this essay is the project titled *Caesar's Cosmic Garden*. It has been commissioned three times, for sites in Brazil, Sweden, and Germany. In each instance the public is presented with what, from all outward appearances, is a tidy formal garden comprised of four quads, centered by a tree. The garden design appears familiar, even unremarkable, except that a stroll though the garden inevitably presents the visitor with a plaque that conveys the essence of the following story.

Of all the aerial photographs taken of Auschwitz-Birkenau during the final year of the war, one stands out above all the others. The photograph I have in mind was taken on August 25, 1944, and was obviously intended to document the Gas Chamber and Crematorium II in the southwest corner of the camp. Like the others, this picture bore labels applied by allied photo interpreters that identified buildings and various incriminating sites. Mostly they were labels one would expect to find on this sort of picture: "gas chamber," "undressing room," and "possible cremation pit." But one label was unexpected. Gazing down into the picture it is clear to see that within a few yards of the crematorium there was a formal garden whose design is easily recognizable as the traditional cosmic plan. The photo interpreters did not decipher its plan, but choose to label the garden descriptively: "LANDSCAPE." Traditionally, the center of a cosmic plan represents Eden and is created out of four intersecting paths that represent the rivers of Paradise, a version of what is at Oxford. Typically a tree, representing the Tree of Life, or a fountain, will appear at the garden's center. The designers of the garden for Crematorium II chose to feature a tree. Because the garden was situated between the "entrance gate" and the "undressing room," one has to imagine that for hundreds of thousands the unexpected garden provided their final glimpse of the world.

Certainly the garden was planted and maintained by the Abteilung Landwirtschaft or the Agricultural Division stationed at Auschwitz. Under the direction of Dr. Joachim Caesar, the Abteilung Landwirtschaft had become an

FIG. 3 Ronald Jones, *Untitled,* 1990.
This table, which appears in Andy Warhol's *Electric Chair* (1963), was positioned in the execution chamber just behind the electric chair at Sing Sing Prison, New York. The table was used for autopsies that immediately followed each execution. One prison official estimated that as many as 614 autopsies were conducted on this table. Sitting on the table is the oxygen connector for the Apollo A–7 11 lunar space suit worn by Eugene Cernan during the December 1972 Apollo 17 mission in which he spent 44 hours of exploratory activity on the moon. Cernan and Harrison Schmitt landed at 20 10' N, 30 45' E in the Taurus-Littrow region of the mountainous highlands bordering southeastern Mare Serenitaitis. Cernan, the last man on the moon, took his final step saying: "We leave as we came, and God willing as we shall return, with peace and hope for all mankind.

Patinated bronze, paint on wood, 35 × 31½ × 51½ in. Edition 1/3. Courtesy the artist and Metro Pictures (MP 39)

FIG. 4 Astronaut Eugene Cernan saluting the flag during the Apollo 17 mission in 1972. Photo courtesy NASA

FIG. 4

important enterprise within the camp as early as 1941. Himmler, who had been an agriculturist, looked favorably upon Caesar's creation of the Landwirtschaftskommando, which was made up of prisoners assigned to cultivate the camp's landscape. One of the important duties of the Landwirtschaftskommando was to plant tall hedges around many of the gas chambers and crematoria, including Gas Chamber and Crematorium II. The hedges or Grüngürtel (Greenbelt) were put up to disguise the inevitable from the uninitiated. Plainly said, camp administrators feared that the awful reality masked by the hedge would unnecessarily alarm those being marched to the showers. The cosmic garden was planted after the hedge went in around Gas Chamber and Crematorium II, and therefore the timing invites the conclusion that the garden was originally intended only for the eyes of those about to be gassed. Who decided to plant this garden, creating this small intersection of paradise within the belly of evil?

This poignant question has never been far from my mind since I first saw the aerial photograph. And it is partially answered in Harold Bloom's comparison of the aspiration of Milton's Satan with a poet's artistic desire in *The Anxiety of Influence*. Bloom reports that there was no flinching when Satan faced up to his circumstances upon his arrival in Hell. He was a dignified realist: "either repent and surrender your selfhood," Satan reasoned, "or create a relative goodness out of radical evil." Who was the dignified realist who authored the garden behind the hedge at Gas Chamber and Crematorium II? It was certainly a member of the Landwirtschaftskommando. Typically, those assigned to the Landwirtschaftskommando were not immediately marked for death but were often like Anna Urbanova, a German Catholic who was condemned to Auschwitz as a political dissident. Unlike most of those who arrived at Auschwitz, Anna possessed an option exceedingly rare within concentration camps. It was the same option thrust upon Milton's Satan. Anna and the others who built the cosmic garden could "repent," relinquishing their selfhood in order to join with their oppressors, or sustain their free will by exploring the limits of damnation, hoping to find a relative goodness. The cosmic garden at Gas Chamber and Crematorium II traces the limits of damnation and resonates with salvation only available near the monstrous heart of radical evil.

> Oh, little leaves that are so dumb
> Against the shrieking city air,
> I watch you when the wind has come,—
> I know what sound is there.

Dedicated to LHM.

FIG. 5

FIG. 5 Electric Chair at Sing Sing Prison,
Ossining, New York. Photo courtesy
Ossining Historical Society Museum

GARDENS

ROBERT HARRISON

For millennia and throughout world cultures, our predecessors conceived of human happiness in its perfected state as a garden existence. It is impossible to say whether the first earthly paradises of the cultural imagination drew their inspiration from real, humanly cultivated gardens, or whether they in fact inspired, at least in part, the art of gardening in its earliest aesthetic flourishes. Certainly there was no empirical precedent for the "garden of the gods" in the epic of *Gilgamesh*, described in these terms: "all round Gilgamesh stood bushes bearing gems . . . there was fruit of carnelian with the vine hanging from it, beautiful to look at; lapis lazuli leaves hung thick with fruit, sweet to see. For thorns and thistles there were haematite and rare stones, agate, and pearls from out of the sea."[1] In this oldest of literary works to have come down to us, there is not one but *two* fantastic gardens. Dilmun, or "the garden of the sun," lies beyond the great mountains and bodies of water that surround and enclose the world of mortals. Here Utnapishtim enjoys the fruits of his exceptional existence. To him alone among humans have the gods granted everlasting life, and with it repose, peace, and harmony with nature. Gilgamesh succeeds in reaching that garden after an arduous and desperate journey, only to be forced to return to the tragedies and cares of his earthly city, for immortality is denied him.

Albert Camus, who grew up on the shores of Algeria before joining the French Resistance in Europe, once remarked: "History taught me that all is not well under the sun; the sun taught me that history is not everything." If ever history—with its rage, death, and endless suffering—were to become everything, human beings would succumb to madness. History is reality, and, as one of the characters in T. S. Eliot's *Murder in the Cathedral* puts it, "humankind cannot bear very much reality." This is not a shortcoming on our part; on the contrary, our refusal to be tyrannized by history's realities sponsors much of what makes human life bearable: our religious impulses, our poetic and utopian imaginations, our moral ideals, our metaphysical projections, our storytelling, our aesthetic pleasures, our passion for games, our delight in nature. For Camus it was the sun, yet more often than not in Western culture it has been the garden, whether real or imaginary, that has provided a sanctuary from history. The gardens may be as far away as Gilgamesh's Dilmun or the Greeks' Isle of the Blessed or Dante's Garden of Eden at the top of the mountain of Purgatory; or they may be on the margins of the earthly city, like Plato's Academy, or the Garden School of Epicurus, or the villas of Boccaccio's *Decameron*. They may even open up in the middle of the city, like the Jardin du Luxembourg in Paris or the Villa Borghese in Rome. In one way or another, however, gardens, in their very concept as humanly created environments, stand as a kind of haven, if not as a kind of heaven.

This does not mean that their enclosed worlds do not invariably bear the traces of history in their real or imaginary features. When Voltaire ends *Candide* with the famous declaration "Il faut cultiver notre jardin," the garden in question must be viewed against the background of the wars, pestilence, and natural disasters evoked by the novel. The emphasis on cultivation is essential. It is *because* we are thrown into history that we must cultivate our

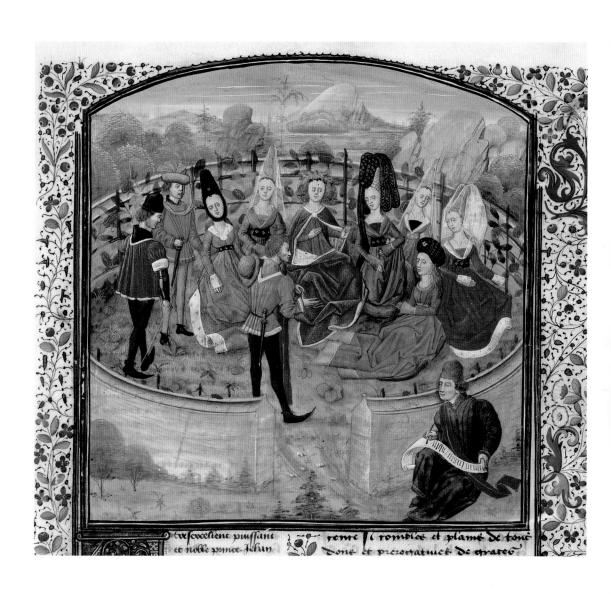

The Storytellers of "The Decameron."
Manuscript illumination in tempera on
parchment, 15⅜ × 11¾ in. Courtesy Bodleian
Library, University of Oxford, England
(MS. Douce 213, fol. ir.)

garden. In Eden there is no need to cultivate, since all is pre-given. Where history unleashes its destructive and annihilating forces we must—if we are to preserve our sanity, to say nothing of our humanity—work against and in spite of them. That is what it means to cultivate for Voltaire—to seek out the healing or redemptive forces (work, cooperation, reason, charity, tolerance) and allow them to grow in us. His is not a garden of private concerns into which one escapes; it is that place within the self or the social collective where the ethical, cultural, and civic virtues that save reality from its own worst impulses are nourished, through moral and intellectual education. Education is a form of spiritual gardening.

Every garden, however humble, represents an affirmation of sorts. Is there such a thing as a purely escapist garden? One thinks of Epicurus, who withdrew from society and turned his back on the city, yet even the garden in which he founded his school was no mere asylum (although it was, like all gardens, a haven). To begin with, the disciples cultivated it assiduously and lived (very frugally) off its modest offerings. Yet there was also a higher, philosophical purpose to their gardening activity, namely, to learn the inner workings of the cosmic order and harmonize themselves with the forces of creation. The garden provided not only the setting but the very exemplar—call it the objective correlative—of the laborious self-cultivation that was necessary to attain the serenity and enlightenment of *ataraxia*. Such a goal required perseverance and discipline; and like the garden itself, it would yield its rewards only in due time.

There is no doubt a tension, or anxiety, at the heart of Epicurian *ataraxia*, understood as the goal of spiritual self-cultivation. The Epicurians, who worked their gardens on a daily basis, knew that gardens require constant vigilance and labor to keep the forces of nature at bay, or under effective control. Under the apparent order and self-gathered calm of the garden lurk the ever-present threats of entropy, decay, and ruination. The freedom from anxiety that defines the state of *ataraxia* requires a similar vigilance if it is to avoid falling back into the worldly perturbations from which it seeks deliverance. This is a dilemma shared not only by the Epicurians but by all those who embrace philosophy's striving after wisdom as a way of life. And what is wisdom if not a state of spiritual tranquility arising from the mastery and control of one's passions? If philosophy in general has had such a long history of association with the garden—from the grove academies of the Greeks, to the Ciceronian villas of the Romans, to the medieval bowers of Saint-Germain—it is in part because of this constant vigilance and labor required by its ideals of self-cultivation, a self-cultivation removed, but not detached, from the sound and fury of the world.

As long as there is a need to cultivate—be it ourselves or our gardens—we remain bound to, although not bound in, history. Gardens enchant us only to the degree that they exist in relation to, or side by side with, the profane worlds beyond their enclosures. Perhaps that is why we got ourselves thrown out of Eden in the first place—because without history to torment us there was no way to take pleasure in an earthly paradise. But more on that later. Let us shift the scene for a moment to Boccaccio's *Decameron*. In this masterpiece of world literature, composed two years after the Black Death of 1348, ten young Florentines leave behind the plague-ravaged city of Florence and retreat to a villa in the surrounding hills, where for two weeks they engage in leisurely walks, dancing, storytelling, and merrymaking. Nothing could be more antithetical to the horrors provoked by the plague in Florence than the idyllic garden settings in which *The Decameron's* one hundred stories are told. Yet here, too, it would be inaccurate to speak of escapism. We should speak rather of an ideal humanism. These gardens, after all, are manmade, infused and pervaded by the spirit of human art. If the plague persists long enough and claims ever more victims, the entropic forces will eventually get the better of their well-manicured appearance; but for the moment their grounds offer evidence of what human cultivation is capable of bringing into being: environments

that quiet the savagery of the human heart and promote a spirit of generosity. In this setting the brigade effectively recreates in an ideal mode the bonds of community that have utterly collapsed in Florence, where the neighbor now represents a threat and family members flee from their infected kin, leaving them to face their death agonies alone and without succor. Here they also cultivate the art of storytelling, which in Boccaccio's hands strives for the aesthetic decorum of the surrounding gardens. A story is like a garden. It has its distinct delineaments, its byways, its unfolding perspectives, its intrigues and surprises, its sinister undersides; and most important for Boccaccio, if the story is well conceived and well told, it delights. Good storytelling enhances human interaction the way gardens enhance nature (in the gardens of *The Decameron*, art has collaborated with, not dominated, nature). That is why, for Boccaccio, storytelling is no mere diversion but represents a social, if not moral, obligation to one's fellow man. What would human societies be without good storytelling? Wastelands of reality.

The Decameron takes place over a two-week period, after which the young Florentines return to the city. Sooner or later such a return is necessary, otherwise the delights, diversions, and divagations of the garden can degenerate into irreality. This balance between obligation and reprieve, history and sun, Florence and Fiesole, is a difficult one to maintain; yet it must be maintained, for if reality can have a Medusa effect on those who look too directly and intently on its horrors, the garden can have a Circe effect, as it were, on those who fall under its fantastical, call it phantasmatic, spells. This is the danger posed by the enchanted gardens that so captivated the medieval and Renaissance imagination—gardens of illusion where the hero (usually a knight) typically succumbs to the bewitching charms of the resident sorceress. Here things are not what they seem: all is false semblance. Everything is designed to appeal to the native capacity and desire for illusion that lurks in us all. On Alcina's enchanted island, for example, in Ariosto's Renaissance epic *Orlando Furioso*, the gems are not real gems, the plants are not real plants, and the beautiful Alcina herself—so irresistible to the knights she lures into her gardens—is eventually revealed to Ruggiero (the epic's hero) for what she really is: an ugly and loathsome hag. Alcina's garden is neither made nor cultivated by human labor. It is created by magic, and is therefore sterile. Indeed, the garden is made up of Alcina's former, now disillusioned lovers, who have been transformed by her magic into the fauna and flora of the place.

Gardens have been associated with the feminine since the night of time, when women created the world's first cultivated enclosures; yet the association is particularly powerful when it comes to enchanted gardens, which ensnare, emasculate, and denature the male hero, deviating him from his larger, noble purpose in life (but is it so noble after all? It is in any case purposeful). The classical precedents for the feminizing and even dehumanizing powers of the enchanted garden are the island of Circe in Homer's *Odyssey*, where Odysseus's men are transformed into swine, and the city of Carthage in Virgil's *Aeneid*, where Aeneas, seduced by the blandishments of the queen and a life of leisure, is derailed from his mission to found the future city of Rome. When Mercury arrives at Carthage to redirect Aeneas on his divinely ordained mission, he finds that the Trojan's sword

> was starred with tawny jasper, and the cloak
> that draped his shoulders blazed with Tyrian purple—
> a gift that wealthy Dido wove for him;
> she had run golden thread along the web.[2]

Orlando Furioso recalls this moment in the scene where Melissa comes to rescue Ruggiero from Alcina's island, where Ruggiero, like Aeneas, wears the evidence of his feminization:

> his soft and gorgeous garments,
> wrought with silk and gold

by Alcina's subtle hand,
were full of ease and wantonness.[3]

In the cases of Odysseus, Aeneas, Ruggiero, and other heroes who have been thus arrested, it is history, destiny, and the claims of manhood that call them forth from the snares of their enchantment. The story must move forward, cities must be founded, enemies must be battled, in short the hero's purposeful drive must be freed from the paralysis of the garden's spell. If it is true that humankind cannot bear very much reality, it is equally true that humankind cannot do without a measure of reality.

The degree to which this is the case can be gauged by the behavior of the knights whom Ruggiero's triumph over Alcina frees from the enchanted island, where they had lost their humanity and become plants. Upon their release, the knights come to Logistilla's realm. If Alcina's island is a false earthly paradise based on illusion, Logistilla's garden, created and tended by Logistilla herself, is the real thing. Here there are no incantations, no false jewels or flora, no deception. The verdure is "perpetual," as is the "beauty of the eternal flowers." All is peace, benevolence, and tranquility. Yet this veritable earthly paradise offers little attraction for Ruggiero and the other liberated knights. A day or two after arriving there, they leave its serene and unchanging environment of their own accord to rejoin a world that offers risks, challenges, rewards, danger, deception, contingency—in a word, a world of action. Certainly Ariosto's poem does not linger very long in Logistilla's garden—no more than the liberated knights do. For a poem that sings of "ladies, knights, arms, loves, manners and brave enterprises," Logistilla's garden is where the poem comes to die, for the poem's element is the whirlwind of history, the vortex of illusion, the compulsions of desire, and the relentless pursuit of elusive, profane, and ever-receding goals.

Although Logistilla's and Alcina's gardens are antithetically opposed in Ariosto's poem, both share a certain sterility—Alcina's because it is created by magic and is not real, Logistilla's because its flowers are eternal and its spring is perpetual. The garden of Logistilla is a place where there is "no change of death," where "ripe fruit never falls," and where "the boughs hang always heavy in that perfect sky." The quotes come from a poem by Wallace Stevens that follows the interior spiritual thoughts of a woman sitting in her garden on a Sunday morning. The changeless paradise evoked by Stevens's "Sunday Morning" is effectively dead, precisely because, according to the poem's narrator, it excludes death: "Death is the mother of beauty; hence from her, / Alone, shall come fulfillment to our dreams." In their own obscure way the knights of the *Orlando Furioso* long for a world where there is death, for without death there is no possibility of growth or transformation, hence no possibility of fulfillment. Every cultivator of earthly gardens knows that death is the very principle that moves the cycles of growth and sustains the life of the garden as such. Likewise with human self-fulfillment.

It hardly seems of great significance in the overall polycentric narrative of the *Orlando*, yet the fact that Ariosto's knights promptly and willingly depart from Logistilla's idyllic garden is at bottom quite remarkable. It shows that the earthly paradise, which had long stood as the image of human happiness in its perfect state, had already lost its ancient appeal in the new humanist imagination of the early modern era. Leisure, repose, beauty, eternal harmony with the cosmic order—these values no longer define, even in a phantasmatic mode, the ultimate end point of human desire. Desire now desires more of itself, more of its own restlessness. Indeed, as Bartlett Giamatti showed in his now classic study *The Earthly Paradise and the Renaissance Epic*, by the seventeenth century the image of Eden begins to fade from literature, and by the eighteenth century it is superceded altogether. "Now real gardens embody man's ideals; actual landscapes animate song," he writes, "When the living landscape can reflect what you believe, why invoke the earthly paradise?" Giamatti goes on to claim that "the formal garden of Pope's day was itself supplanted—by the Nature of the Romantics, those vistas into which a man walked

to find his better self and, hopefully, to become reconciled with it." This move from ideal to real gardens, and from real gardens to the wilder "nature" of the Romantics, follows a meandering path that leads to the modern city: "And here is what finally happened to the earthly paradise: it was overtaken by the actual City, as before it had been trimmed into a real garden."[4]

Even Giamatti admits that this is an "oversimplified" account of what happened in the wake of Milton's culminating (and consummating) epic treatment of the Eden myth in *Paradise Lost*, yet there is little doubt that, in the broadest terms, the earthly city wins out over the earthly paradise in the modern imagination. Here we must understand the earthly city expansively, both as the literal metropolis in its new ascendant reality as well as the so-called City of Man generally. The City of Man, which before had stood juxtaposed to the City of God, now assumes its own autonomy and dignity, at least in idea. Secular history breaks free from the containing framework of providential history and becomes self-governing and self-determining. Following in the wake of the humanism of the Renaissance, which exalted the world-creating potential of human beings, an aggressive humanist ideology slowly took hold in various domains—politics, science, letters, etc.—which increasingly brought human destiny under the governance of the human will. We now make and unmake history according to our projected designs.

The gardens of Versailles offer an almost allegorical instantiation of this triumphalist ideology, for they not only glorify the political power of their monarch creator, Louis XIV, who reigns (or so he presumed) over the city of man; they also glorify the absolute sovereignty of human will over the powers of nature. In Versailles nature is tamed, even humiliated, into submission; its formidable powers are subjected to human control and domination. A contemporary of Louis XIV, in reference to the Versailles gardens, speaks of "ce désir superbe de dominer la nature." Here the word "superbe" still has a dark Christian connotation of pride, or *superbia*. This is Satan's sin, which lands him in the lowest depths of Dante's hell.[5] Be that as it may, the gardens of Versailles, in all their superb architecture, belong to the jurisdiction of the earthly city, where man forges, fashions, and literally engineers his destiny by becoming nature's master.

The new faith in human self-determination and perfectibility had precarious foundations at best; and in any case its triumphalist spirit was relatively short-lived. This was due not simply to a stubborn pessimism about the powers of reason to re-found human society on an enlightened basis—the incipient traits of which pessimism are already present in Voltaire's *Candide*, as we have seen—but also to what I would call a dawning "geological" awareness of the insignificance and accidental nature of human history in the cosmic order. Such awareness finds eloquent expression in a late-nineteenth-century poem by Swinburne titled "The Forsaken Garden." Here the speaker describes a garden, on the edge of the sea, which over the course of a century has fallen into disrepair. Its paths are overgrown with weeds, its structures lie in decay, its bygone roses are reduced to thorns. The entropic forces against which any and all gardens contend have reduced it to ruin. The desolation that time has visited upon Swinburne's garden, which stands for all that man makes of himself and his world, is evidence of the ultimate fate of all human constructs. History as a whole is doomed to share the ruin of this forsaken garden. The poem ends with a cosmic vision of nature's erasure of all traces even of history's ruins:

> All are at one now, roses and lovers,
> Not known of the cliffs and the fields and the sea.
> Not a breath of the time that has been hovers
> In the air now soft with a summer to be.
> Not a breath shall there sweeten the seasons hereafter
> Of the flowers or the lovers that laugh now or weep,
> When as they that are free now of weeping and laughter
> We shall sleep..

Here death may not deal again for ever;
Here change may come not till all change end.
From the graves they have made they shall rise up never,
Who have left nought living to ravage and rend.
Earth, stones, and thorns of the wild ground growing,
While the sun and the rain live, these shall be;
Till a last wind's breath upon all these blowing
 Roll the sea.

Till the slow sea rise and the sheer cliff crumble,
Till the terrace and meadow the deep gulfs drink,
Till the strength of the waves of the high tides humble
The fields that lessen, the rocks that shrink,
Here now in his triumph where all things falter,
Stretched out on the spoils that his own hand spread,
As a god self-slain on his own strange altar,
 Death lies dead.[6]

The afterimage of a once thriving garden described at the beginning of the poem becomes, by the end, a pre-ludic image of the eventual but inevitable triumph of geological time over human, historical time. In such a vision the *superbia* of any humanism whatsoever receives its ultimate humiliation.

A similar type of humiliation, although with different causes, occurs in the climactic scene of Jean Paul Sartre's 1938 novel *Nausea*. Here the protagonist Roquentin wanders into a "public garden" *(jardin public)* in the provincial town of Bouville and comes face to face with the loathsome, underlying absurdity of human existence. I use the word "underlying" deliberately, for Roquentin focuses his attention not on the garden as such but on a gnarly chestnut tree whose root, sinking into the ground, offers an image of all that lies absurdly *below* the possibility of explanation. There is no way this root could ever be humanized: "faced with this great wrinkled paw, neither ignorance nor knowledge was important: the world of explanations and reasons is not the world of existence. A circle is not absurd, it is clearly explained by the rotation of a straight segment around one of its extremities. But neither does a circle exist. This root, on the other hand, existed in such a way that I could not explain it. . . . This root, with its colour, shape, its congealed movement, was . . . below explanation." [7] Underneath the deceptive surface of the garden's domestication lies the dreadful, chaotic truth of the chestnut root. Roquentin has seen through the garden's façade to the inhuman reality that underlies the ground on which human beings carry on their business, absurdly and in bad faith.

The *jardin public*, which in *Nausea* serves as the scene for this revelation, is one of the most disenchanted gardens in literature. Roquentin is finally a humanist who cannot give up his humanism, yet who despairs of it. In a visionary moment he sees how the inhuman forces with which the chestnut root is aligned will eventually get the better of the earthly city as a whole:

I am afraid of cities. But you mustn't leave them. If you go too far you come up against the vegetation belt. Vegetation has crawled for miles toward the cities. It is waiting. Once the city is dead, the vegetation will cover it, will climb over the stones, grip them, search them, make them burst with its long black pincers; it will blind the holes and let its green paws hang over everything. You must stay in the cities as long as they are alive, you must never penetrate alone this great mass of hair waiting at the gates; you must let it undulate and crack all by itself.[8]

Sartre was certainly no gardener. Nothing horrified him as much as the vegetable world. Gardens merely mask the horror. Nature, he believed, is our antagonist. All that is left to us, in Sartre's petrifying humanism, is history.

No god, no Eden, no sun, no sanctuaries, only history. History is everything. That is finally the decisive difference between Sartre and Camus, and the reason why the dustbin awaits the one but not the other.

In Malcolm Lowry's great novel *Under the Volcano*, published in 1947, there is a garden scene that brings together many of the various strands of this essay and points the way to a provisional conclusion. The novel, set in the year 1938, in Mexico, revolves around the figure of Geoffrey Firmin, the so-called British "Consul," who wastes himself away in a mindless, almost demonic alcoholism. The story takes place in a single day and deals with the Consul's failure to live up to the occasion of his wife's sudden, unexpected return after a year of estrangement. She reappears one morning almost miraculously, after having filed for and obtained a divorce, to offer the Consul one last chance to save their marriage and begin a *vita nuova* in another place. For the Consul it amounts to an offer of personal salvation, for he is damned without her; yet his "other wife"—the bottle—will, by the end of the day, win out over Yvonne. Or over them both. Late on the night of that same day, the Consul will be shot by a band of Mexican fascists after having abandoned his wife and sought out the infernal sanctuary of a low-life cantina called the Farolito. His body will be thrown by his murderers into the *barranca*, or gorge, that cuts through the city of Quauhnahuac.

The garden of the Consul's house is situated near the edge of this *barranca*, which has several associations with the chasms of Dante's Inferno. For the Consul the garden has by now become primarily a hiding place for the bottle of tequila that he seeks out on the morning of his wife's return, in a mild panic. Reflective of the state of his soul, as well as his failed marriage, the garden is overgrown and turning wild. In its neglect it stands in stark contrast to the adjacent, well-tended garden of Mr. Quincey, a retired American who observes the Consul drinking stealthily from the bottle he has hidden in the underbrush. In the tense conversation that ensues between the two neighbors across a fence, the Consul declares to the right-minded Mr. Quincey:

> "By the way, I saw one of those little garter snakes just a moment ago," the Consul broke out. Mr Quincey coughed or snorted but said nothing,

> "And it made me think . . . Do you know, Quincey, I've often wondered whether there isn't more in the old legend of the Garden of Eden, and so on, than meets the eye. What if Adam wasn't really banished from the place at all? That is, in the sense we used to understand it. . . . What if his punishment really consisted," the Consul continued with warmth, "in his having to *go on living there*, alone, of course—suffering, unseen, cut off from God. . . . And of course the real *reason* for that punishment – his being forced to go on living in the garden, I mean—might well have been that the poor fellow, who knows, secretly loathed the place! Simply hated it, and had done so all along. *And that the Old Man found this out*"[9]

Lowry no doubt was aware that the Church fathers traditionally figured the sacrament of marriage as a prelude or "foretaste" of the garden of Eden.[10] On one level, both Eden and Adam's secret loathing of it are associated with the Consul's marriage—its false promise of happiness. On another level, Eden figures as the terrestrial world of nature itself, which we continue to inhabit in a state of loneliness and alienation from God. What interests us the most here, however, is the Consul's revision of the myth.

Even if we already saw intimations of this loathing of Eden in Ariosto's poem, the Consul's version of it has the distinct signature of what the critic Lionel Trilling, in an essay of 1964, calls the "spiritual militancy" of the post-Nietzschean age. Trilling takes up the thesis of Wallace Fowlie to the effect that the modern quest for spiritual freedom inevitably entails "some propagation of destructive violence." Fowlie: "In order to discover what is the center of themselves, the saint has to destroy the world of evil, and the poet has to destroy the world of specious good." Trilling comments: "the destruction of what is considered to be the specious good is surely one of the chief liter-

ary enterprises of our age"[11] This seems undeniable. The spiritual militants of the nineteenth and twentieth centuries have typically (but not exclusively) identified the specious good with bourgeois ideology in its political, economic, and cultural forms, yet the specific identification is not so crucial. What is crucial is to *identify* a specious good and then set about to attack it, for only through the propagation of destructive violence can the intoxication of spiritual freedom and the "more life" that we seek be attained. Trilling:

> How far from our imagination is the idea of "peace" as the crown of spiritual struggle! The idea of "bliss" is even further removed. The two words propose to us a state of virtual infantile passivity which is the negation of the "more life" that we crave, the "more life" of spiritual militancy. We dread Eden, and of all Christian concepts there is none which we understand so well as the *felix culpa* and the "fortunate fall"; not, of course, for the reason on which these Christian paradoxes were based, but because by means of the sin and the fall we managed to get ourselves expelled from that dreadful place.[12]

I will return to Trilling's comments about peace and bliss further on. But first let us note that *Under the Volcano* suggests, in almost fablelike fashion, that the fall from Eden is a continuous, ongoing event; it shows how, long after the original sin, we continue with active will to repeat our expulsion from the garden and tumble into the tumult of history. During the years in which the novel takes place, the West found itself between world wars. From that point of view there is clearly something specious about Mr. Quincey's garden. In its groomed and well-maintained appearance it offers a false image of the age—an age that, like the Consul, is in the grip of destructive and self-intoxicating passions. For all his sanctimonious disapproval of the Consul's alcoholism, Mr. Quincey too belongs to an age that has lost all sobriety. His name, which recalls the English opium eater, Thomas De Quincey, suggests as much.

Even more destructive than the drive toward a new world war is the mindless assault on nature by a Cerberus-like civilization that would, in its insatiable appetite for the fruits of the earth, devour the planet as a whole. The age, drunk on its own unredeemed materialism, craves "more life" at the expense of indiscriminate death for the natural world. If Eden is indeed nothing but the earth that we inhabit in the absence of God, as the Consul suggests, our loathing of it expresses itself in the modern era through the devastation that we visit upon her species, habitats, and resources. As another modern militant, Jim Morrison, put it one of his lyrics:

> What have they done to the earth?
> What have they done to our fair sister?
> Ravaged and plundered
> and ripped her and bit her,
> Stuck her with knives
> in the side of the dawn,
> And tied her with fences,
> and dragged her down.[13]

This from the same poet who, shortly before his self-consuming demise at age twenty-seven, wrote: "They are waiting to take us into the severed garden," meaning the garden of death.[14] For cemeteries, too, are gardens of sorts.

On the other side of the Consul's garden—away from Mr. Quincey's—there is yet another garden: a public garden still under construction. Peering onto its grounds, the Consul sees a warning sign in Spanish:

> LE GUSTA ESTE JARDIN?
> QUE ES SUYO?
> ¡EVITE QUE SUS HIJOS LO DESTRUYAN!

These words—which the Consul mistranslates in his mind to mean: "You like this garden? Why is it yours? We evict those who destroy!"—recur periodically throughout Lowry's novel; they are in fact its very last words. *Under the Volcano* is a tragedy—one of our very few genuine modern tragedies—about an individual's and civilization's "eviction" from a garden neither of them can help destroying. This is not the Edenic garden of "infantile passivity" that offends our human nature. It is the postlapsarian garden of the mortal earth where, for better or worse, we make our human home. This garden, which requires cultivation, caretaking, and labor if it is to be humanly inhabitable, lies on the edge of the yawning abyss of the *barranca*, or chasm of damnation, which awaits those individuals and societies that let their self-destructive drives get the better of their cultivating efforts. Time and again we have, like the Consul, taken the plunge during the course of history. To be human means to be forever faced with such an alternative: either to care for the garden of our mortal earth, or to turn it into a living hell by unleashing the nihilistic forces that tradition associates with the legacy of Adam.

One of the tragedies of our modern spiritual militancy is its excessive promiscuity with the nihilistic forces of the civilization against which it takes its stand. In its rage to destroy the specious good, it too often neglects to identify and cultivate the non-specious good that would render history less infernal. Hell is not the only alternative to Eden, yet the warrior poets of the twentieth century have frequently, if inadvertently, shown themselves to be destroyers rather than caretakers of the postlapsarian garden of human culture, broadly understood. This is the risk of aggravated spiritual militancy—it partakes of, or employs, the same kind of violence that it presumes to counteract. Our destructive and creative powers, after all, arise from the same basic source; the vandal's hammer is the same as the sculptor's; and every gardener knows that cultivation involves a lot of brute destruction, pruning, and cutting back to the ground. Destruction can be liberating, fascinating, creative, and even beautiful; yet too much of what we call modernism, in its spiritual rage, has neglected the hard, creative, form-and-life-giving work of cultivation. As a result, modernism finds its objective correlative in the wasteland rather than the garden. The fragments that bring Ezra Pound's wild and at times hysterical *Cantos* to a pathetic conclusion offer one of modernism's most honest confessions of failure:

> M'amour, m'amour
> what do I love and
> where are you?
> That I lost my center
> fighting the world?
> The dreams clash
> and are shattered—
> and that I tried to make a paradiso
> terrestre.[15]

Pound goes on to ask for forgiveness: "Let the Gods forgive what I have made / Let those I love try to forgive what I have made."[16] In the subsequent fragment, which brings the *Cantos* to an end, the last line reads: "To be men not destroyers."[17] These are the eternal alternatives. To be men means to be gardeners, caretakers of the earth, makers of culture. To be destroyers means to ravage what we have cultivated.

Whether it is because the specious good ended up triumphing over its antagonists, or whether the latter were altogether too contaminated by the nihilism against which they contended, or whether the intoxicating materialism of late-twentieth-century culture simply enucleated the quest for the "more life" of spiritual freedom, there is little doubt that the spiritual militancy identified by Trilling in 1964 has given way, in our day, to a culture of spiritual apathy. Frenzy, attention deficit, the desire for instant gratification, mental and psychic brutalization—it little

matters whether these are the symptoms or causes of such apathy. The fact is that the era of spiritual militancy is over, to say nothing of those eras when "peace" and "bliss" were considered "the crown of spiritual struggle." Long gone are the days when we had either the will or intellectual curiosity, let alone the attention span, to experience gardens like Stowe or Stourhead as they were meant to be experienced, namely, as places of self-cultivation, of spiritual and personal transformation. Gardens not only require time to grow into their cultivated forms, those forms require time to be internalized and spiritualized by the viewer. Time in this sense is measured not merely by the clock but by the deeper temporal recesses of self that gardens have a way of opening up to those who linger in them thoughtfully. Our age has declared all-out war on this kind of deep time, hence we hardly know what to do in these havens of deep time anymore.

If gardens, real and imaginary, have long embodied the ideals of the cultures that produced them, it is fair to say that today we belong to a gardenless era. Those who can afford them may keep up their own private gardens, but the garden as a place of insight, as an ideal of self-cultivation, as a sanctuary from the excesses of history, or as a promise of happiness, no longer thrives in our midst. One of the founding fathers of modern spiritual militancy, Friedrich Nietzsche, declared toward the end of the nineteenth century: "The wasteland grows. Woe to him who harbors wastelands within." It seems that the wastelands, both in their internal and external reaches, have continued to grow over and under and through the gardens of the Western imagination. And yet today, more than ever, it is needful to "cultivate our garden," for the alternatives identified by Pound at the end of his career are as stark and real as ever: to be men, not destroyers.

1. *The Epic of Gilgamesh*, translated by N. K. Sandars (London: Penguin, 1972), 100. Copyright N. K. Sandars, 1960, 1964, 1972. Reprinted by permission of Penguin Books Ltd.

2. Virgil, *Aeneid*, translated by Allen Mandelbaum (New York: Bantam Books, 1983), Book IV, 261–64.

3. Ariosto, *Orlando Furioso* (Milan: Rusconia, 1982) Canto 7, stanza 53. The English translation from the Italian is mine.

4. A. Bartlett Giamatti, *The Earthly Paradise and the Renaissance Epic* (Princeton: Princeton University Press, 1966), 356–57.

5. The sin of *superbia*, or pride, haunts the gardens of Versailles in more ways than one, for the idea of Versailles sprang from the envy and offense that the gardens of Vaux-le-Vicomte provoked in Louis XIV when they were first unveiled on August 17, 1661. These gardens, built by the king's minister, Nicolas Fouquet, were so grand and so "superb" that the Sun King promptly had his minister thrown into prison, where he languished for the rest of his long life. Fouquet's offense, it seems, was that of prideful overreaching. Like Satan, who tried to rise above his station and become the equal of God, Fouquet (in Louis XIV's estimation) challenged the monarch's sovereignty by the kingly grandeur and magnificence of Vaux-le-Vicomte. Like Satan, he, too, was cast down into the depths. Yet in the all-too-human *envy* that Vaux-le-Vicomte inspired in him, Louis XIV showed to what extent the analogy between himself and God only went so far. The first thing he did after punishing his minister was to hire Fouquet's team of gardeners, architects, and engineers and set about the project of building Versailles. For more on what he calls the "spiritual beginnings" of Versailles, see Christopher Thacker, *The History of Gardens* (Berkeley and Los Angeles: University of California Press, 1979), 146–49.

6. Algernon Charles Swinburne, *Swinburne: Selected Poetry and Prose*, edited by John D. Rosenberg (New York: Modern Library, 1968), 212–13.

7. Jean Paul Sartre, *Nausea*, translated by Lloyd Alexander (New York: New Directions, 1964), 129.

8. Ibid., 100.

9. Malcolm Lowry, *Under the Volcano* (New York: Harper & Row, 1984), 138–39.

10. For a full bibliography on this typological figure, see Henry Ansgar Kelly, *Love and Marriage in the Age of Chaucer* (Ithaca: Cornell University Press, 1975), 245 ff.

11. Lionel Trilling, "The Fate of Pleasure," in *Literary Views: Critical and Historical Perspectives* (Chicago: Chicago University Press, 1964), 106. See Giamatti's brief invocation of this essay in his conclusion to *The Earthly Paradise* (357–59).

12. Ibid., 108.

13. Jim Morrison, *The American Night: The Writings of Jim Morrison*, vol. 2 (New York: Villard Books, 1990), 106. From *Wilderness* by Jim Morrison, copyright 1988 by Columbus and Pearl Courson. Reprinted by permission of Villard Books, a division of Random House, Inc.

14. Ibid., 10.

15. Ezra Pound, *The Cantos of Ezra Pound* (New York: New Directions, 1983), 802. From *The Cantos of Ezra Pound* by Ezra Pound, copyright 1934, 1937, 1940, 1948, 1956, 1959, 1962, 1963, 1966, and 1968 by Ezra Pound. Reprinted by permission of New Directions Publishing Corp.

16. Ibid.

17. Ibid., 803.

SELECTED BIBLIOGRAPHY

SALLY APFELBAUM

Apfelbaum, Sally. *Sally Apfelbaum: Photograms and Photographs.* New York: Hirschl and Adler, 1999.

Handy, Ellen. "Genius Loci, Ingenious Locations, and Landscape Photography Today, Nostalgia, Femininity, and Looking Toward the Millennium." *Camerawork: A Journal of Photographic Arts,* vol. 23, no. 2 (Fall/Winter 1996): 4–7.

Leeds, Valerie Ann. *Seeking the Sublime: Neo-Romanticism in Landscape Photography.* Daytona Beach: Southeast Museum of Photography, 1995.

Miller, Mara. "What is the Subject of (in) Landscape Photography?" *Photography Quarterly,* no. 74 (Spring 1999): 4–9.

DANIEL BOUDINET

Boudinet, Daniel. *Un Paysage ou Neuf Vues du Jardin de Ian Hamilton Finlay.* Jouy-en-Josas: Cartier Foundation, 1987.

Caujolle, Christian, Emmanuelle Decrou, and Claude Vittiglio. *Daniel Boudinet.* Paris: Patrimoine Photographique, 1993.

Coignard, Jérôme. "Daniel Boudinet: Entre Chien et Loup" [Daniel Boudinet: Between Dog and Wolf]. *Beaux Arts Magazine* (France), no. 109 (February 1993): 65–69.

Vedrenne-Careri, Elizabeth. "Daniel Boudinet: Paysages et Architecture" [Daniel Boudinet: Landscapes and Architecture]. *Camera International* (France), no. 32 (Spring 1992): 42–51.

Vittiglio, Claude. "Daniel Boudinet (1945–1990)." *Photographies Magazine* (France), no. 48 (March/April 1993): 42–47.

GREGORY CREWDSON

Craig, Garret. "Gregory Crewdson: American Sensibility." *Flash* Art (October 2003): 74–76.

Crewdson, Gregory, as told to Tim Griffin. "80s Again." *Artforum International* (March 2003): 71.

Dompierre, Louise. "Gregory Crewdson." *Digital Gardens: A World in Mutation.* Toronto: The Power Plant, 1996.

Ducklo, Matt. "The Surreal Thing: Gregory Crewdson." *Surface* (Fall 2003): 5-6.

"Gregory Crewdson: Engine of Change." *New York Times Magazine* (September 19, 1999): 102–103.

Hall, Peter. "Gardening At Night." *Print* (July/August 2003): 41–49.

Homes, A. M. "Dream of Life: Gregory Crewdson." *Artforum,* vol. 31, no. 8 (April 1993): 70–73.

Moody, Rick, and Gregory Crewdson. *Twilight: Photographs by Gregory Crewdson.* New York: Harry N. Abrams, Inc., 2002.

Moody, Rick, et al. *Hover.* San Francisco: Artspace Books, 1998.

Morrow, Bradford. "Gregory Crewdson." *Bomb,* no. 61 (Fall 1997): 38–43.

"Portfolio: Gregory Crewdson Sees Stars in His 'Dream.'" *The New York Times* (November 10, 2002): 39–50.

Spector, Nancy. "There Goes the Neighborhood: Gregory Crewdson's Suburban Chill." *Guggenheim Magazine* (Spring 1997): 24–31.

PETER FISCHLI & DAVID WEISS

Armstrong, Elizabeth, Arthur C. Danto, and Boris Groys. *Peter Fischli and David Weiss: In a Restless World.* Minneapolis: Walker Art Center, 1996.

Dannatt, Adrian. "Fischli & Weiss." *Modern Painters* (Summer 2002): 119–20.

Fischli, Peter, and David Weiss. *Bilder, Ansichten.* Zurich: Edition Patrick Frey, 1991.

—. *Plötzlich diese Übersicht.* Zurich: Edition Stahli, 1996.

—. *Sichtbare Welt.* Cologne: Verlag der Buchhandlung Walter König, 2000.

—. *Will Happiness Find Me?* Cologne: Verlag der Buchhandlung Walter König, 2003.

Fricke, Christiane. "Peter Fischli/David Weiss: Fragen Projection." *Kunstforum Internationale* (January/February 2003): 322–25.

Groys, Boris. *Peter Fischli and David Weiss.* New York: Matthew Marks Gallery, 1998.

Heiser, Jorg. "Seeing Double: Jorg Heiser on the Floral Tributes of Peter Fischli and David Weiss." *Frieze* (U.K.), no. 44 (January/February 1999): 62–65.

Matzner, Florian, ed. *Gärten* by Peter Fischli and David Weiss. Oktagon Verlag, 1998.

Nemitz, Barbara. *Trans Plant. Living Vegetation in Contemporary Art.* Ostfildern-Ruit: Hatje Cantz Publishers, 2000.

Obrist, Hans-Ulrich, ed., Peter Fischli, and David Weiss. *Fischli/Weiss.* New York: Distributed Art Publishers, 1997.

Stegmann, Mark, ed. Fleurs: *Blumen in der zeitgenössischen Kunst und Naturkunde.* Basel: Schwabe & Co., 2000.

SALLY GALL

Gall, Sally. *Subterranea.* New York: Umbrage Editions, 2003.

Gall, Sally, and James Salter. *The Water's Edge.* San Francsico: Chronicle Books, 1995.

Gornik, April, and Sally Gall. "Landscape." *Bomb* (Summer 1993): 36–41.

Quarta, P. "Sally Gall." *Zoom* (Italy), no. 12 (January/February 1996): 44–49.

LYNN GEESAMAN

Anderson, Scott. "Lynn Geesaman." *Art News,* vol. 95 (April 1996): 138–39.

Geesaman, Lynn, and Jamaica Kincaid. *The Poetics of Place: Photographs by Lynn Gessaman.* New York: Umbrage Editions, 1998.

Goodman, Jonathan. "Lynn Geesaman at Yancey Richardson." *Art in America,* vol. 85 (July 1997): 92.

Hixson, Kathryn. "Lynn Geesaman." *Arts Magazine,* vol. 66 (January 1992): 88–89.

Klinkenborg, Verlyn, ed. Lynn Geesaman. *Gardenscapes.* New York: Aperture Publishers, 2003.

Pagel, David. "Lynn Geesaman at Stephen Cohen." *Art Issues,* no. 56 (January/ February 1999): 39.

Rahr, Christina. "The Photographs of Lynn Geesaman." *Orion* (Summer 1994).

LINDA HACKETT

Jonas, Susan, ed. *Ellis Island: Echoes from a Nation's Past,* by Norman Kotler et al. New York: Aperture, 1989.

Renner, Eric. *Pinhole Photography: Rediscovering a Historic Technique.* Boston: Focal Press, 2000.

Traub, Charles, Luigi Ballerini, and Umberto Eco. *Italy Observed in Photography and Literature.* New York: Rizzoli, 1988.

GEOFFREY JAMES

Constantini, Paolo, and Thomas Weski. *Identifazione di un Paesaggio.* Venice: Silvana Editoriale, 2000.

"Gardening Utopia: An Interview with Geoffrey James." *Border Crossings* (Canada), vol. 9, no. 1 (January 1990): 11–14.

Gopnik, Adam. "Olmsted's Trip." *The New Yorker* (March 31, 1997): 96–102.

Harbison, Robert. *The Italian Garden.* New York: Harry Abrams, Inc., 1991.

James, Geoffrey. *La Campagna Romana.* Montreal: Editions Galerie René Blouin, 1990.

—. "Olmsted: Some Other Space." *Descant 79/80,* 1992. [artist's project, 8 plates]

—. "The Republic of Images." In *Responding to Photographs.* Toronto: Art Gallery of Ontario, 1994.

James, Geoffrey, and Hubert Damisch. *Paris.* Paris: Collection de l'Esplanade, 2001.

James, Geoffrey, Elizabeth Armstrong, Sebastian Rotella, and Dot Tuer. *Running Fence.* North Vancouver: Presentation House Gallery, 1999.

James, Geoffrey, and Rudy Wiebe. *Place.* Vancouver: Douglas and McIntyre, 2002.

Kozloff, Max. "Olmstead: Photography and the Democratic Pastoral." *Canadian Art,* vol. 13, no. 4 (Winter 1996): 50–58.

Lamarche, Lise, and Guy Mercier. *Terrains Vagues, Unspecified.* Quebec: Editions J'ai Vu, 2000.

Lambert, Phyllis, ed. *Viewing Olmstead: Photographs by Robert Burley, Lee Friedlander, and Geoffrey James,* by Paolo Costantini, John Szarkowski, and David Harris. Cambridge and London: The MIT Press, 1997.

LEN JENSHEL

Beardsley, John, Roberta Kefalos, and Theodore Rosengarten. *Art and Landscape in Charleston and the Low Country: A Project of Spoleto Festival U.S.A.* Washington, D.C.: James G. Trulove, 1998.

Cook, Diane, and Len Jenshel. *Hot Spots: America's Volcanic Landcape.* Boston: Bulfinch Press, Little Brown & Co., 1996.

—. *Aquarium.* New York: Aperture, 2003.

"Out of the Garden: Photographs of National Parks by Len Jenshel." *Aperture,* no. 120 (Late Summer 1990): 44–49.

Pool, Peter E., ed. *The Altered Landscape,* by Patrica Nelson Limerick, Dave Hickey, and Thomas Southall. Reno and Las Vegas: Nevada Museum of Art in association with the University of Nevada Press, 1999.

Sorvig, Kim. "Sharp Focus, Blurred Boundaries: The Landscape Photography of Len Jenshel." *Landscape Architecture* (February 2003): 76–79, 93.

Sullivan, Constance, and Susan Weiley, eds. *Travels in the American West: Photographs by Len Jenshel.* Washington, D.C.: Smithsonian Institution Press, 1992.

ERICA LENNARD

Cox, Madison, and Erica Lennard. *Artists' Gardens: From Claude Monet to Jennifer Bartlett.* New York: Harry N. Abrams, Inc., 1993.

D'Arnoux, Alexandra, Erica Lennard, and Bruno de Laubadere. *Gardens by the Sea.* New York: Crown Publishing Group, 2002.

Gornick, April. "Portfolio: Erica Lennard." *Bomb,* no. 32 (Summer 1990): 62–67.

Herscher, Georges. *Jardins d'Ecrivains.* France: Actes Sud, 1998.

Hobhouse, Penelope. *Gardens of the World.* New York: Macmillan, 1991.

Les Jardins Japonais. Paris: Insense, 1997.

SALLY MANN

Johnson, Lizabeth A. "Sally Mann: The Power of Everyday Life." *View Camera,* vol. 5, no. 2 (March/April 1992): 26–31.

Lippard, Lucy. "Outside (But Not Necessarily Beyond) the Landscape." *Aperture,* no. 150 (Winter 1998): 60–73.

Mann, Sally. *Still Time.* New York: Aperture, 1994.

—. *Mother Land.* New York: Edwynn Houk Gallery, 1997.

—. *What Remains.* New York: Bulfinch Press, 2003.

Mann, Sally, and Reynolds Price. *Immediate Family.* New York: Aperture, 1992.

"Sally Mann: Photographs from the South, Portfolio of Landscapes." *Creative Camera,* no. 334 (February/March 1997): 16–21.

Solomon, Deborah. "The Way We Live Now: 09-09-01; Portrait of an Artist." *New York Times Magazine.* (September 9, 2001): 39.

CATHERINE OPIE

Boyle, Kevin J. *Escape Space*, Germany: Ursula Blickle Stiftung, 2000, p. 106-113, ill.

Bush, Kate, Joshua Decter, and Russell Ferguson. *Catherine Opie*. London: The Photographers' Gallery, 2000.

Cortes, Jose Miguel G. *Zona F.*, Castello: Espai d'Art Contemporanei de Castello, 2000.

Feminin Masculin: le sexe dans l'art. Paris; Centre Georges Pompidou, Gallimard/Electra, 1995.

Fogle, Douglas, and Catherine Opie. *Catherine Opie: Skyways and Icehouses*. Minneapolis: Walker Art Center, 2002.

George, Adrian, ed. "Art, Lies and Videotape: Exposing Performance." *Fact or Fiction*, London: Tate Gallery, 2003, pp. 44–47.

Gumpert, Lynn. *La Belle et La Bete*, Paris: Musee d'Art Moderne de la Ville de Paris, 1995.

Melo, Alexandre. *Lost Paradise: Catherine Opie, Joachim Koester, Ellen Cantor*. Portugal: Presenca Galeria, 1998.

Reilly, Maura. "The Drive to Describe: An Interview with Catherine Opie." *Art Journal*, vol. 60, no. 2 (Summer 2001): 82–95.

Sante, Luc and Amy Steiner. "The Secret of the Man Made World." *Metropolis* (April 1999): 88–91.

Smith, Elizabeth A. T., and Colette Dartnell. *Catherine Opie*. Los Angeles: Museum of Contemporary Art, 1997.

Steiner, Rochelle. *Catherine Opie: In Between Here and There*. Saint Louis: Saint Louis Art Museum, 2000.

Visser, Hripsime. *From the Corner of the Eye*. Amsterdam: Stedelijk Museum, 1998.

JACK PIERSON

Behenna, Veralyn. "Jack Pierson: Little Triumphs of the Real." *Flash Art* (Italy), vol. 27, no. 175 (March/April 1994): 88–90.

Jack Pierson. Milan: Photology, 2001.

Kertess, Klauss. *Edward Hopper and Jack Pierson: America Dreaming*. New York: Whitney Museum of American Art, 1994.

Lucie-Smith, Edward. *Borealis 7/Desire*. Helsinki: Nordic Arts Centre, 1995.

Mahurin, Matt. *Jack Pierson*. Santa Fe: Twin Palms Publishers, 2001.

Molon, Dominic. *Jack Pierson: Traveling Show*. Chicago: Museum of Contemporary Art, 1995.

Pierson, Jack. *Jack Pierson, All of a Sudden*. New York: PowerHouse Books, 1995.

—. *Pretty Lies*. Tokyo: Taka Ishii Gallery, 1997.

—. *Sing a Song of Sixpence*. Cologne: Salon-Verlag, 1997.

Pierson, Jack, and Jim Lewis. *Real Gone*. San Francisco: Artspace Books, 1994.

Raabe, Andreas Reiter. "'I Like to Try My Hands on Everything': An Interview with Jack Pierson." *Eikon* (Austria), no. 21–22 (1997): 24–28, 162–63.

Rimanelli, David. "Jack Pierson Regrets." *Artforum International*, vol. 41, no. 3 (November 2002): 179.

Romano, Gianni. "Jack Pierson." *Zoom* (May/June 2001): 58–65.

Weiermair, Peter, ed. *The Lonely Life*, by Jack Pierson and Gerard A. Goodrow. Zurich: Edition Stemmle, 1997.

MARC QUINN

Arnold, Ken. "Framed: Marc Quinn." *Tate Magazine*, vol. 28 (Spring 2002): 19.

Celant, Germano, and Darian Leader. *Marc Quinn*. Milan: Fondazione Prada, 2000.

Crow, Thomas. "Marx to sharks." *Artforum*. (April 2003): 45–52.

Gisbourne, Mark, David Thorpe, Will Self, Brian Eno, and Marc Quinn. *Marc Quinn: Incarnate*. London: Booth-Clibborn Editions, 1998.

Gisbourne, Mark. "The Self and Others, the Art of Marc Quinn." *Contemporary*. (February 2002): 51–57.

Grunenberg, Christoph, and Victory Pomery, eds. *Marc Quinn*. London: Tate Liverpool, 2002.

Leader, Darian. "Thoughts on the Work of Marc Quinn." *Kunstverein Hannover* Germany, 1999.

"Marc Quinn in Conversation with Karljeinz Lüdeking." *Kunstforum International*, vol. 148 (December 1999): 182–93.

Marc Quinn: *Flesh*. Dublin: Irish Museum of Modern Art, 2004.

Marlow, Tim, and Phillip Cribb. *Marc Quinn: Sculpture at Goodwood*. London: Goodwood Sculpture Park, 2003.

Pomery, Victoria, ed. *New Work: Marc Quinn*, by Sarah Whitfield and John Sulston. New York: Harry N. Abrams, Inc., 2002.

Preece, Robert. "Justa Load of Shock? An Interview with Marc Quinn." *Sculpture*, vol. 19, no. 8 (October 2000): 14–19.

Rose, Aidin. "The Mighty Quinn." *The Times Magazine* (January 19, 2002): 24–27.

Thorp, David. *Marc Quinn*. London: South London Gallery, 1998.

JEAN RAULT

Durand, Regis. *The Pensive Look: Places and Objects of Photography*. Paris: Editions de la Différénce, 1988.

Henric, Jacques. *Du Portrait*. Paris, Editions Marval, 1991.

Jean Rault Photographies 1983–1999. Yvetot, France: Collection Petit Format, Edition Galerie Duchamp, 1999.

Ouaknin, Marc-Alain. *Cent Vues du Potager du Roi*. France: Filigranes Ed., 2003.

Schaeffer, Jean-Marie. "Jean Rault: On the Photographic Portrait." *Art Press* (France), no. 191 (May 1994): 46–50.

INDEX